WITHDRAWN

 **St. Louis Community
College**

Library

5801 Wilson Avenue
St. Louis, Missouri 63110

MOVIE SPECIAL EFFECTS

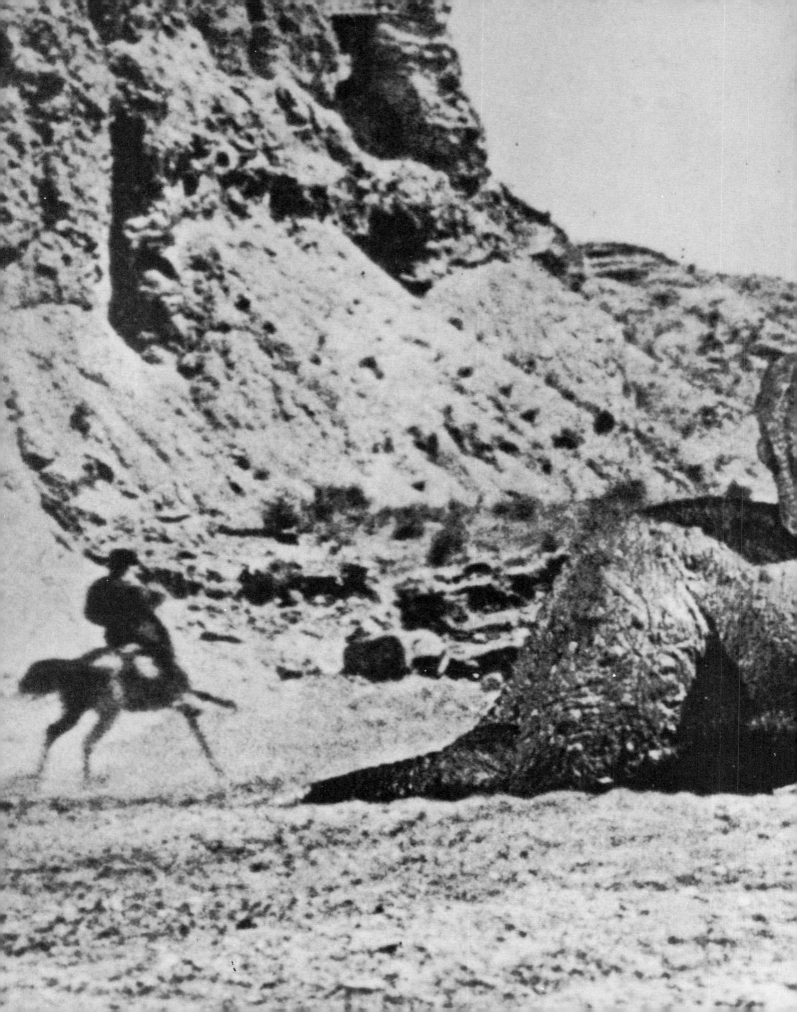

MOVIE
SPECIAL EFFECTS

Jeff Rovin

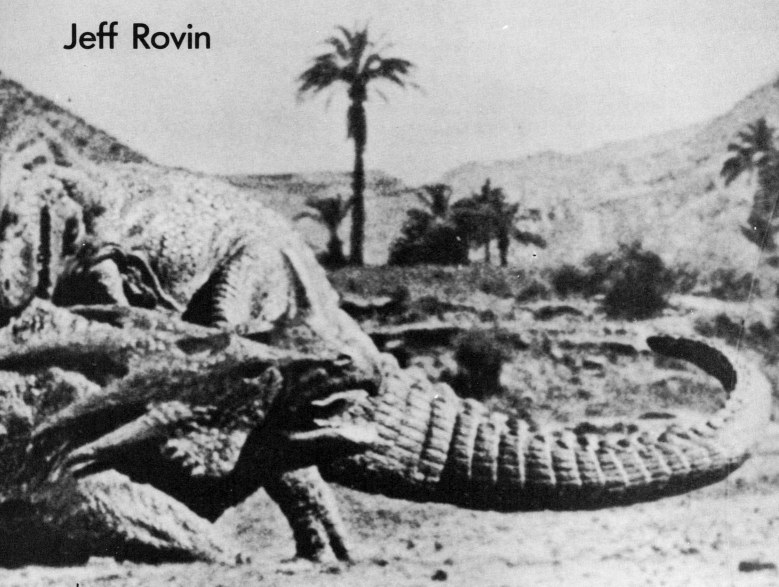

SOUTH BRUNSWICK AND NEW YORK: A. S. BARNES AND COMPANY
LONDON: THOMAS YOSELOFF LTD

A. S. Barnes and Co., Inc.
Cranbury, New Jersey 08512

Thomas Yoseloff Ltd.
Magdalen House
136–148 Tooley Street
London SE1 2TT, England

Library of Congress Cataloging in Publication Data

Rovin, Jeff.
 Movie special effects.

 Includes index.
 1. Cinematography, Trick. 2. Cinematographers
—United States—Biography. I. Title.
TR858.R68 778.5'34 76-50212
ISBN 0-498-01949-7

Also by JEFF ROVIN:

A Pictorial History of Science Fiction Films
The Films of Charlton Heston
Of Mice and Mickey
Hollywood Detective #1 and #2
The Hindenburg Disaster
The Fabulous Fantasy Films

PRINTED IN THE UNITED STATES OF AMERICA

to
Shesh and Nubbelles
with all my love

Contents

Acknowledgments

For making invaluable contributions to this volume, I would like to thank the late Fritz Lang, Ray Harryhausen, Dick Siegel, Tom A. Jones of Walt Disney Productions, Paula Klaw of *Movie Star News*, Booker McClay of Universal Pictures, M. Oiwa of Toho International, Mary Corliss of the Museum of Modern Art, Geraldine Duclow of the Philadelphia Free Library, Mrs. Darlyne O'Brien, and the National Film Board of Canada.

Introduction

Most of us are unaware of special effects in movies. We never stop to consider that the *Hindenburg*, soaring majestically through the Robert Wise film, is only a miniature model, or that the one-hundred-thirty-eight-floor *Towering Inferno* is, in fact, a nine-story fake. And this blissful ignorance of the wizardry being wrought is as it *should* be. If a special effect is obvious, then it has not succeeded in its prime function, which is to fool us.

Accordingly, the special effects man is one of the film industry's largely unrecognized heroes. He works diligently, often dangerously, behind the scenes to create illusions that can make or break a film. His daily routine consists of sinking ocean liners, constructing mechanical sharks, placing giant apes atop the Empire State Building, and turning men into werewolves. In this book, we're going to examine his world of magic, from its unsophisticated origins to the incredibly complex work being done today. During the course of our study, we will meet the great special effects men, thread our way through technical jargon to explain their trickery, and look at all the great special effects films, from *A Trip to the Moon* (1903) to *The Ten Commandments* (1956) to *Earthquake* (1974). There's also a section on the origins and workings of such film gimmicks as Smell-O-Vision, 3-D, and Sensurround, and a chapter on television, with an explanation of the special effects used in "Star Trek," "Superman," and many others.

When we are through, you will never again see a movie in quite the same light.

MOVIE SPECIAL EFFECTS

1
The Early Days of Film

Filmmaking offers such a variety of pursuits, demands such a quantity of work of all kinds, and claims so sustained an attention, that I do not hesitate to proclaim it the most attractive of all the arts.

—George Melies

If we discount the caveman, huddled around a chip-and-log fire, casting shadowed images of his hands on a cold, stone wall, then the first thought of projecting an image with light belonged to the German priest Athanasius Kircher. In his book *The Great Art of Light and Shadow* (1646), Kircher unveiled his design for an *opaque projector*, a long, metallic cylinder with one open end, a mirror at the other end, and a candle in the center. On the mirror was a painted silhouette. The candlelight was reflected by the glass, except where it had been opaqued, shined through the cylinder's open end, and thus projected the shadow of the solid, painted image.

Throughout the seventeenth and eighteenth centuries, Kircher's idea was modified and incorporated into the construction of *magic lanterns*.

Depending upon its design, the magic lantern used convex or concave lenses to throw slides against a wall with candlelight. These slides were small paintings done on glass, and no longer were they simply shadowed projections but colorful, detailed renderings.

The next landmark development was understanding *persistence of vision*. This was a phenomenon first recorded by the Alexandrian scientist Ptolemy in A.D. 147. The Greek observed that a colored section of a rapidly revolving disk gave a slight tint to the entire surface. A similar experiment, which the reader can perform without elaborate Hellenic equipment, is to spin a coin quickly on end. From a given vantage point, both the head and tail will be visible simultaneously. Persistence of vision, then, is simply the eye's ability to retain an image for a brief moment after the object itself has been removed. By 1832, this property had been incorporated into the scientific toys known as the *Stroboskop* and the *Phenakitiscope*, created independently and respectively by the Viennese Simon Ritter von Stampfer and M. Plateau of Brussels. This device

featured drawings, in progressive stages of movement, rendered side by side around the circumference of a disk. Small slits were cut in a second disk, which was placed with the first on an axle so that the two were parallel and several inches apart. The axle was mounted on a stand and cranked by a viewer, who stared through the slits at the pictures beyond. Each individual drawing would appear for an instant, register on the observer's eye, then disappear behind a solid section of the disk. But before this image was lost to the eye, it had been replaced by the next, then the next, and so forth. This caused an illusion of movement, and the serrated disk was our first *shutter;* the illustrated disk was our first "movie."[1]

A method for projecting these moving images became the next order of business, and it came about in 1853 courtesy of Baron Franz von Uchatius, an Austrian military officer. His projector was unique in that rather than rotate his picture disk, he simply sent the light source around in circles. This eliminated the need for a shutter, since the spaces between each illustration served to kill the projected image and make way for a new one. Unfortunately, to create a brief moving picture required a cumbersome twelve lenses—one for each glass slide—all focused at the same spot on a screen. It remained, then, to unite persistence of vision, a more practical projecting device—and photography.

Photography itself was a relative contemporary of the *Stroboskop,* the first photograph having been taken in 1816 by the Frenchman Nicephone Niepce. Although his image was short-lived and quickly went black, the example inspired his partner, Louis Jacques Mande Daguerre, to create the so-called *daguerrotype* in 1837. This process used a polished plate coated with iodine to record an image, which became visible and permanent when exposed to mercury vapor. Within a decade, the first *negatives,* made of glass, were being used to allow multiple printings of one image, and by 1870, photographers had replaced progressive drawings on the *Stroboskop* and kindred devices with specially posed progressive photographs. It wasn't long after this that Philadelphian Coleman Sellers thought to combine a photographic disk with Baron Uchatius's projector. He improved the unit's quality of image by keeping his light source stationary and spinning one slotted and one photographic disk before it. This new "moving picture" system

premiered on February 5, 1870, to a wildly receptive audience of 1,500.

Seventeen years after this landmark display, chemically treated paper replaced the unwieldy glass and metal plates that had been used in photography for over half a century. Two years after that, rigid but lightweight celluloid became the standard film for cameras. With this development, recording a moving object was no longer a matter of staging each successive position. The action could occur naturally while a dozen or so lenses on a specially constructed camera opened and shut in rapid consecution. Since this was a comparatively clumsy means of recording motion, a means was sought, instead, to move the chemically coated strips past a single lens. Before they could do this, however, photographers had to find a strip flexible enough to be wound inside a camera. Celluloid was simply too tough to do the job. *Film* was the answer, a substance made of the same gun cotton base as celluloid, but processed with fusel oil and amyl acetate rather than camphor and alcohol. This gave film its pliability. Meanwhile, experiments in Europe and the United States—these latter under the auspices of Thomas Edison—produced shuttered lenses, gates that opened and closed to expose predetermined measures of film at a clip. The cameras themselves were hand-cranked or, under studio conditions, electrically driven, and Edison displayed the resultant moving pictures in *Kinetoscopes.* These were large boxes featuring fifty feet of film passed between an electric light source and a shutter and viewed through a magnifying glass. The Kinetoscopes were premiered on April 14, 1894, serviced one customer at a time, and were coin-operated for a nickel a show.

The projecting of moving picture films followed hard upon. A young man by the name of Jean LeRoy built a crude projector and displayed some of Edison's Kinetoscope productions hoping—and failing—to sell the idea to theatrical agents. Then, a year after the Kinetoscope went into operation, science teacher Woodville Lathams and his sons exhibited their *Magic Lantern Kinetoscope* to the press. The subject of their film was boys at play in a park. The Lathams' machine re-created a near life-size vision of the youngsters' frolic, but it was an awkward presentation, with the projector unsteady and the illumination inconstant. There was another drawback: the machine cast a costly forty individual pictures or *frames* on the screen every second. In

France, the Lumiere Brothers, Louis and Auguste, had already built a machine that cut this to sixteen frames per second—which was to become the standard silent speed—thus decreasing the amount of film required to create a proper screen entertainment. With this new economy and improved projector, moving picture production became an attractive proposition to photographers. Accordingly, the Lumieres opened a small theater, the Cinema Saint-Denis, on December 28, 1895, and Parisians willingly paid a franc to see the novelty of the moving picture or *cinematographe*. Certainly, the Lumieres enjoyed far greater success than the Lathams, who had set up a small theater in an abandoned shop on lower Broadway. After several unprofitable months of making and showing their own movies, the family was forced to shut down operation.

Meanwhile, an effective and streamlined projector had also been built by inventors C. F. Jenkins and Thomas Armat in 1895, and impressed the men who were distributing Edison's Kinetoscopes. They saw the possibility of entertaining, like the Lumieres, hundreds of paying customers at a throw, and convinced Edison to manufacture and market the Jenkins-Armat machine. Unlike the Lathams, Edison had the name and capital to successfully underwrite the venture. Especially attractive to the inventor was the fact that this machine had a clarity of image that is common to our current projectors. The visuals were considerably more distinct than those of the Lumieres due to precision tooling of the feeder mechanism. Thus, on April 23, 1896, Edison held a public christening of his first *Vitascope* projector at Koster and Bial's Music Hall in Manhattan, now the site of Macy's Department store.[2] The audience was treated to the famous waves, which came crashing silently at them from the 20' x 30' screen, dancing girls, boxing matches, and a scene from the play *A Milk White Flag*. It was a triumphant debut and, both at home and abroad, moving pictures were here to stay.

The distinction of having been first to project a fiction film, the minute-long *Le Jardinier*, belongs to the Lumieres. However, of greater importance to our study is the "first" of another Frenchman, the creation of the world's first special effects film. George Melies discovered the medium when he was thirty-four, in 1896. He was a man of varied artistic experience, having been a newspaper caricaturist, an actor, a magician, and a scenic painter. However, it was the moving picture camera he bought that most fascinated him, and he traveled about Paris on weekends shooting anything that moved, simply for the fun of it. One day, as legend has it, while photographing a street scene, his camera jammed. Clearing a tangle of film from the *aperture gate*—an iris that regulates the flow of light into the camera—Melies resumed his shooting. When the film was developed, what the cinematographer saw caused him to start. As if by magic, a bus was transformed, on-screen, into a hearse. Rewinding the film, Melies studied the sequence again and again until he understood what had happened. When his camera jammed, the bus had just entered the picture. By the time Melies set the aperture right, the coach had gone on its way and a hearse had moved into frame, exactly where the bus had been when the film caught. It was an amazing illusion, and one that caused the magician's mind to fill with the limitless possibilities of camera trickery.

Experimenting further over the next few weeks, Melies devised most of the cinema's basic special effects techniques. Among these were *split-screen photography*, a trick accomplished by means of a *mask*, an opaque lens-covering in two matching pieces. Melies would mask a portion of the lens and shoot, as he did in an early film, a man sitting in a chair, on the screen's left side. Rewinding the camera, he would mask this exposed portion of film, uncover the other side of the lens, and photograph that same man entering the room from the right. When the processed reel was screened, the effect was that of the man simultaneously reading in and entering the room. These masks, of course, could be cut in whatever shape and divided into as many parts for as many exposures as Melies wished. All that mattered was that, together, the pieces cover the entire lens. If one portion of film were exposed twice in succession, the result was a *double exposure*. The only sensible use for this technique was to create ghosts, since the on-screen images were always transparent.

Running his camera backward but projecting the developed film forward, Melies found he could shoot things in reverse; running the film quickly or slowly through his camera, but projecting it at normal speed, the filmmaker was able to shoot in slow or fast motion, respectively.[3] Mastering these and other basics, Melies quit his newspaper job, built a small, glass-enclosed studio, and between 1896 and 1900, made over two hundred one- and

two-minute moving pictures. These were primarily showcases for his technical acuity, and boasted such titles as *The Vanishing Lady, The Laboratory of Mephistopholes, A Conjurer Making Ten Hats in Sixty Seconds, The Haunted Castle*, and so forth. Shown in the United States, these pictures were the envy of Edison and his people, who were still producing attractive but ultimately redundant travelogues.

In December of 1900, Melies achieved a cinema landmark: *Cinderella* was the first moving picture to be made in what he termed *artificially arranged scenes*. In other words, his production told a story. It was a substantial improvement over *Le Jardinier*, in which the camera remained stationary throughout, and actors entered the frame from right or left, as though on-stage. *Cinderella* had twenty different scenes, actors in costumes, and a host of trick effects. Among these were the famous transformation of rats into horses, and of the pumpkin to a coach. These were accomplished through a repetition of the bus-hearse illusion. Melies photographed the pumpkin and rodents, stopped the camera, replaced them with a cardboard carriage and a team of horses, and continued filming. The six minute picture was extremely well received, and an enthusiastic Melies rushed others into production. *Red Riding Hood* (1901), *Off to Bloomfield Asylum* (1901), and *The Maiden's Paradise* (1901) were among his subsequent efforts. A year later, his four hundredth and most ambitious production, *A Trip to the Moon*, became the artist's enduring masterpiece. Based on Jules Verne's *From the Earth to the Moon* and H. G. Wells's recently published *First Men in the Moon*, this unprecedented thirteen-minute-long epic employed every trick known to the fledgling craft, and *then* some.

The story revolves around members of the Astronomic Club, led by Melies himself, who journey to the moon in a giant space bullet. Fired over the rooftops of Paris from a huge cannon—manned by a line of bathing beauties—the men travel through space, strike the eye of the Man in the Moon, and step onto the habitable lunar surface. There, they encounter hostile, insectlike Selenites, do battle with the creatures, and are forced to make a hasty departure for earth. Their return is an ignoble one, although strangely prophetic: the manned bullet splashes down in the ocean, where the intrepid astronauts are rescued and feted by marines.

Melies himself either created or supervised the building of all the props and canvas backdrops used in the film. He later admitted that, "the entire cost of *A Trip to the Moon* was about ten thousand francs, a sum relatively high for the time, caused especially by the mechanical sceneries and principally by the cost of the cardboard and canvas costumes made for the Selenites. The Selenites themselves were acrobats from the Folies Bérgère."

Among the most impressive special effects in the world's first science fiction film are these meticulous monster costumes, the space capsule's soaring flight over Paris, and the craft's lunar approach. To show the launching, Melies constructed a model of the ship and, with overhead wires, simply pulled it alongside a detailed backdrop of the Parisian skyline. Later, to give the viewers a look at earth's satellite from the explorers' vantage point, he sculpted a large model of the moon and hauled it along a lengthy horizontal track toward the camera. This created an unprecedented sense of audience participation, with theatergoers actually "flying" toward the moon.

A Trip to the Moon was a tremendous success, and Melies followed it with films like *Gulliver's Travels* (1902), *Beelzebub's Daughter* (1903), *Fairyland* (1903), and *The Impossible Voyage* (1904). In many ways, this latter production surpassed the craftsmanship and panache of Melies's first adventure in outer space. For one thing, it boasted three times the budget, and ran a full twenty minutes. For another, Melies pushed the humor of his burlesque-house rocket attendants in *A Trip to the Moon* to a delightful out-and-out parody in *Impossible Voyage*. The film relates how, under the auspices of The Institute of Incoherent Geography, Melies's own Professor Polehunter, Vice-President Humbug, Secretary Rattlebrains, and the mad scientist Crazyloff, took to the skies at three hundred miles per hour. Their goal: to fly to the sun. They succeed, of course, passing through the aurora borealis, being frozen in the Milky Way—another of Melies's marvelous canvas backdrops—getting battered by a solar flare, and finally returning to earth where they are decorated by the government. Although the special effects techniques were the same as in the previous space film, Melies used his large budget to polish their execution. However, even these impressive displays were dwarfed by his later film *Conquest of the Pole* (1912). With eight additional years of filmmaking skills under his belt,

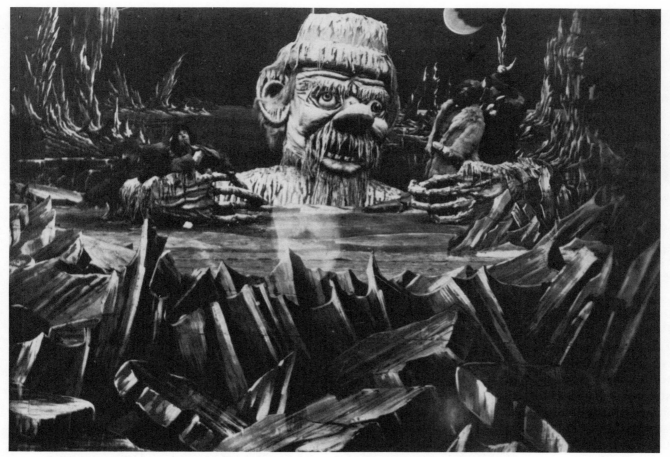

The mechanically operated Frost Giant from Melies's *Conquest of the Pole. Courtesy Museum of Modern Art.*

Melies gave a concise seven-minute account of Arctic explorers and their encounter with a man-eating snow giant. In one especially extraordinary sequence, the monster erupts from the ice and devours one of the adventurers. The entire scene was enacted without optical trickery: the very abominable snowman was actually a twenty-foot-tall model whose exterior was molded of plaster and cardboard over a latticed wooden skeleton. We see the creature from the waist up only. Behind surrounding chunks of Arctic scenery, atop scaffolds, and inside the model's skeleton, technicians operated enormous cables via a complex pulley system, which gave the creature's arms, eyes, and jaws their mobility.

Although competition from other filmmakers and rising production costs slowed Melies's output, by 1913 he had produced over five hundred films. Unfortunately, the coming of World War I saw his studio commandeered by the government as a research facility. Lacking the funds to open a new

shop, the father of movie special effects sold the bulk of his films to local scrap dealers. For this reason, most of the Frenchman's work is known to us solely through contemporary journals and records. Not surprisingly, shortly after this personal debacle, Melies faded to obscurity until 1928, when he was recognized by a journalist while selling toys and candy in a kiosk. The French film industry paid Melies homage, giving him medals like those awarded to the characters in his pictures, and presenting retrospectives of his surviving films. However, this didn't put bread on the table, and Melies stayed with the newsstand until 1933. Seven years later, he died in a home for destitute actors.

At the same time that Melies's fortunes were slipping, film production in the United States was on the upswing. The war had severely depleted European resources—film stock and explosives were made from the same raw materials—and the world looked to America for the majority of its screen entertainment. Filmmakers met this chal-

The eye-slitting scene from the Salvador Dali/Luis Bunel production *Un Chien Andalu* (1929). The film is a surrealistic fantasy; the face is that of a cow doubling for its human counterpart.

lenge with enthusiasm. Years before, with Edwin S. Porter's *The Life of An American Fireman* (1903) and *The Great Train Robbery* (1903), they had begun replacing travelogues with serious fictional narratives and comedies. The average moving picture started to run longer than the original one-to-fifteen-minute standard, but the greatest changes were yet to come. As early as 1910, producers had begun shifting their moviemaking operations from the fickle climate of New York and New Jersey to the steady warmth and sunshine of California. The majority of these filmmakers settled in Hollywood, a pleasant, rural orange grove nestled among mountains, desert, and an ocean. Taxes were low, hired help was relatively cheap, and Mexico was nearby. This latter was particularly handy on occasion, since there were a great many legal battles being fought back East as to who had invented, and who was entitled to royalties on, various mechanisms being used in cameras and projectors. In any case, by 1919 and the end of World War I, Hollywood had become the world's foremost center of film production, and mone's from home and abroad made the West Coast studios ever more powerful. They began planning cohesive advertising promotions for their pictures, and saw the value of creating "movie stars," popular personalities who would serve as presold commodities in new screen product. They established distributorships to lease their movies, thus keeping a larger share of the profits, and began buying up movie theaters to boost revenue even more.

In terms of art, directors like D. W. Griffith, in *Birth of a Nation* (1915) and *Intolerance* (1916), were learning the value of that new kid on the block, the *camera position*, and began varying close-up shots and long shots to great dramatic effect. Film editing became a tool for narrative impact rather than for simply changing the camera's perspective, and title cards were introduced to communicate dialogue or make clear certain subtleties in plot and character.

During these early days, the first movie special effects men were free-lancers, and their independent experiments helped broaden the scope of the motion picture. As we shall see, they enabled the filmmaker to shoot pictures in a jungle, blizzard, or Ancient Rome without ever leaving Hollywood. Indeed, in 1906, Edwin Porter even made it possible for a man's dinner to rise from his stomach in *Dreams of a Rarebit Fiend*. An achievement equal to that of Melies's early product, the film featured foodstuffs that chase our hero from floor to wall to ceiling of his bedchamber, after which they send him on a mad nighttime flight over the streets of Brooklyn. This latter trick was accomplished via split screen, with the first take used to record the city below, and the second exposure filming the bed and its passenger before a dark, skylike backdrop. The matchline of the two pictures fell along a straight horizon. The bedroom scene was executed with the dreamer and men in food costumes running in place while the room and camera were spun clockwise and in unison by burly aides.

Despite contributions such as these, many directors resented the special effects man, whose technical requirements imposed severe artistic restrictions on the filmmaking process. In essence, he dictated where the actors would stand, in what directions the camera could and couldn't move, and how to light scenes involving his work. It would not be until the thirties that this tension was resolved with the formation of the in-studio special effects department—but we get ahead of ourselves.

In addition to the magic practiced by early moviemakers, the growth of special effects was due to the adaptation of processes used by still photographers. In this respect, Norman O. Dawn was responsible for making some of the first major exchanges between the media. Greatly intrigued by camera trickery after a meeting with Melies in Paris in 1906, the twenty-one-year-old Dawn returned to America, determined to master this budding field. But he did more than master it, giving the industry some of its most enduring tricks. Principal among these was the movie *glass shot*, a technique used to

surround real people with an imaginary setting. We are not certain who actually invented this staple of still photography, but we do know that Dawn was the first to use it in a movie, to re-create the destroyed portions of an old Spanish church for his documentary *The Missions of California* (1907). Basically, it requires that a painting be placed between the camera and its subject, in Dawn's case the ruins of a mission. To show how the building looked a century before, on a large sheet of glass he painted those portions of the mission which had since decayed or collapsed. Careful to match his exquisitely detailed rendering with the surviving walls and columns, Dawn left the rest of the glass perfectly clear. Positioning it in a large frame several feet before the lens, Dawn's glass shot fooled his camera into thinking that the entire building was there. Backed by real sky, mountains, and trees, the painting bled naturally into the remaining church structure to create a convincing composition. Of course, the problem with a glass shot is that the camera must remain stationary throughout the scene. If it moves, the flow from painting to reality will shift, thus destroying the illusion.

Another of Dawn's inaugurations, also borrowed from still photography, was *rear-screen projection*, a method of placing actors in a foreign locale without having to leave the studio. He tried this process for the first time in his film *The Drifter* (1913), which Dawn produced after two years of free-lancing for the established studios. Frustrated with the temperament of egomaniacal directors, he resolved to build his own production company. It was a short-lived dream, the economics of bucking any giant being what they are, but Dawn did manage to create a handful of interesting films. *The Drifter* was the first of these, and it presented Dawn with a puzzle. He didn't have the money to go on location,

yet he needed a realistic western background. He also wanted complete control over the light striking his actors, which, due to the comparatively crude nature of film stocks, necessitated remaining in his small studio. Thus, Dawn had a photograph taken of the desired terrain and projected this on a large, translucent screen back in the studio. This ground-glass surface rendered the image visible from both the front and back. The next step was a careful positioning of the actors. Had Dawn placed them between the projector and the screen, they would have cast a shadow across the background. Thus, he set the players, lights, and camera on the opposite side of the screen where, due to the ground glass, the rear-projected scenery was also visible. Peering through the lens, Dawn saw the cowboys standing, apparently, in the middle of a sprawling plain. Unfortunately, the system was marred by four major imperfections. First, because he was enlarging a photograph by a ratio of 12:1, it lost much of its clarity and resolution. Second, the thickness of the screen tended to haze the image as it passed from one side to the other. Third, the lights used to illuminate the actors helped wash out whatever image *did* sneak through, and finally, the film itself was extremely grainy. All told, these elements blurred the background to the point where it was all but indistinguishable in the finished film. These and other problems—which we will discuss later—had to be overcome before rear-screen projection could serve as an effective substitute for location photography.

In the meantime, having established the development of these very primitive special effects, we now turn to an event that transpired in San Francisco that had an awesome impact on film, and lent new definitions to the art of the motion picture.

2
Birth of a Notion

In *The Ten Commandments* and *The Lost World*, the camera work is remarkable. [Scenes like] the opening of the Red Sea give a feeling which quickens the pulse and sets the imagination on a rampage.

—*The New York Times*
March 1, 1925

The year was 1913, and a twenty-seven-year-old Bay Area stonecutter was about to change the course of special effects history. Willis H. O'Brien, an amateur sculptor and artist, molded a pair of clay boxers around tightly joined wooden skeletons. With a borrowed camera, he filmed the pugilists one frame at a time, making slight changes in their position between exposures. When the film was processed, it showed a fight that was jerky and crude, but encouraged O'Brien to make another picture, this one about a prehistoric animal and a cave man. Cutting in half the degree to which he manipulated his models for each single-frame shot, O'Brien thus increased their fluid motion and gave the clay creations an inarguable charm. Certain that there was a market for this second film, he decided to try and sell it theatrically. Traveling to Hol-

lywood, O'Brien was unaware that he would soon be one of the most respected technical wizards in film history, and a master in the art of *stop-motion photography*.

Stop-motion photography, the animation of three-dimensional models, was not a new screen process when O'Brien first tried his hand at it. As early as 1897, Edison had sponsored a forty-second film entitled *The Humpty Dumpty Circus*, in which animals were made to march across the screen a frame at a time. These models were made of wood and had tightly pegged joints to enable them to hold any position in which they were placed. The film was well received and prompted a second stop-motion effort from Edison, *Visit to a Spiritualist*. Later, Melies, Porter, and other filmmakers dabbled in the painstaking process, but few of them had the patience to produce more than one or two experimental movies.

It's not difficult to see why.

As we noted before, silent film speeds through a projector at the rate of sixteen frames per second: to shoot these sixteen pictures required at least an hour

of fastidious labor, depending on how many figures were to appear on-screen. Thus, a minute-long picture might involve six days of intense production. Cameras had to be securely anchored to prevent their being jostled and causing an abrupt jump in the action; the models themselves had to be progressively positioned with the utmost care. If one of them fell during photography, there was no way for it to be repositioned with precision. To try would have caused a sudden and awkward break in the action.

Prior to 1913, stop-motion photography had been looked upon as a curiosity, something to amuse the children. O'Brien was to change all of that. Arriving in the office of a film producer—we are not certain who this was—O'Brien unreeled his films and crossed his fingers. That night, he went home with a check for several thousand dollars. The producer had seen potential in the dinosaur film, and asked O'Brien to reshoot it, increasing its running time and elaborating on the props and sets.

O'Brien was enthusiastic and, holding onto his daytime position, shot the stop-motion film on days-off and at night. After two months of exacting labor, he had completed *The Dinosaur and the Missing Link* (1914), the story of how stasis between cavemen and their dinosaurs was broken by a mischievous, apelike creature. The five-minute-long film was sold to Edison's New York distributorship and released later that year. It was quite successful and, quitting his job, O'Brien went East to head a one-man subsidiary for Edison, *Manikin Films.* Over the next three years, O'Brien helmed ten very clever stop-motion films of prehistory, each one produced for five hundred dollars and running five minutes apiece. Among their number were *Birth of a Flivver* (1915), in which cavemen create a dinosaur-driven transportation system; *Prehistoric Poultry* (1916), a tale of Neanderthals and a friendly, birdlike dinornis; *Rural Delivery, 10,000 B.C.* (1917), about the world's first post office; and *The Girl and the Dinosaur* (1918). Two years later, working under the independent aegis of producer Herbert M. Dawley, O'Brien released a more ambitious effort, the sixteen-minute-long *Ghost of Slumber Mountain.* O'Brien himself played the title role, the spirit of hermit Mad Dick, who gives a magic telescope to Dawley. Looking through the spectral glass, Dawley sees life on earth as it was in the days of the dinosaurs. Produced at a cost of three thousand dollars, *Ghost of Slumber Mountain*

returned a profit of thirty times that amount. This convinced O'Brien that the public had not only accepted his adult approach to stop-motion photography, but was ready to see it used as the basis for a feature-length motion picture.

As far as O'Brien was concerned, there was never any question about the choice of subject matter. A popular novel, published in 1912 by Arthur Conan Doyle, the creator of Sherlock Holmes, would provide the plot. Thus, early in 1923, with the financial backing of Watterson R. Rothacker—who had bought screen rights to the novel in 1918—and First National Pictures, O'Brien went back to California to begin work on *The Lost World. The Lost World* was but one of A. C. Doyle's many Professor Challenger books. In it, the scientist leads an expedition up the Amazon River to a volcanic plateau where time has stood still. Dinosaurs roam freely about and, after several confrontations with the monsters, Challenger succeeds in capturing a brontosaur. A volcano destroys the plateau, and the explorers hasten to London with their find. As the monster is being unloaded from the ship's hold, his cage breaks and the animal goes free. After causing considerable consternation among city officials, the creature tires of this strange adventure. Dropping into the Thames, he swims home.

Before production of *The Lost World* could get underway, there were many technical hitches to be resolved. The first thing O'Brien did upon his return

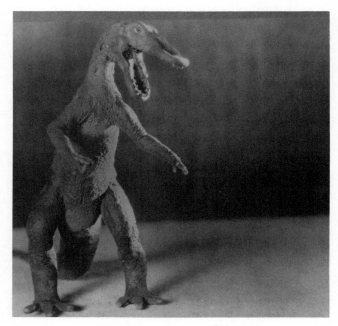

A rare pose of the trachodon from Willis O'Brien's *Lost World.*

to the West Coast was to enroll in anatomy and sculpture courses at the Otis Art Institute. This, to ensure the accurate look and movement of his creations. Next, he began searching for the means to build more durable models. In his previous pictures, O'Brien's figures had been made largely of clay, which were wont to 'melt under prolonged exposure to hot movie lights. To spearhead research in this department, O'Brien enlisted the aide of a young artist by the name of Marcel Delgado. Delgado was a student at Otis, and his skill in anaglyphics impressed the moviemaker. The commission flattered Delgado, but he wasn't certain he was qualified for the assignment. O'Brien disagreed, and the men joined forces.

Working with rubber and various lacquers, Delgado found a way to create less transient and more naturalistic skins for the monsters. To build the interior musculature, he carefully molded cotton and carved rubber atop the models' wooden skeletons. Veins were simulated by running electrician's wire just beneath the skin surface. After several weeks of experimentation, Delgado had a viable monster-making formula and began construction of the forty eighteen-inch-long stop-motion dinosaurs called for by the script. O'Brien, meanwhile, concentrated on perfecting the more complicated optical effects techniques. Among these were methods of photographically enlarging the foot-tall monsters and combining them with live actors. There was also the problem of creating the Lost World itself, its cataclysmic volcano, and planning the brontosaur attack on London. And, since there was no precedent for this sort of film, O'Brien had to invent new special effects methods or borrow and

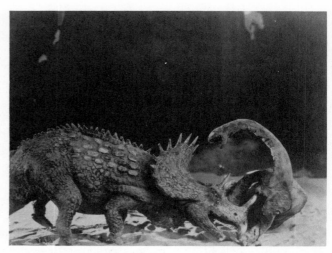

A styracosaur gores a brontosaur in a specially posed publicity shot from O'Brien's *The Lost World*.

amend those which had been used in previous films.

Beyond the stop-motion photography itself, O'Brien's most assiduous attention was given the split-screen photography. Unlike previous films in which the breaks were usually right down the middle of the screen, Marion Fairfax's scenario required people to be placed behind huge boulders and such while, beyond, monsters were fighting for survival. To accomplish this effect, O'Brien used a more sophisticated form of split-screen mask called the *matte*. While its origins are unknown, the first popular use of the matte—French for mask—was in Porter's *The Great Train Robbery*. By combining two images, Porter was able to show thieves ransacking a mail-car while, through an open door, the terrain went flying by. Norman Dawn was also an early proponent of the process. In essence, a matte is nothing more than a solid black glass painting rendered in the shape of the object to be superimposed. In the case of *The Great Train Robbery*, this meant the open door. The partially opaqued pane, usually six inches square, was then fitted into a light-proof *matte box* that attached directly to the front of the camera. The background action was photographed, the film rewound, and a *counter-matte* fitted into the matte box. This was a black glass painting that covered those areas of the lens which had been open on the film's first run. The foreground action was photographed, and the composite footage showed the two separately filmed elements together in one image. For *The Lost World*, this entailed photographing the miniature background and models a frame at a time through a

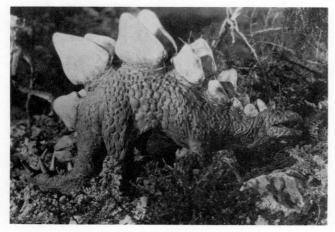

A stegosaur from the silent *Lost World*.

boulder-shaped matte. Rewinding the film, the normal-sized monolith was photographed with the people behind it, shot through a counter-matte.

Mastering this method of superimposition, O'Brien turned his attention to the miniature sets. They had to be flawlessly detailed. It was on these table-top dioramas that the dinosaur models were to be posed, and he constructed them on a scale so as to make the monsters appear huge. They were built at a ratio to life-size of 1:40. Accordingly, huge stones passed for boulders, and broken branches, covered with starched or prop foliage, became trees. Sandy stretches were carefully glued in place to prevent the individual grains from moving during animation and jiggling on-screen. Another problem was that of balancing the dinosaurs. We mentioned before that if a model fell during filming, the entire sequence would have to be reshot. To prevent just such an occurrence, O'Brien drove screws through his sets from the bottom up, thus bolting the monsters in place. For scenes in which a dinosaur was required to walk, the animator predrilled holes in the set and plugged them with pieces of terrain, making certain to keep one of the model's feet firmly secured at all times.

With these basic techniques established, O'Brien turned his attention to the more specialized, "once-only" effects. On the Lost World itself, for instance, an incredible dinosaur stampede and the volcano posed their own unique problems. The former offered the enormous challenge of simultaneously animating some fifteen monsters as they hurried from the eruption. To maintain continuity from frame to frame, it was necessary to keep track of the direction in which every limb was moving as well as its speed, since faster motion required larger incremental movements. The volcano, harbinger of this mad rush for safety, was a more mechanical effect but no less authentic. Set on stilts, the mountain miniature was hollow and made of plaster. Lights were positioned beneath the baseless model and made to shine from the crater while smoke was fed through a hose. Small blowers beside the lights sent this smoke billowing skyward, and the cloud was effectively illuminated by these "fires" burning within the mountain. Meanwhile, there were also the subtleties for which O'Brien is famous. Using gelatin instead of real water, he was able to mold it between frames to simulate the movement of an apatosaur in a swamp. Finally, a sequence involving care of a different sort in planning and execution was

the brontosaur's rampage of London. Beyond the complex matte shots that were required, a pair of full-scale mock-ups of the monster were constructed for two important close-ups. Pedestrians crushed by a swipe of the monster's massive tail were, in fact, stuntmen squirming beneath a light-weight prop made of wood and canvas. When the animal thrust its head through a club window to snap at members, a life-size head was employed. Extras had to be well-versed in acting with a prop dinosaur!

And so, early in 1924, with every element of production carefully outlined, and the special effects predesigned, *The Lost World* went into production. The only real problem faced by O'Brien and producer Rothacker was getting out from under a $100,000 lawsuit issued by Herbert Dawley. O'Brien's *Ghost of Slumber Mountain* partner claimed that the animator had stolen special effects processes patented by Dawley. This was true: Dawley *had,* indeed, taken out the patents. But O'Brien had created the techniques, and the court decided in his favor. There were no further disruptions, and the movie rolled to completion. Released in 1925, it was a runaway success. Even the finicky *New York Times* loved it, saying,

> *The Lost World* is an effort likely to provoke a great deal of discussion, as the movements of the dummies appear to be wonderfully natural. Some of the scenes are as awesome as anything that has ever been shown. There are several battles between different species of monsters which are most effectively staged. In the initial scenes, these monsters were shown without any double exposure effects, and therefore their supposed huge dimensions could not be contrasted with human beings. Later, in the double exposures, the effect is remarkable. Through wonderful photographic skill and infinite patience in the camera work, Sir Arthur Conan Doyle's *The Lost World* makes a memorable motion picture.

The film's wide acceptance should come as no surprise: it was the first American film that transported viewers into a masterfully fabricated world of fantasy. Indeed, audience response to *The Lost World* was surprisingly more enthusiastic than it had been a year before to box-office giant Douglas Fairbanks and his fanciful but shoddy *Thief of Bagdad.* This latter production only hinted at the wonders that O'Brien was able to deliver. The key words, of course, are *O'Brien* and *deliver.* In the end, the overwhelming popularity of *The Lost World* was a tribute to the talent and dedication of

this incredible special effects man. In fact, to see the difference made by the man, rather than the tools at his disposal, let's return to 1913, where we first met O'Brien, and pick up the events that led to the development of the Hollywood special effects department. You will notice a remarkable prejudice in our perspective toward the historic, aesthetic, and technical worth of this growth, and the reason is simple. Willis O'Brien was our first special effects *artist*. Most of his contemporaries were exemplary *technicians*. In this respect, the stop-motion model animator is unlike any other film craftsman. Like any special effects man, he is proficient in the techniques of cinematography, lighting, and optical trickery, and understands the science behind his lenses, film stock, and other raw materials. Here, however, the engineer becomes an artist on a level undreamed of before the advent of film. Shut in a studio for the entire working day, and over a period of many months to a year, the animator's constant companion is a figure to which he is slowly imparting movement. Every motion in every frame is his to control, to imbue with his own sense of gesticulation. Just as a composer builds a symphony from thousands of notes, or a painter constructs a canvas with a myriad brush strokes, so does the model animator build life with his jointed figurines and a camera. For this reason, it will be difficult to compare his work to that of any other special effects man, no matter how polished his skills.

There is, however, an obverse consideration.

We have just looked at a film in which the plot and performers took a back-seat to the special effects. Ideally, a director hopes for a more equitable showing, something we will not find in any of O'Brien's films. We *will* find it in the silent comedies, which offer the viewer a fine balance between characterization, plot, and exciting visual effects. Featured in the works of such comedic entrepreneurs as Mack Sennett and Hal Roach were such gimmicks as performers sliding through breakaway walls, cars that fell apart piece by piece or were demolished in bizarre accidents, or people who rode on floods of water issuing from a once-small leak in the bathroom. Of course, in the first few years of filmmaking on the West Coast, the *making* of a comedy motion picture was, itself, a raucous free-for-all. For example, the Mack Sennett fun-fests that began production in 1912 at the rate of twelve short films a month were built around local events: a parade, a balloon flight, a car race, and so

forth. In an era of limited budgets, these exhibitions offered an easy route to spectacular footage. They also posed the problem of a framing story, which Sennett, his cast, and crew would dream up while rushing to a location. Thus married to a story and situation, the filmmakers often had to devise ingenious special effects to make the *rest* of the film! In these primordial days, only the cinematographer had a steady responsibility in this area, which was to create the few optical effects that were used as an occasional novelty, such as split screen or double exposure. Everyone else involved in picture-making, from the director to the man in charge of props, contributed his ideas to the design of mechanical effects. Fortunately, since many of these craftsmen had come to film from the theater, lured West by the availability of work, they were familiar with simple stage tricks. As a result, early comic routines were done with theatrical gimmicks. That man being kicked skyward by an angry goat was actually drawn aloft by strands of invisible piano wire suspended from a scaffold or crane; the car balancing so precariously on a cliff usually *was*, held there by yards of piano wire and cable. Then there was the actor who crossed the girders of an in-construction skyscraper, something he did without rear-screen projection. There simply wasn't the time or budget—or, in many cases, the technology—to work complex special effects.

Two developments helped change this situation. One was the advent of the star system, and the other was the flowering of feature-length comedies. The two arrived hand-in-hand: name comedians wanted the screen time in which to develop more substantial productions. And while many of the stars continued to do risky stunts, producers found it advantageous to protect their meal tickets. This was true for dramatic actors as well as the comics. Also an influencing factor was that, by the early twenties, there was simply a *need* for ever more intricate effects in growingly elaborate productions. These were films in which, unlike *The Lost World*, the special effects were not overbearing, but were vital to the story. And with responsibilities in every department skyrocketing, there was no longer time for a cameraman or electrician to divorce himself from his primary job to design and execute special effects. The result was that many of the studios began hiring men with an engineering background to handle odd-jobs in a technical capacity. This was done on both a staff and free-lance level, with an

occasional art specialist called in for such diverse needs as glass paintings, unusual sets, or painted period backdrops. However, it took Cecil B. DeMille to convince filmmakers that this move toward specialization was more than just a need: it was an asset to the marketability of a motion picture. To better understand his grasp of the situation, let's contrast DeMille's attitude toward special effects with that of industry pioneer D. W. Griffith, looking first at Griffith, a man who refused to "fool" his audience with tricks.[1]

As we mentioned earlier, the paradox of movie special effects is that to be effective, they must completely fool the audience. This postulate can be carried one step further. Oftentimes, in the pursuit of authenticity, a director will shun special effects for the real thing. An example of this is Griffith's *Birth of a Nation* (1915) in which he literally enacted a battle, hiring an unheard of five hundred extras to portray soldiers. Cameras were concealed in bushes to catch close-ups of the action, and these scenes were later edited into panoramic sweeps taken from atop a forty-foot tower. Into the midst of this frenzy, Griffith flung live artillery shells, which made for technical realism and convincing human reactions. Since no one was hurt, one can hardly fault Griffith for his pursuit of authenticity;[2] it would have been futile, of course, to argue that blank projectiles fired at charges set in the ground would have been just as effective. Later, however, we find a seeming hypocrisy as Griffith went *out of his way* to call attention to an optical trick, in this case a dissolve. Ordinarily, the dissolve is a transitionary device, the soft fading from one scene to another. It is accomplished by nursing one scene into blackness with a variable shutter, rewinding the camera several feet, and beginning a new scene before the last one has ended, slowly shading it from darkness to normalcy. Griffith, however, used the process to fill a set of South Carolina's deserted House of Representatives with rowdy legislators. Yet there's no contradiction here: keeping with Griffith's credo, it is a brilliant example of special effects used to communicate contrast rather than to fool. But special effects *did* wreak vengeance on Griffith, and no one in the audience was the wiser! Since the picture was wrought in an impressive scope, economy was bound to win a compromise from the spendthrift producer sooner or later. For an important set, a street in Piedmont, South Carolina, Griffith reluctantly employed *forced perspective* to save money on brick and lumber. This meant that each successive house, fence, lamp, and plot of land had to be built progressively smaller so that they seemed to be receding into the distance. Young boys dressed as men portrayed soldiers; ponies doubled for horses. Thus, what looked like several acres to the camera's two-dimensional eye was, in fact, only some sixty yards of studio lot. Another theatrical convention, forced perspective would prove to be a popular device in many films to come. For Griffith, however, it was a nagging expedience, but proof that special effects *could* be inconspicuous if properly executed. It was obviously not a lesson well learned.

Birth of a Nation, a three-hour lesson in dramatic film editing and pictorial composition, was followed into release by Griffith's *Intolerance* (1916), the director's brilliant spectacle of man's unforbearing evil throughout the ages. *Intolerance* tells four stories simultaneously, skillfully jumping among the Crucifixion, the fall of Babylon, the St. Bartholomew's Day Massacre in Renaissance France, and a murder mystery in twentieth-century America to underline their similarities. Given Griffith's attitude toward special effects, one is not surprised to find them conspicuously absent for most of the film. Unfortunately, when they *do* appear, they are so haphazardly—almost disdainfully—dispatched that the scenes surrounding them suffer. The most glaring "fake" is a miniature set seen for one brief long-shot as the Persians' siege tower assaults the Gates of Belshazzar in the Babylonian segment. Once again, it was the budget that tempered Griffith's quest for absolute realism. Despite the fact that he had spent almost two million dollars on a life-size recreation of the walls of the ancient empire, this was a night shot and would have been terribly costly to light on the large set. Thus, Griffith reluctantly substituted models, which are betrayed by the flickering of miniature flames. Then, during the battle that follows, Griffith gives us the screen's first decapitation, and a sloppy one at that: wearing a false torso, which extends past his shoulders, one of Babylon's defenders is attacked by an enemy swordsman, losing his mannequin's head in the exchange. More satisfactory were the bodies that fell from the full-size sets during this massive conflagration. The "corpses" were fully costumed dummies built with specially hinged joints and wires that allowed them to bend only in a fashion that was anatomically correct. As a result, they fell to their deaths like men, rather than like broken rag dolls.

Cecil B. DeMille shows visitors from the armed forces a miniature prop from one of his early films.

However, it is clear that most of Griffith's special effects were unwelcome compromises. He felt that only comedians and spinners of film fantasies should indulge in camera tricks, as a means of parody and caricature. One must also suspect that he resented, as had others before him, the artistic control he surrendered to free-lance or studio mechanics who were called in to build and light a model, or construct a street in distorted perspective and told him where the camera *had* to be placed in order to maintain the illusion. His sentiments were echoed by the *New York Times*, which noted several years later that, "Trick work in motion pictures is only a means to an end. It is very seldom used unless absolutely necessary. Motion picture producers are constantly striving for realism, and the less trick camera work there is in a picture, the more real it appears to the audience." While these opinions are not without merit, the answer to the question of special effects was not necessarily to *eliminate* them, but to do them well. And it was Cecil B. DeMille who, a decade after Griffith, and in the wake of such trailblazers as Norman Dawn, took the first bold steps in this direction.

Throughout his long and prosperous film career, DeMille would never be one to shun ostentation. He had a successful formula, which was to tell a tale with grandeur and melodrama, and if special effects could accent his product, why not use them? As it developed, this was an astute judgment. DeMille's first special effects marathon, his original version of *The Ten Commandments* (1923), ran sixty-three weeks on Broadway, and was universally praised for its awesome technical wizardry. As one reporter summed it up, the parting of the Red Sea "drew applause from the packed theater" at every performance he attended. *The Ten Commandments* was not DeMille's first spectacle. It had been preceded

by both *Joan the Woman* (1917) and *Manslaughter* (1922), this latter a tale of sadism in the Roman Empire. But *The Ten Commandments* was his biggest film to date, costing well over one million dollars and offering the public one of its earliest glimpses of Technicolor.

To part the Red Sea, DeMille's technicians Roy Pomeroy and Fred Moran borrowed a leaf from Willis O'Brien's journal. Using a small tank filled with thick jelly, they caused it to "open" a frame at a time. Next, to simulate the divided walls of sea, they simply used split screen photography to place the extras between a pair of studio manufactured waterfalls. The overall effect was striking, one of the most ingenious technical displays of the silent era.

The Ten Commandments did much to silence the detractors of special effects and helped liberate the field from the shackles of parody and fantasy.

Griffith's career had peaked and fallen within eight years; after almost a decade, DeMille's popularity was still increasing. Thus, there was a willingness in Hollywood to follow his example and tackle properties in which special effects other than glass shots, dissolves, or piano wire played an integral part. To do this required trained professionals, and studios began to build separate special effects units. These were not yet special effects *departments*, but they were men versed in film, no longer the moonlighting architects of the teens. And, as the twenties edged on, more and more of these specialists began to appear on studio payrolls as full-time employees, rather than as free-lancers. Joining their talents with the growingly sophisticated storytellers and production artists, they quickly made special effects both a potent box-office force and an indispensable tool for the filmmaker.

3

The Silents Are Golden

The illusions which one could have on-stage are nothing compared to what can be done by a clever motion picture cameraman.

—Anonymous Film Critic, 1924

One of the films caught between the transformation from the jack-of-all-trades technician to the new studio special effects man was the aforementioned Douglas Fairbanks film *Thief of Bagdad* (1924). Fairbanks, however, had mixed emotions about the changeover. He was afraid that increasing specialization would lead to an increase in temperament. After the premiere of *Thief of Bagdad*, the athletic superstar noted,

We had a whole troupe of glass blowers working for several weeks, building the city under the bed of the sea, a city of crystal. We had a room for them, and they seemed happy . . . until pay day, when a delegation of them came to see me. "We are artists, not carpenters," they said. I agreed that they were not carpenters, and asked what had peeved them. I looked at their checks. They were made out from the construction department. I apologized and saw that the art department issued them new checks.

Thief of Bagdad was the first feature film to rely so extensively on camera magic, and thus exposed itself to a whole new area of criticism. Prior to its release, special effects were not an important enough element for critics or moviegoers to scrutinize with great severity. Even a picture like *The Ten Commandments* offered only a handful of dramatic special effects that either succeeded or failed to convince an audience, but merited little consideration as other than window-dressing. But the very structure of the Fairbanks spectacle was rooted in special effects. And though a bold experiment, it was largely unsuccessful. There were a swami's rope tricks, a flying horse, the requisite magic carpet, a monster spider, and a dragon, not to mention the undersea city and, for long shots, a miniature replica of Arabia's legendary Bagdad. Although Fairbanks was as exuberant as ever, and the full-size sets were impressive, the million-dollar production did not live up to its press hype. As one contemporary reporter observed, "Every time Fairbanks was seen on his [flying] horse, the audience fell into a state of hilarity. It was merely a white horse decorated with wings."

Not to detract from the film's initiative, it was a hurried production period and not the lack of available resources or skills that dulled its punch. For example, the winged horse was poorly and transparently double exposed over a prefilmed background, while the huge spider and dragon were life-size mechanical models—not unlike the Frost Giant in Melies's *Conquest of the Pole*—operated by men within and above the monsters. Unfortunately, time permitted the rigging of only simple pulley and cable systems, which restricted the beasts to halting, limited mobility. Monster-maker Hampton Del Ruth should have studied the dragon in Fritz Lang's *Der Nibelungen* (1923) before constructing his Arabian Nights monster. A full seventy feet long, made of painted wood and cardboard, and weighing almost two tons, Lang's dragon was built on a chassis with wheels, both of which were below the set. Ten men sitting inside the beast moved its arms and legs; twenty-two hands working in the pit beneath the creature guided it along its circuitous mountain course. Such extravagance was not without cost: the four-hour film was over a year in the making.[1] Nonetheless, time should have been spent on *Thief of Bagdad* for experimentation. In this respect, Watterson Rothacker had the right idea when he gave Willis O'Brien over a year in which to perfect his stop-motion and matte techniques. He knew that quality camera trickery would pay off handsomely at the box office. Producer Fairbanks, for his part, should have realized the need for a *complete* monster, rather than simple giantism, to fool increasingly sophisticated audiences. To the picture's credit, however, there *were* some impressive technical displays. The rope tricks, with piano wire attached to a writhing cord, were effective, as was the similarly executed magic carpet stunts. Best of all, however, were the underwater sequences, filmed in the studio on dry land. Seaweed was made to sway and float by overhead wires, the camera lens was fitted with a glazed filter to duplicate the look of underwater photography, and the scenes were shot in slow motion to make the illusion complete. Had this inventive attention been paid to the rest of the film, it would have been a special effects classic. Yet Fairbanks's name on the marquee made *Thief of Bagdad* a moderately profitable venture, despite its cost. The film's failure to rack up the impressive totals of earlier Fairbanks swashbucklers like *Mark of Zorro* (1920) and *Robin Hood* (1924) was attributed to the implausible storyline, and not to the

disappointing special effects. In fact, producers were not unimpressed by the considerable publicity these effects had generated, and inspired by the success of *The Ten Commandments* and the upcoming *Lost World*, began planning new productions that prominently featured special effects.

By this time, the newly instated movie technicians had improved upon the old special effects standards, particularly in the case of the matte shot. One of their early innovations was *bi-pack contact matte printing*, which sounds ferocious but isn't, really. It produced the same result as a matte box, i.e., placing a foreign element in a prefilmed scene, but did so using a *process camera*. This special camera was capable of running two strips of film past the lens simultaneously. Closest to the aperture was the prefilmed action. Behind it was an unexposed role of film. A white board, on which a black matte had been painted, was placed in front of the camera. To reiterate, it was in this black area the new action would be added. Shooting through the process camera, the white board bounced light through the lens, save where the matte had been painted. Thus, on the second roll of film, the raw negative, everything from the first roll was reproduced except for the blackened area. This portion of the *second generation print* could then be reexposed in the process camera, along with the film containing the action slated for integration. This time, the white board held a counter-matte that covered the area that had been exposed on the negative's first run-through.

The bi-pack matte and process camera were valuable in that they gave the technician greater control over his material. However, they led to an even more important development, the invention of the *traveling matte*. An incredibly meticulous craft, this technique involved the enlarging of every frame of the action to be superimposed. Mattes were then hand-traced and opaqued from these blow-ups and shot on the process camera a frame at a time. The white boards with successive black mattes were positioned between exposures. This method allowed for a matted element to travel across the prefilmed background, or change positions with every new frame. Examples of special effects that were now possible include combining a miniature model falling atop a throng of scattering extras, or a small, studio-made flood engulfing life-size buildings.

Technicians even created a method to replace that

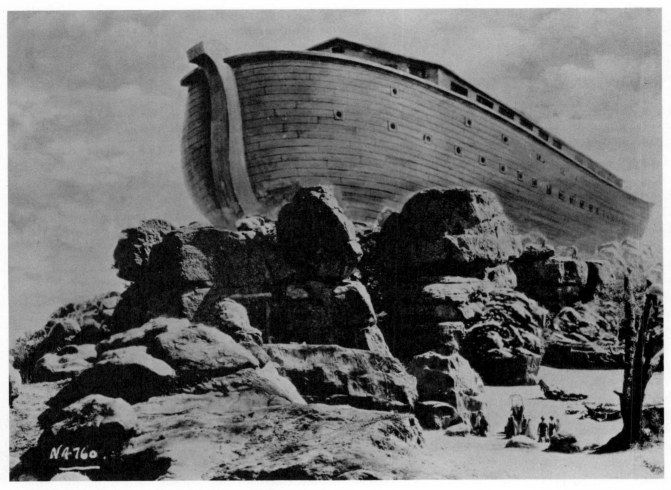

A glass shot from *Noah's Ark*. The huge boulders and sky are real, although many of the background rocks are part of the painting. This scene was photographed through a frame of the sort used by Norman Dawn.

old stand-by, the glass shot. The late Fred Waller, one-time head of Paramount's special effects department, and the man who invented Cinerama, explained in 1923,

An interesting use of an architectural model instead of a glass painting occurs in *Puritan Passions*. When it came to shooting the scene before the Puritan Church in Old Salem, only the first story was built in normal proportions. A model of the second story was suspended at the properly determined distance and height before the camera. It was a small model equipped with its own cyclorama background, and was constructed on a scale of inches as compared with feet in the real set. So accurately was it made that the eye of the camera registered a complete structure. Photographically, it possesses important advantages over painted glass. For one thing, it gives depth on which the camera can focus. Again, when changing light is required, both the

miniature and the set can be treated with identical light, while in the case of glass, the corresponding light values must be painted on as many different plates and substitutions made.

Another important development noted by Waller that year was the invention of a camera "capable of photographing at thirty times the usual speed. This camera, in taking the blowing up of a miniature castle, can depict all the motion that would be attendant upon a ninety-foot structure."

Following in the footsteps of DeMille, Hollywood decided to make a pair of ambitious biblical spectacles, *Ben-Hur* (1926) and *Noah's Ark* (1927). Employing all their new and versatile tools, film craftsmen had a field day. For example, a highlight of *Ben-Hur* was the collapse of the Senate Building on a crowd of people. The capital's demise was done in miniature and combined with the actors and life-size portion of the set with a traveling matte. The top of the Circus Maximus, site of the great

chariot race, was supplied courtesy of the model process described by Fred Waller for *Puritan Passions*. One noteworthy amendment to the technique was the inclusion of ten thousand small, miniature people cheering in the stands. As Waller would later note about one of his own movies, "It was realized that the public was becoming accustomed to shots of miniature vessels, trains, and structures because there was no sign of life on them. [The answer was] articulate figures, tiny images of human beings that move their arms and legs." By and large, these dummies were built with jointed limbs and were controlled by intricate, hand-operated mechanisms behind or to the side of the miniature sets; in other cases, the puppets were simply manipulated by piano wire from above.

Apart from the exciting chariot race, the sea battle between Macedonian and Roman warships ranks as the most thrilling scene in the picture. Staged a half-mile off the coast of Italy, full-scale replicas of the ships were built for the sequence—as opposed to the poor miniatures used in the 1959 remake—the high point of which was the ramming of a Roman flagship by one of the pirate vessels. It was an encounter executed with considerable jeopardy to the special effects man and performers involved. The enemy ship was attached to a strong cable and literally pulled into its target by motor boats. When the two ships collided, the four hundred warriors, played by Italian extras, had at one another. Meanwhile, special effects director A. Arnold Gillespie, dressed as a Macedonian, ran about the ship setting fire to clandestine barrels of sulpher and combustible chemicals. This, to create a thick, picturesque blaze. Although the wind had been carefully charted, and the boat positioned so that the fire would spread no farther than the bow, gusts of air rushed through the six dozen oar holes in the galley and whipped the flames quickly out of control. The hull of the vessel had been weakened to facilitate the ship's eventual sinking, but the intensity of the blaze caused it to go down ahead of schedule. Extras began leaping into the sea and were rescued by boats that had been positioned just out of frame. There is still some question as to whether or not all the players were recovered. Gillespie himself, still wearing his full battle regalia, jumped overboard just before the ship went under, and swam the nine hundred yards to shore.

Not to be outdone, the makers of *Noah's Ark* took even greater chances with their personnel. Director Michael Curtiz, who went on to helm Errol Flynn's classic *Charge of the Light Brigade* (1936) and *Robin Hood* (1938), insisted on spectacular flood footage at any cost. He felt that the same people who had gone to see DeMille part the waters and made *The Ten Commandments* a box-office giant would run to see the submersion of the world. Photographer Hal Mohr was in complete agreement with this theory, and went to work plotting the scene with special effects men Hans Koenkamp, a veteran of the gimmick-filled comedies, and Fred Jackman. When Mohr revealed to Curtiz and screenwriter Darryl F. Zanuck their collective idea to matte extras into a miniature deluge, the producers adamantly rejected the plan. They wanted to out-DeMille DeMille, which meant keeping the optical tricks to a minimum. Curtiz and Zanuck had worked out their own plan: to drop six hundred thousand gallons of water on extras. Mohr quit the film under protest, complaining that this method was dangerous. He pointed out to Curtiz that only some fifty-odd people among the thousands needed for the scene had any stunt experience; the rest would be men and women who were hungry for work. The producers refused to yield and, for the scene in which sinners are drowned while worshipping idols, the full complement of water was unleashed from upraised studio tanks. The temple set was heavily battered, and many people were severely injured. Although the filmmakers claimed there was no one killed, conflicting reports said that three people had drowned. Meanwhile, the matte camera wasn't idle: Koencamp used it to shoot the animal sequences, running from zoo to zoo to make composites of the required fauna. Glass paintings were also employed, notably in the Tower of Babel scenes and for long shots of the ark.

To flood the city itself, Curtiz mercifully allowed the utilization of miniatures. Jackman supervised the building of a set covering one thousand square yards, which showed the temple and its environs. This was latticed above and below with pipes used to channel and unleash the holocaust, while the dozens of model buildings were prebroken to fall before the flood. They were held together in the interim by bits of clay; small charges of gunpowder were strategically positioned to help them collapse on cue. The same tanks were used to unleash six hundred thousand gallons of water on the miniature set, with one hundred and fifty technicians on hand to man wind machines, control the water flow, create

lightning effects, and cause it to rain; fifteen cameras, with eleven shooting at high speeds for slow motion were in use. Later, three hundred actors running from full-size sets that crumbled before the deluge were matted into this footage. As a result, Curtiz got the spectacle he was after although, unlike *Ben-Hur* and *The Ten Commandments*, the movie failed to generate the anticipated flood of box-office dollars. It is perhaps unfortunate that the film was released just before the Depression, when movie audiences were in no mood to witness glimpses of Armageddon.

Filmmakers had even less luck with the classics. A film version of *Moby Dick* was released in 1926 with John Barrymore as Ahab. Called *The Sea Beast*, it drew undistinguished notices. Particularly hard hit were the special effects. As one critic complained, " . . . glimpses of a miniature to show the vessel plunging through angry waters are shown too frequently, and the exploits of the whale are not as effective as they might be. Virtually all one perceives of the monster is its tail splashing in the water." These shots showing the whale of a tail were done with a life-size canvas and plaster model, operated from within and below the tank by technicians. But moviegoers were not content with seeing only a portion of the title character, and stayed away. Clearly, many filmmakers did not yet understand that special effects had to *show*, not just *suggest*. This wasn't an isolated incident; there were batteries of mundane products from producers who were simply cashing in on the innate allure of special effects. However, there were two films released in 1927 that were notable for their special effects. One of them, a war film called *Wings*, won the first Oscars for Best Picture of the Year and Best Mechanical (Special) Effects. The other movie, *The Show*, was directed by Tod Browning, the man who would film Bela Lugosi's *Dracula* three years later.

The challenge to the men behind *Wings* was to accurately stage World War I dogfights, midair collisions, and spiraling crashes without losing any real planes. To the picture's credit, actual aircraft were used for all the disasters, at which point marvelously detailed miniatures were employed. These were most likely made of balboa wood, a substance introduced to miniature makers by Fred Waller and that splinters realistically upon impact. Indeed, film historians are largely agreed that the Best Picture Oscar was more a testimonial to these battle scenes than to the movie's superficial drama.

Browning's *The Show* starred John Gilbert as a carny boss, and our host to a gathering of such special effects created freaks as the Mermaid, the Living Head, the Half-Woman, the Spider-Lady, and others. Remarkably, every one of these exhibits were normal human beings "deformed" with mirrors. Perhaps the most straightforward of these was the Mermaid. The actress was positioned in a glass enclosure that was filled with rocks, sand, and seaweed, and painted to resemble the bottom of the sea. Placed between the girl and her audience was a thin tank filled with fish and water. Thus, from the viewer's vantage point, she was apparently underwater. To give the illusion added reality the mermaid made her every motion slow and deliberate, while Gilbert moved at normal speed. The film's other effects were more unusual and exciting. The Living Head display was a re-creation of the John the Baptist-Salome confrontation, with one major alteration: John's head was alive and well on its silver platter. The plate, itself, was set on a table with four thin legs. The prophet performer had simply poked his head through a hole in the tray, and was squatting on the floor behind a mirror. This mirror was placed diagonally between the right front leg and left rear leg of the table, and reflected a wall of black velvet that was on the side of the stage. This wall exactly resembled the velvet backdrop behind the table and, seen from the front, there appeared to be nothing under the table. This same trick was used for the Half-Woman, a living human torso perched on a table, but the Spider-Lady required somewhat more elaborate preparation. The on-screen image showed a huge web strung diagonally from the foot of the stage to the top of the far wall. In the middle of the web was a girl's head atop a spider's body. Since we can see through the web to the floor and wall behind it, there was apparently nowhere an actress could secret herself. In fact, she was leaning against a mirror that was poised at a forty-five degree angle from the bottom of the rear wall to the center of the web. The mirror reflected the floor, which was a duplicate of the far wall; the spider was simply a model.

While Hollywood was learning its various lessons about special effects and their proper use, Fritz Lang was treating the field like an old friend. The German director, who had already embarrassed foreign filmmakers with his stunning *Der Nibelungen*, made them positively green with envy with his next effort, the magnificent *Metropolis*

Technicians ready the robotrix Maria for a scene in Fritz Lang's *Metropolis*.

(1925). *Metropolis* is the story of a city in the world of 2026. It is a time of upheaval: a girl named Maria is preaching a gospel of hope to the downtrodden subterranean worker-caste of Metropolis. Wishing to crush her and further subjugate the masses, the governor of Metropolis orders Rotwang, a mad scientist, to create a robot-duplicate of Maria. When this is done, the android stirs the people to revolution and defeat: as they gather to storm the awesome spires of the upper world, their catacombs are flooded. Only the intervention of Freder, the governor's son, prevents the tyrant from destroying the trapped rebels, after which the boy negotiates a just peace between the warring factions.

A fable of incomplex extremes, *Metropolis* was a tour de force for the special effects men of Germany's UFA studios. Technicians built the largest structures of the surface city over six feet tall, with countless miniature cars and planes pulled along their courses by piano wire. The workers' shadowed subterranean dwellings were also miniatures, constructed at half the size of the skyscraper models. These latter buildings were destroyed in the flood, while scenes of people fleeing the deluge were filmed on a life-size set in much the same fashion as *Noah's Ark* almost two years later. However, the most astounding effect of all was the birth of the robot. When we first see her in Rotwang's murky laboratory, the new Maria has not yet been covered with skin. She sits, a golem of gleaming silver, in the life-giving embrace of electric bands that Rotwang sends pulsing around her body. This was accomplished by surrounding the costumed actress with three different sized,

gas-filled circular tubes, each one charged by thin electric wires dropped from catwalks above. These wires, looped around pulleys, also enabled technicians to raise and lower the glowing hoops at a slow, staggered pace. As for the robot, shortly before his death, Mr. Lang told me, "She was made of light-weight metal. It covered only her front; you never see her back." Beyond these primary effects, the rest of the camera magic was fluent but utilitarian. Television was created through rear-screen projection on a miniature screen, while great bolts of electricity were made to jump between huge generators by placing the full-size set and actors in the distance, and small, highly charged coils close to the lens, just out of frame. Since a camera can see in only two dimensions, it was fooled into believing that, when properly aligned with the background, the 110-volt sparks of the small coils were actually a massive issue of the two large motors.

Lang followed *Metropolis* with *Frau im Mond* (1929)—*The Girl in the Moon* or, as it was released in the United States, *By Rocket to the Moon*—the story of five men and one woman who journey to the moon, where they find plentiful supplies of gold. Greed follows hard-upon, and guns are eventually brought to bear. A stray bullet finds extra stores of oxygen, and the woman strays behind with her lover that the others may return to earth. Unlike *Metropolis*, the only miniatures used in *Frau im Monde* were those of the conical rocket ship and its launch site. The interior of the ten-story craft, as well as the lunar settings, were all studio sets. Star-spotted cycloramas were painted to back the space scenes.

The films at which we have looked thus far represent a different attitude toward the creation of special effects for the science fiction film as opposed to the straight adventure picture. In an action movie, a technician must whistle up, on cue, *known* events or situations. The task of the special effects man in a movie like *Metropolis* or *The Lost World* is to capture the unreal on film. Yet, the technical rift is not as wide as the conceptual break. The effects in each genre are executed with the same basic processes, and the technicians have but one goal: to make whatever they are doing seem real. And as we move into the thirties, the challenge this represents, no matter *what* the mode, will become staggering. The result? The arrival of well-stocked special effects departments and a deluge of inventive new minds and methods.

4
The Thirties

What we've done is magnificent!

—Raymond Massey in
Things to Come

By the time the thirties had arrived, Hollywood was no longer making silent movies, and before the decade was out, color would be an important part of the picture-making spectrum. The rising cost of sets and the control offered by studio shooting as opposed to location work placed ever-growing demands on such craftsmen as the glass painters, model-makers, and rear-screen technicians. Improvements in film stock called for more precise matte work, and film plots themselves had evolved into both a special effects man's dream and nightmare. Among the assignments he would land in the thirties were the animation of *King Kong*, the Oscar-winning destruction of India in *The Rains Came*, the creation of an ethereal reality for *The Wizrd of Oz*, the filming of H. G. Wells's vision of man-gone-mad, *Things to Come*, and so forth. But there were also less sprawling jobs for the special effects man, and it is to these we will first turn our attention.

One of the advocates of the miniature set was Cecil B. DeMille. Although this sounds like a dichotomy, there was method to the epic-master's madness. While the use of a model tended to limit the spectacular angles and shots that were accessible, it allowed DeMille to lavish the bulk of his budget on those elements which could not be faked: costumes, interior sets, props, and so forth. For example, at the climax of his second sound film, *Madam Satan* (1930), he sent a huge dirigible crashing into Central Park after it had been struck by lightening. Filmed at the height of the Depression, his special effects men saved DeMille enough money with their camera tricks to allow the proper staging of an extravagant ball that is underway when the disaster strikes. Thus, by using a well-built model for the actual crash, he had the money to create scenes of destruction and spectacular tumult on the life-size sets. DeMille even had enough money left over for a variation of the painted canvas background. Rear-screen projection had not yet been refined to the point where it could give DeMille the crisp vistas of nighttime New York,

A miniature building falls before this dump-tank flood in *The Rains of Ranchipur,* 1955 remake of *The Rains Came* (1939).

which he wanted to be seen through the airship's windows. However, neither could a drawn backdrop convey the scintillating life of Manhattan's evening skyline. Thus, he had hundreds of electric bulbs wired to the "windows" of his painted scenery, thus producing the desired effect. In fact, the special effects in *Madam Satan* were far more plausible than the plot: just before the dirigible crashes, the hero leaps into a Central Park lake—and survives. In any case, the film is more impressive than the stark and realistic *Dirigible* (1930) starring Fay Wray and Jack Holt. The irony, of course, is that *this* picture was actually filmed in an airship! The story about . . . "a man who slapped Death in the face and laughed!", *Dirigible* was shot entirely on the huge zeppelin *Los Angeles* at the Naval Base in Lakehurst, New Jersey. It was here, seven years later, that the German airship *Hindenburg* burst into flames as it approached the mooring tower.

Perhaps DeMille's most intricate model of this period, and one for which the term *miniature* is not really applicable, was the extraordinary barge in *Cleopatra* (1934). This beautifully realized model was eighteen feet long and boasted five hundred electrically operated oars. The two-ton craft was, itself, driven by powerful motors. Likewise, the Battle of Actium was fought with miniature ships, two vessels multiplied by mirrors and split screen to form the vast fleets of Marc Antony and Octavian. Another interesting economy in *Cleopatra* was the film's marble decor. Tanks filled with water and paint were stirred. Sheets of paper placed atop the mixture picked up the swirling design; these were

then pasted on wood and passed admirably for marble. Skipping to 1187 for DeMille's next epic, *The Crusades* (1935), we find a relatively small model used to represent the city of Jerusalem. In actuality it was only a few yards in breadth, with legions of articulated miniature soldiers on conveyor belts recruited in place of extras. This set was convincingly used on numerous occasions by placing actors in the foreground, marching toward the holy city and disappearing behind a ridge. The players would then reappear as puppets. DeMille successfully placed "miles" of terrain between the actors and their doubles by propitiously forcing the perspective of the full-size foreground set. Of course, not everyone had DeMille's eye for photographing miniatures or dressing faults in the special effects with dramatic music and careful intercutting of the trick shots with actual sets and performers. Thus, in a picture like *Cruise of the Bounty*—the shooting title for *Mutiny on the Bounty* (1935)—the producers reconstructed the infamous *Bounty* and its pursuit ship, the *Pandora,* for long shots. Both vessels were built atop old barges, one of which met with disaster during photography. On July 26, 1935, the company was setting up a shot on the eighty-foot *Pandora* when a strong wave caught the craft and weakened the hull. As the crew began transferring to another vessel, cameraman Glenn Strong decided to rescue his equipment. He was heading aft when the superstructure of the boat collapsed, tossing the remaining film hands overboard. Strong drowned, and over $50,000 worth of cameras and lights were lost. Stars Clark Gable and Charles Laughton had

not been a part of this scene. The accident fostered strong arguments *for* special effects, but the magnificent results on-screen offered potent rebuttal.

At this juncture, with the so-called major effects under the gun, let's pause to examine a few of the simple, very handy illusions that technicians had created by 1936. One problem faced by producers in Southern California was the lack of snow. Lugging equipment and personnel to the mountains was an expensive proposition, and hardly the solution that was needed. Thus, a major breakthrough was the discovery of a means to mix gypsum, salt, and bleached, untoasted cornflakes to form snowflakes. Previous attempts at making frozen precipitation had been tentative, at best; this was the only formula that fell and caked realistically. And one of the first pictures to use it can hardly be charged with a lack of enthusiasm: *Elmer the Great* (1933) required forty-six tons of the mixture, and twelve hours of steady precipitation to fully transform a balmy street set into a snow-bound country village. Icicles were the product of cellophane cones dipped in paraffin, with the dividend that the wax melted authentically under the hot lights. Frost was simply camphor shot through spray guns.

Another contemporary development was the rainmaking process, originated in 1932 and still in use today. For instance, in the Loretta Young picture *Life Begins*, it was necessary to create a shower just outside a maternity ward. Since the set was in a studio, a long pipe was run alongside the window. Riddled with tiny perforations, it sent a gentle rain trickling down the pane. The floor boards had been removed and a hole dug underneath the stage, allowing the water to be absorbed into the ground. However, it did not soak through as quickly as the special effects men had expected. A puddle formed, and the splashing was picked up by overhead microphones. Technicians solved this problem by placing felt pads over the hole to prevent an accumulation of water, then laying a wire mesh screen on top of this to create a soft pattering effect. Even DeMille, despite his elaborate special effects, made an enduring contribution to the cinema's basic repertoire: in *Four Frightened People* (1934) he was the first major filmmaker to use a rubber snake controlled by wires from above. However, DeMille was dissatisfied with the results, and forced Claudette Colbert to place a real asp to her bosom in *Cleopatra*. Also destined to become a

ready element in the screen's bag of tricks was the use of glycerine to simulate tears, which was a development of the early thirties.

Yet, of all the technical devices introduced during this period, none was more important than the *optical printer*. A glorified projector-camera link-up, the optical printer was capable of projecting and photographing several rolls of film simultaneously, performing dissolves, speeding up or slowing down the action, adding credits, and so on. It even replaced the process camera in matte photography. A special effects man could now shoot the matte on a separate strip of film, feed it through the optical printer with the background film and an unexposed negative, and have the original reproduced on the negative with the proper area blacked out. Threading this new negative in the optical printer, along with the action to be superimposed, he could make his composite with mechanical precision. Heartened by this growing proficiency, filmmakers began to put more faith in special effects, and by the mid-thirties the newly formed special effects departments had achieved parity with the other facets of motion picture production.

Each studio had its own peculiar organization. At MGM, for example, mattes and optical effects were handled by the studio's titling department. Paramount, on the other hand, had a special division that was concerned only with rear-screen projection. However, there was still room for the great wizards, and one of them was James Basevi. His attitude toward the field was honest and perceptive. In an interview conducted during a hectic 1936 production schedule, he said, "It would be wholly impractical—often impossible—to accomplish many of our effects through anything *but* tricks. I don't necessarily mean trickery; I mean engineering skill and ingenuity." Basevi had come to special effects well equipped for whatever a studio might need. He had graduated from Great Britain's finest technical schools, and had been a practicing architect in Canada before the Great War. In 1922, he went to work for movie mogul Samuel Goldwyn as a draftsman, and from there became a specialist in mechanical effects. Basevi's first major assignment was with A. Arnold Gillespie, the man who had sunk the *Ben-Hur* galley and was now head of the MGM special effects department. Their joint project was *San Francisco* (1936), the story of the 1903 earthquake. To effect the picture's climactic shakedown, the men built full-scale sets on hy-

John Dehner and a prop lance—the staff and blade are two separate pieces—from *Rogues of Sherwood Forest* (1950).

draulic jacks, offering the structures over a yard of vertical play. This allowed walls and facades to crumble in a fashion that was true to life. In fact, legend has it that the first take sent the extras running from the set, the studio, and the city, so real were the tremors. Regardless, miniatures and rapid-fire editing accounted for the remainder of the twenty-minute cataclysm, while careful matte and rear-screen work enabled star Clark Gable to rush through the holocaust in absolute safety. Basevi and Gillespie did a magnificent job on *San Francisco*, and were assigned the task of filming the famous locust swarm in Pearl Buck's tale of a Chinese farming couple, *The Good Earth* (1937). Close-ups of the insects presented no problem. Dead locusts, preserved in jars of alcohol, were mounted on small, wooden tongues and manipulated by assistants stationed out of frame. The cloud of bugs that spirals over the horizon and descends on a field of crops was not as easily realized. The problem, of course, was not only that of creating a moving mass, but giving it the illusion of being millions of tiny insects. Cartoon animation would have been too costly, and available newsreel footage was of a decidedly poor quality.

After weeks of experimentation, the team hit upon a viable solution to the problem, and one that ranks among the strangest effects ever devised. Setting their camera upside-down before a huge fish tank, the men poured an endless stream of coffee grounds into the water. Spilled at a carefully calculated angle, the angry hordes swirled as planned. Since the bottom of the lens had been level with the top of the tank, it recorded the "locusts" rushing from bottom to top, and the special effects men had their fiendish infestation. Running this footage through an optical printer, it was superimposed over a prefilmed background showing the horizon and rice fields. Doubtless star Paul Muni would have preferred the crew to use coffee grounds in scenes he shared with the locusts. To show him struggling beneath the aerial onslaught, Basevi and Gillespie simply used huge fans to blow bagfuls of their dead bugs at the actor.

Not one to rest on his laurels, Basevi had no sooner finished with one disaster than he dispatched another: *Hurricane* (1937). This John Ford film, about the idyllic life of Manikoora Island, features a storm finale that remains the most colossal such sequence ever filmed. The picture's prime focus during the hurricane is on the foreshore of the island, an area spotted with a wharf, homes, and a church. To build his disaster, Basevi battered the six-hundred-foot-long waterfront set with wave machines, wind machines, and hoses that flung huge quantities of water into enormous fans. Stuntmen and extras went tumbling across the terrain as Basevi uprooted prop trees with piano wire and drove his storm to a proper frenzy. As the climactic razing of the town neared, the special effects man turned his machines loose on a duplicate 60′ x 40′ miniature set, destroying it completely and with aplomb. Shooting at high speeds gave his miniature waves impressive bulk and impact.

Elsewhere, special effects men were distinguishing themselves with both optical and mechanical advances. In terms of technical developments, there was the first use of color rear-screen photography in *Nothing Sacred* (1937). Unfortunately, in order to record the rear-screen image, it had to be very bright. To get this intense picture meant keeping the projector close to the translucent screen, resulting in a small 8′ x 8′ image. This, of course, precluded medium or long shots. A year later, the airplane saga *Men With Wings* introduced a system wherein three projectors threw the same image on

one spot simultaneously. This provided the requisite brightness as well as scope, and the process was ready for use in a landmark film of 1939, which we will discuss in a moment. *Men With Wings* also gave technicians the opportunity to better the miniature wrecks in *Wings*. How? Simple. They were filmed with real planes. The pilots would take dives that flattened out literally yards above the ground. The action was cut just before the planes pulled out of the spiral and, when all the aerial photography had been completed, the crackups were created by having cranes drop the *real* planes from a height of twenty feet. By shooting at slow speeds, the crashes were recorded in fast motion and, edited to the tail end of the actual dive, the result was a thrilling and convincing bit of action.

Less dramatic, but no less impressive, was a film that won the first special effects Oscar in a decade. *Spawn of the North* (1938) was a Henry Hathaway film about the Alaskan salmon industry during 1900–10. Actually, the Academy Award went less to the special effects per se than to the remarkable sets and the exceptional use of color rear-screen projection. Technicians photographed the in-studio action before a huge, two-way screen using their new 24mm lens. This lens broadened considerably the range that could be achieved in 16mm. In essence, it gave added area and, thus, depth to the rear-screen scenes. *Spawn of the North* also featured Paramount's lavish new water tank that was 100' x 80' and cost $20,000 to build. It could hold four fishing boats weighing seventeen tons each, which is what *Spawn of the North* required. On either side of this indoor lake were ramps fifty feet tall and one hundred feet long. These led from six dump tanks on either side, stores of water that emptied their contents down the slides and onto aprons. The curved sills shot the water skyward to create waves, typhoon rains, and so forth. *Spawn of the North* also featured hundreds of rubber salmon, which were less expensive to keep and control than the real thing. Incidentally, it's interesting to note that animals, then as now, were a frequent object of the special effects man's skills. Apart from locusts, the dinosaurs of Willis O'Brien, and the various snakes employed by DeMille, it was necessary to drum up a wealth of hostile beasties, such as fifteen-foot-long radio-controlled alligators for Tarzan films. These were built by Bob Mattey, whose work we will study in chapters seven and eight. Another Tarzan trick was a pachyderm attack, which was accomplished by

matting two elephants three times over into the same image. The ape-man's simian friends were all men in monkey costumes, while pythons and other serpents were represented by rubber duplicates. Of course, these are rather routine effects, but there was a clever scene in *Tarzan* (1936), Johnny Weissmuller's first appearance as the hero. The script called for a rhinoceros to fall beneath the ape-man's knife. Since the animal could not be trained to buckle on-cue, an alternate method of felling the beast was devised. A rather tame creature named Mary was brought to the set and coaxed to lay down. The ape-man climbed on her back and put the handle of his prop blade close against her skin. The cameras began rolling, and the animal was allowed to rise at her leisure. When she eventually took to her feet, Weissmuller pulled the knife from her hide and a concealed spring shot the collapsible blade from its handle. When the scene was printed in reverse, it appeared as if the jungle lord had, in fact, sunk his weapon into the rhino and she went down.

We mentioned earlier that 1939 would be an important year for color rear-screen work. This was true, as well, for glass and matte shots, miniatures, explosions, and the wide variety of "wound" makeups that were necessary to bring *Gone With the Wind* to the screen. Almost two-score years after its release, audiences continue to be impressed by the film's visual splendor, the magnificent shots of the plantation Tara, and remarkable sunsets. Yet, almost every one of these vistas was a glass painting. The foreground elements were supplied by an optical printer. As equally indebted to special effects was the Burning of Atlanta, which, as is well known through years of publicity hype, was executed with full-size sets. Producer Selznick reduced the lot to ashes with two separate networks of pipes run along the backs of the facades. A flammable mixture containing twenty percent rock gas was pumped through one network, while water and extinguisher was run through the other pipe system. Manning the control board that regulated the flow of each to suit the action was Selznick himself. Scenes of Clark Gable driving his carriage through the confused city were done largely with rear screen; indeed, he wasn't even present for the famous ride through the flaming Atlanta railway station, stuntman Yakima Canutt stepping in to double this dangerous sequence.

The splendor of the glass shots and mechanical effects in *Gone With the Wind* offers no greater

Yakima Canutt doubling for Clark Gable in the Burning of Atlanta railyard sequence from *Gone with the Wind*.

defense for the dramatic potential of special effects. Indeed, so naturally did the film's magnificent visuals meld with the rest of the film that they went undecorated in the picture's route of the 1939 Oscar race. The award that year went to another spectacular production, *The Rains Came*. Remade in 1955 as *The Rains of Ranchipur*,[1] *The Rains Came* is the story of a Hindu doctor (Tyrone Power) and his love for a married Englishwoman (Myrna Loy). The story is an average soap opera until the award-winning earthquake levels the affair and half of India, outperforming even *San Francisco* in its matte work and utilization of miniature sets. Yet, despite the epic's bravura, even greater disaster films lay just beyond the turn of the decade. Before we look at these, however, let's return to 1930 and examine the impressive demands made on the skill of special effects men by the fantasy and science fiction film.

When we last saw Willis O'Brien, he was being both sued and universally applauded for his work on *The Lost World*. Subsequently, he failed to raise finances for films about *Lost Atlantis* and *Frankenstein*, this latter planned for production two years before the Karloff film went before the cameras. Then, in 1930, on the basis of an album of drawings, O'Brien persuaded RKO Pictures to advance seed money for the development of his film *Creation*. From the sketches that survive, it is obvious that this new film was to be a sound retelling of *The Lost World*, with explorers finding prehistoric monsters in a time-forgotten land. While O'Brien was busy drawing storyboards—sketches that depict the visual flow, camera angles, and action of important sequences—Marcel Delgado began building the stop-motion models. Among these were a mother triceratops and her litter, a prehistoric bird, and the huge horned sloth known as an arsenotherium. Test footage was shot using these monsters, and all that remained was for the studio to give its go-ahead on feature production. Unfortunately, RKO was sold

and the project was shelved. *Fortunately*, one of the producers hired to analyze studio inventory was Merian C. Cooper, who, with Ernest B. Schoedsack, shot exotic semidocumentary films in such far-off locales as Persia, Siam, and Sumatra. Cooper was impressed with O'Brien's *Creation* material, and saw the possibility of merging it with a story he had long wanted to film. Complaining that, "No longer is there any mystery of hidden adventure in films," he, Schoedsack, and author Edgar Wallace had concocted the most astounding adventure story of all time, the tale of an autobiographical film crew in search of the incredible Malaysian god King Kong.

Cooper decided that O'Brien was the man best suited to design visuals as distinctive as the property itself, and commissioned animation footage to help sell the idea to the new RKO executives. Delgado built a model of Kong and O'Brien put him through a few rather violent paces with a tyrannosaur. The test reel was well received by the studio heads, and the film was allocated a budget of just over a half-million dollars. Production got underway in 1932, and the set was off-limits to everyone not directly associated with the picture. *King Kong* would be a year in production, and Cooper didn't want his idea pirated and rushed into release by a rival studio.[2] The picture was released April 7, 1933, and is credited with having rescued RKO from bankruptcy during this trying post-Depression era. In New York City alone, it played to 100,000 people every week in an unprecedented dual run at both Radio City Music Hall and the rival Roxy Theatre.

The plot of *King Kong* is legend. The aforementioned film production unit visits Skull Island to shoot a documentary about the natives and their mythical lord Kong. When the fifty-foot ape appears, Producer Carl Denham (Robert Armstrong) realizes that he is worth "more than all the moving pictures in the world!" and captures the huge gorilla, putting him on display in a Manhattan theater. The monster escapes, goes on a city-wide rampage, and is shot by airplanes from atop the Empire State Building. Beyond the monster-on-the-loose plot, there is the romantic angle: Kong falls in love with Ann Darrow (Fay Wray), Denham's leading lady, and manages to keep her in his fury paw for most of the film.

In *King Kong*, Willis O'Brien created one of the screen's great personalities. Unlike the *Lost World* animations, Kong was able to emote with extraordi-

The *King Kong* pteranodon as it looks today.

nary range. This ability to create a realistic character depends very much on that rapport, of which we spoke earlier, between the model and the animator. In the case of *King Kong*, of course, the model's simian rather than saurian design did much to increase its inherent expressiveness. As a result, according to what the late Mr. O'Brien's widow, Darlyne, told me, "O'bie's personality shined through everything he made Kong do. I could see his sense of humor in everything Kong did." Beyond the stop-motion photography, Marcel Delgado's models were a vast improvement over the monsters in his previous epic. There were five dinosaurs in all—the tyrannosaur, a brontosaur, a pteranodon, a stegosaur, and an elasmosaur—and their skin was carefully crafted of latex and rubber with considerable attention paid to detail like scales and other distinctive surface textures. The skeletons, or *armatures*, were made of metal, with ball and socket joints atop which cotton and sponge were sculpted to form muscles and fleshy bulk. As for the Kong figurine, it was covered with rabbit's fur with a real ape's skull mounted atop the metal frame. However, the quality of *King Kong* as compared to *The Lost World* cannot be credited entirely to refinements in materials and even in the animation camera: the models themselves were considerably larger than those used in *The Lost World*. Kong, for example, was just under two feet tall, while the brontosaur extended nearly a full yard from head to tail. Another first in the filming of *King Kong* was the construction of a half-dozen miniature ape models for the picture. This was dictated by the fact that over an extended period of time, the rubber exteriors of stop-motion models dry and crack, and the jointed armatures loosen. This second problem

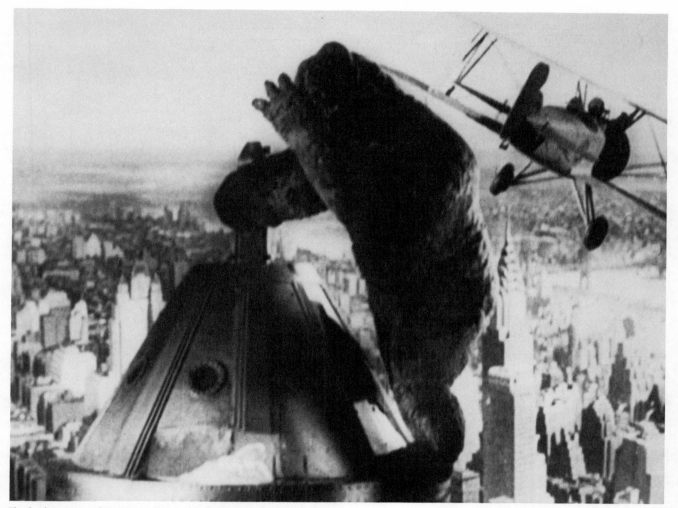

The final moments of *King Kong*. The airplane is a miniature, flown over the model of Kong and the Empire State Building by an aerial brace. The New York skyline is a photograph propped behind the set, and actress Fay Wray is present courtesy of a matte.

is especially hazardous, since a limb may sag imperceptibly on the miniature set, only to appear on-screen as a poorly animated article. Since tightening the joints would require dismantling the model and losing precious and costly production time, the answer was to build several identical models. This remains a standard practice in films where stop-motion monsters are featured players. The duplicate nature of the models also enabled assistants to arrange and dress new sets while O'Brien was locked in animation.

King Kong also introduced a number of optical techniques, most of which were vast improvements over previous methods of superimposition. Perhaps the most valuable of these was *miniature screen photography*. This procedure is actually a form of

the rear-screen process. The prefilmed background is rear-projected on a small, translucent screen behind the miniature set. A camera is placed before the table-top set-up, while the projector exposes and holds a single frame of the prefilmed footage. The stop-motion figure is moved ⅛" to 1", depending upon the required speed and sweep of the creature's movement, and one frame of film is shot. Seen through the camera lens, the miniature projected background and stop-motion model form one two-dimensional image. In this way, for example, the stop-motion figure of Kong and the miniature summit of the Empire State Building were able to be shot before a prefilmed, miniature projected background of real biplanes soaring above the New York skyline. Shots of Kong plucking a plane from mid-flight were accomplished with a miniature aircraft "flown" at the ape model a frame-at-a-time using an *aerial brace*. This is a

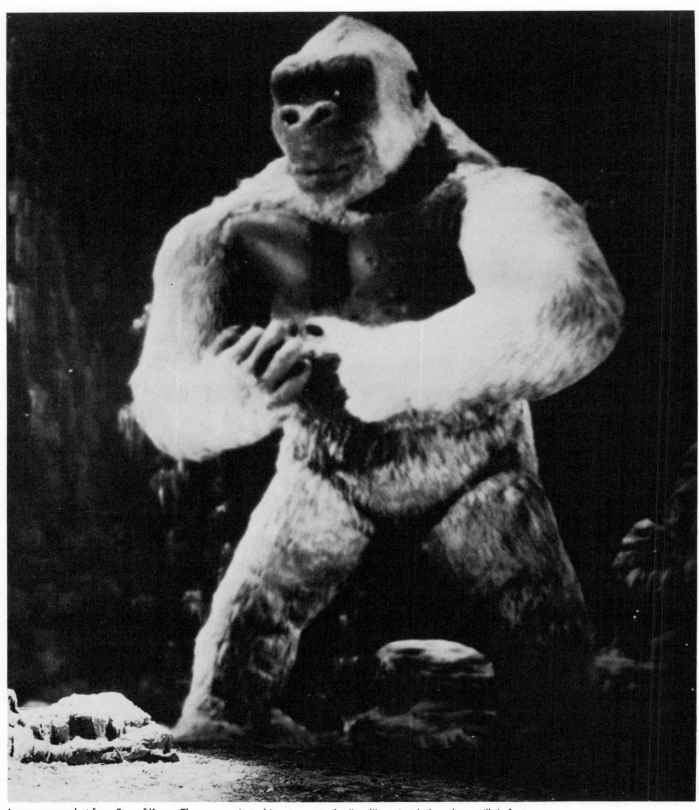

A rear screen shot from *Son of Kong*. The rear-projected image meets the "real" set just below the gorilla's feet.

device we will discuss further in chapter 6. The miniature screen process can be further embellished by setting a glass painted foreground between the table-top setting and the camera. Much of the florid Skull Island foliage was created in this fashion, with glass paintings placed one behind the other for additional depth.

Not only did RKO invent miniature screen photography for *King Kong*, but the film gave the studio its first experience with regular rear screen photography. Cooper later recalled that it was first used in the scene, "where Fay is on top of the tree and the tyrannosaur comes for her. That shot took us three days because none of us knew how to do it."

One of the more interesting special effects used in *Kong*, although it was not invented by the film's craftsmen, was a revolutionary matte process that, in essence, allowed an object to serve as its own on-the-spot matte. It was based on the principle that the *tones* of different colors have unique effects on raw black and white film stock. To create the matte required a *bi-pack camera*, a unit capable of running two strips of film, one behind the other, past the lens. First, the prefilmed background was dyed an orange hue and slipped into place before the lens. The second spool, containing an unexposed negative, was run in back of it. On the set, the actor or model was lighted with orange tinted lamps and performed before a blue screen. Certain shades of blue do not photograph on black-and-white film, so the blue screen's only function was to bounce enough light at the camera to reproduce the preshot background onto the negative behind it. But there was a model or performer between the screen and the lens: thus, the blue light was blocked wherever he was standing. Ordinarily, this would have left his opaque matte image on the new background negative. However, since the actor was being illuminated simultaneously in orange, his well-lit features slipped through the orange-bleached—and thus insensitive-to-orange—background film without reduplicating the footage. In this way, the two images were neatly combined. In addition to visual effects, sound effects played an important part in the film's overall impact. The ape's mighty roar was that of a lion, recorded at half-speed and printed in reverse on the film. The cries of the dinosaurs were all created on a vox humana pipe organ, the notes and chords recorded, again, at half-speed and reversed on the soundtrack.

These, then, were the major special effects in

Helen Mack, Robert Armstrong, and the life-size paw and wrist of the *Son of Kong.*

King Kong. Before leaving the film, however, we should say a few words about the long-held views that the original Kong was either a "robot," a man in a monkey costume, or a huge mechanical model. In only one scene was there ever a man in a Kong suit, for an extreme long shot of the Empire State Building with a speck of ape seen climbing the skyscraper. Further, several closeups of Kong's head, foot, and paw were executed with life-size reconstructions, but these were interspersed with the stop-motion footage only when necessary. The paw, like the animated model, was fully jointed and covered with rabbit's fur. It was operated by pulleys and built on a crane, which workmen manipulated from out of frame. This hand was used in scenes where the "real" Fay Wray, and not her four-inch-tall stop-motion double, was shown in her captor's grip. This action was performed before a rear screen on which the New York skyline or Skull Island backgrounds were projected. The paw was also used for the scene where Kong pulls Miss Wray from her hotel room in New York City, and when he does the same to someone whom he mistakes for his "bride." As for the huge Kong head, with rolling eyes and

grinding jaws, it was used in an occasional snarling close-up or, in the uncut version, for the scene in which Kong snatches a New Yorker from a subway car, chews him to pulp, and spits him out.[3] Likewise, the scale-model foot is briefly seen—or censored, depending upon the print—as it crushes one of the Skull Island natives into the mud.[4]

When the public's overwhelming acceptance of *King Kong* became apparent, *Son of Kong* was rushed through production and released that same year. Built over the stripped skeleton of King Kong, the baby leviathan was discovered on a return trip to Skull Island. O'Brien, however, was dissatisfied with the white-furred do-gooder who helps Denham uncover the treasure of the island, and all but disavowed the production. Further, the hurried production schedule left O'Brien no time to experiment or improve upon the techniques used in *King Kong*. For his next project, O'Brien had the time but not the *money* to work his wizardry; Merian Cooper's *Last Days of Pompeii* (1935) was an exercise in economy. Beyond such minor annoyances as reusing music from *Son of Kong, Last Days of Pompeii* skimps on many important scenes. For instance, midway through the film, we watch as warrior Preston Foster prepares his men for a crucial battle. In the next scene, he is boasting about how his soldiers have whipped the enemy! Cooper simply skipped the fight because it was too expensive to stage. However, disappointments such as these are forgotten during the lavish climax of Mt. Vesuvius' eruption. The spectacle, of course, was due solely to O'Brien's masterful union of miniatrue sets with actors. Especially striking is the model of a colosseum, complete with a two-hundred-foot-tall statue guarding the entrance. The collapse of this figure is the high point of the volcano, roiling crowds of extras and fleeing chariots nicely combined with the toppling models.

At this point in his career, although he contributed incidental special effects to a handful of films—including, it is reported, Orson Welles's *Citizen Kane* (1941)—Willis O'Brien's years as an innovator ground to a halt. We shall rejoin him in a decade. In the meantime, there were other miracles being wrought on the silver screen, of which *The Invisible Man* (1933) and *Things To Come* (1936) had more than their share. Both were based on novels by H. G. Wells, although they are of a markedly different timbre.

Hollywood, of course, was not the only bastion of screen wizardry. To provide a balanced view of special effects developments of this period, we'll look first at the British *Things To Come*. Based on the novel *The Shape of Things To Come*, the movie spans one hundred years of history, following the microcosmic fate of Everytown, England, from the outbreak of a world war in 1936 through its suffering the ravages of a petty tyrant and the virulent Wandering Sickness, to the rebirth of science and the Everytown of 2036, a crystalline underground paradise where scientists are engaged in launching men to the moon. Directed by William Cameron Menzies, who went on to become the art director of *Gone With the Wind*, *Things To Come* is a sprawling stage on which unrounded characters pontificate Wells's various philosophies and special effects men create a spectacle of warfare, ruination, and, ultimately, utopia. While there is no question but that the film is well-acted and thematically stimulating, the miniature models and glass paintings are the picture's real stars. Accordingly, although the processes were well established by this time, the sheer wealth of optical tricks used to combine the actors with these miniature settings was awesome. For example, in the opening scenes alone there were a number of glass shots as the first bombs dropped on Everytown and the city was shown in an ever-mounting state of decay. In a montage that followed, miniatures were used extensively to show the escalation of hostilities, as the sleek and rumbling war-machines crumbled cities beneath their onslaught. Later, with the fall of the warring despots, great airships announced the coming rule of the scientific community Wings Over the World. Careful matte work and double exposure enabled these miniatures to fly, while on landing fields hundreds of people were shown entering these ships via superb split-screen craftsmanship. Life-sized hatchways were matched with model airplanes, a process that was also used to place extras in the miniature settings of the subterranean Everytown. In cases where split screen would have been too obvious, the technique of depth perspective described by Fred Waller as used in *Puritan Passions* was employed. This latter process not only combined actors with miniature models, but allowed for street scenes showing hydraulic carriages soaring above the crowds. Like *Last Days of Pompeii*, *Things to Come* was able to reap all the benefits of the spectacle without weathering the cost. On the opposite end of the special effects scale, however,

Una O'Conner and Claude Rains in *The Invisible Man*.

was a more personal film, *The Invisible Man*.

The Invisible Man is the story of a scientist who goes slowly mad after injecting himself with a serum that renders him transparent. The title role marked the screen debut of Claude Rains, and gave a marvelous vehicle to one of the industry's all-time special effects greats, John P. Fulton. Fulton had studied electrical engineering before leaving college to become a surveyor for the Southern California Edison Company. In his spare time, Fulton watched Griffith and others make movies. He became interested in motion pictures and, in 1923, convinced a cameraman to take him on as an assistant. This position entitled Fulton to carry cameras to and from the set, but not actually to photograph a film. For his services, Fulton earned twenty-five dollars a week. By 1929 he had become a full-fledged camera operator, but found himself growing slowly more interested in special effects than cinematography. Making the acquaintance of Frank Williams, owner

of a free-lance special effects shop in Hollywood, he went to work for the man. Fulton's technical and cinematographic background brought him quickly to the fore of this new breed of craftsman and, in 1931, he accepted the post of head of Universal Pictures' newly created special effects department. After working on various films such as *Waterloo Bridge* (1931) in which he recreated London, fog and all, and *Air Mail* (1932), a film that required miniature cliffs, snowscapes, and airplanes, he tackled the awesome task of *The Invisible Man*.

Studio heads had originally wanted to make the picgure in 1931, which would have enabled it to ride on the coattails of their enormously popular horror films *Dracula* (1930) and *Frankenstein* (1931). Unfortunately, technicians of the time hadn't the know-how to create realistic special effects of the sort the property required. For instance, to show the Invisible Man walking about in his clothes, they had shot some footage of garments being suspended

by piano wire. Unfortunately, the clothing hadn't the fullness of a human body, and the experiment was discarded. Mirrors were tried, but they, too, proved unsatisfactory. Even Fulton, when he inherited the project, required several months of research to devise the intricate effects. Of course, by this time he had the benefit of a new fifty-thousand-dollar special effects soundstage and equipment such as the optical printer.

Complete invisibility presented no problem to Fulton and his staff. As Rains recalls,

All that was done with wires. If you stood close you could see the wires; if you stood near the camera, you couldn't. I sat around for hours watching them do it, and I never had such a lark in my life.

These wires were used to lift peoples' hats from their heads, carry objects through the air, overturn bicycles, and so forth. The challenge was to show Rains, his head swathed in bandages, remove these wrappings and his clothing to reveal absolute invisibility. Fulton achieved this effect through a complex series of mattes. As with other mattes, the background was prefilmed and stored for later use. In a room that was literally wallpapered with nonreflective black velvet, the Invisible Man donned a black leotard that covered everything from his hair to his feet. The bandages and clothing were then fitted over this and the actor went through his unwrapping motions. Since, by stripping, he revealed only black, his body was lost almost completely against the dull black background. This piece of film was developed and printed and, from it, Fulton was able to make two very clever mattes. First, he made a copy of the film. In developing the negative of this copy, he *burned in* all the blacks. In other words, using chemicals, he made them completely opaque. All of the tones that had leaned toward white became clear. Since this negative was simply a reverse of the positive, Fulton had a strip of film in which the background was clear and the clothes and bandages were a solid black. Printing a new positive from this, he had a print with a solid black background and a clear area where the Invisible Man had gone through his paces. These two pieces of film served as Fulton's matte and countermatte, which he used in an optical printer to combine the prefilmed background with the original, *non*burned in footage of the actor undressing.

There is some question as to whether the man in the leotards was actually Claude Rains. As one can imagine, being swathed in two layers of clothes can be rather uncomfortable, especially since breathing had to be done through tubes that ran along a pants leg and were inserted directly into the actor's nostrils beneath his leotards. However, this borders on the unendurable when it is excuted under scalding lights, in a jet black room, and with the need for as many as thirty different takes of the same scene. This vast amount of repetition was dictated by the precision movement demanded of the performer beneath the bandages. For example, after the Invisible Man had removed his gloves, the actor had to be careful where he moved his hands. Beneath the costume glove was, as we've noted, a black covering that was necessary to work the invisibility trick. However, it was still a solid object, and if it had passed between the lens and the actor's body, which was still robed, it would have created a clear spot in the negative matte, and thus an unwanted blotch of invisibility in the clothing. In any case, this scene would have been a trial even for someone in perfect physical condition. To hear Rains tell it, of course, the work was all his own.

They photographed me straight and then made me disappear. Each night I saw the day's rushes and could see what they were doing to me. Sometimes they didn't get total invisibility. At night, in the projection room, I would come out opaque, or just the outline of my figure would be visible. But after the film went through the laboratory, I just disappeared. You can blame the laboratory for removing me from sight, although the special backgrounds, the masks, and the bandages had a lot to do with it too.

However, most students of the film agree that the undressing sequences were probably executed by a double, with Rains's voice added to the soundtrack at a later date.

There were several other rather amazing illusions in the movie, such as imprints of the Invisible Man's bare feet appearing in the snow, and his body slowly materializing upon death. The first effect was accomplished by sawing foot-shaped holes in a long board, laying this across a furrow, and then replacing the print cutouts. Supporting these dies were small pegs to which ropes were tied. The entire rigging was then covered with "snow" while, out of frame, one of Fulton's assistants pulled a cord-at-a-time. This caused the wooden foot pieces to fall from the stencil and the prints to "appear" in the snow.

The scientist's loss of invisibility was also ingeniously realized. We see Rains on his deathbed; more accurately, we see an indentation in the pillow where Rains's head should be, and the blankets bulging with the shape of his body. The pillow, with its head-shaped impression, was sculpted in plaster; the contoured sheets were made of papier mache. By using the dissolve technique discussed earlier, Fulton shaded his subject from invisibility by showing a skeleton, then a mannequin with carefully crafted viscera, and finally Rains himself. This was the only time the actor's face was seen on-screen.

After *The Invisible Man*, Fulton went to work on Universal's legendary spate of horror film sequels, including follow-ups to *The Invisible Man* including *The Invisible Man Returns* (1940), *The Invisible Woman* (1941), and *The Invisible Man's Revenge* (1944). Throughout the series, there was very little change in Fulton's basic technique. However, one clever variation did appear in *The Invisible Agent*, which was nominated for the special effects Oscar in 1942. At the film's conclusion, the title character kisses Ilona Massey on the lips. The actress was photographed against the standard black velvet background, while a prop man, dressed entirely in black, pushed a black mallet against her lips. The only problem was that the hammer obscured a small part of Miss Massey's profile, which necessitated a frame-by-frame retouching of the negative.

We mentioned above that Fulton was involved with other fantasy special effects. Together with makeup genius Jack P. Pierce, the man who created Boris Karloff's classic *Frankenstein* and *Mummy* disguises, Fulton put the curse of lycanthropy on Henry Hull and Lon Chaney, Jr. both. For *Werewolf of London* (1935) and *The Wolfman* (1940), it was necessary to turn the respective actors to monsters in full view of the camera. The challenge was not new: it had already been accomplished in both the 1920 and 1931 versions of *Dr. Jekyll and Mr. Hyde*. In the first Jekyll film, a long shot of the scientist's laboratory saw John Barrymore become the monster simply by mussing his hair and contorting his features. Makeup rendered his facial lines more subtly bestial for the close-ups. Fredric March used a less theatrical device for his metamorphosis. The makeup had been applied before the transformation began, but was so-colored that it became visible only when exposed to infra-red light. This made for a smooth, effective change, but Fulton wanted something a little more dramatic, a

scene in which the hairs would appear a few at a time and literally *grow* from the actor's face.

For *Werewolf of London*, Fulton settled on a simple camera trick. The transformation took place as Hull hurried down a portico, with the camera moving along a parallel course on the opposite side of the colonnade. Each time Hull emerged from behind a pole, he was successively shaggier. What Fulton had done was to simply stop his camera cold when a column completely filled the screen. Pierce applied makeup to his werewolf and the action continued. By the time Hull had reached the end of the arcade, he was a full-fledged monster. Chaney's *Wolfman* ordeal was considerably more taxing. Yak hairs were applied a strand at a time and filmed via stop-motion photography. Thus, Chaney had to hold his head, hands, or feet—whichever was the subject of the transformation—absolutely stationary for from three to seven hours. The entire scene would then last only ten seconds on screen, but they were ten seconds of virtuoso special effects. A less arduous method, used in the more hurried of Chaney's five Wolfman outings, was to slowly dissolve into progressive makeups. After each successive application had been made, the camera was back-cranked a few frames and double exposed. Thus, the tail-end of one shot bled neatly into the beginning of the next, unless Chaney moved his head. However, since this procedure added entire sections of hair with every exposure, it lacked the impact of the slower, stop-motion build.

Another of Fulton's remarkable accomplishments came later in the horror cycle, although we mention it now to provide a perspective on Fulton's versatility. This trick was the on-screen transformation of Dracula to a bat, an effect used in both *House of Dracula* (1945) and *Abbott and Costello Meet Frankenstein* (1947). When John Carradine or Bela Lugosi respectively, spread his cape prior to the change in each film, Fulton stopped the camera. The actor left the set and several feet of background were photographed. The camera was stopped once again, and a small, rubber bat, suspended on piano wire, was made to perform. Back in the lab, Fulton matted realistically drawn cartoon animation over the empty, intermediary background footage, which carried the performer from his human posture to that of a bat.

Before leaving the horror film, a few of the genre's less magniloquent standbys merit our attention. There was, for example, the ever-present studio fog.

Depending upon the effect desired, there were several different ways of shrouding a set with clinging haze. Steam was the simplest fog-substitute, but it tended to rise and quickly dissipate under hot studio lights. Bee smoke was popular for a while, a cloud used to lull the insects to sleep when beekeepers went to collect their honey. It had lingering weight, but produced the unpleasant side-effect of stinging the eyes and throat. Liquid vaseline, which had been introduced in 1933, enjoyed a longer tenure. Blown through an airhose, it was most effective but tended to disperse the light with its millions of tiny oil droplets. This, of course, could work to the director's favor, if he wanted a dreamlike look about the set. However, in 1940 special effects man Fred Wolf found a way of frosting the air with dry ice, thus creating the most realistic screen mist to date.

Cobwebs were also an important element of these gothic chillers, and were made with glue or rubber shot through a pressure gun. When it was necessary for an actor's face to come in contact with the stuff, thoughtful special effects men replaced the latex mixture with spun sugar. To compliment this eerie dressing, set directors also applied a substance known as clear poplac to props and furniture. The poplac dried and cracked, thus aging a surface several decades per coat. Fringes were browned with a blow-torch to complete the effect.

Of course, not all of Hollywood's fantasy effects went into misty moors and vampire blood, which, incidentally, was nothing more lethal than chocolate syrup in the black and white films. For example, when filmmakers turned to the imaginative worlds of Shakespeare and L. Frank Baum, they provided their technical crews with the opportunity to create some of the cinema's most exotic special effects. *A Midsummer Night's Dream* (1935) is a lavish and complex tale of princes, peasants, and pixies. And when the script called for these sprites to work all manner of wonder, this included materializing from a bank of fog. The scene was worked with pipes encased in ice and run under the set. An oil mist was forced through the system and, because the droplets were semifrozen, they could be jet-blown into predetermined shapes. When these had assumed human form, the camera was stopped, the studio cleared of smoke, and fairies positioned in place of the clouds. Back-cranking the camera, a slow dissolve changed the fog into the nymphs. Later in the film, these attendants to Queen Titania (Anita Louise) were required to run up a ramp of moonbeams. Actually, they were scurrying along ramps colored with process blue, the shade that does not reproduce in black and white. Powerful arc lamps shining sharply down the walkways provided the rays of lunar light. Less elaborate effects were also used throughout the film, such as the changing of the head of tradesman Touchbottom (James Cagney) into that of a donkey. Four successive makeup applications dissolved one into the other to make the ass whole. More inventive was the fog that magical Puck (Mickey Rooney) was forced to blow from his mouth. A hose sprayed the forest set with haze for the long shots, while close-ups were done with Rooney blowing smoke from a cigarette that had been laid end-down in a thin glass tube on his tongue.

Although this mythical land of Shakespeare's imagination was more fanciful than anything the screen had ever seen, it was conservative when compared with the realm of *The Wizard of Oz* (1939). For one thing, Oz was wrought in glorious Technicolor. For another, complementing every light-hearted spirit, munchkin, or winkie was a dark and malevolent winged monkey or living tree.

Most of the wonders of Oz were created by the set designers or makeup men; the optical and mechanical effects were few and simple. Young Judy Garland was carried "over the rainbow" in her house, a miniature sent tossing and spinning on piano wire before a rear projected tornado. Likewise, in scenes where one of Oz's many witches (Margaret Hamilton) takes to the air on her broomstick, she did so by dangling before a rear screen, or was a puppet launched from the miniature parapets of a model castle by wire. In general, however, the makeups were better than these simple displays. Chief craftsman Jack Dawn spent six months devising the various disguises, which included thirty-six of the aforementioned monkeys, twenty-six winkies—the tall, green residents of the Wizard's Emerald City—one hundred and twenty-five munchkins, a trio of apple-throwing men in tree costumes, and the three principals: the scarecrow, the tin woodsman, and the cowardly lion. For this last grouping, Dawn went so far as to have a technician stalk the soundstage catwalks with wire, to cause Bert Lahr's lion's tail to twitch and slink realistically.

And so, with *Gone With the Wind* representing the utility of special effects in mainstream film-making, and *The Wizard of Oz* speaking for the more

fantastic application, we move into the forties. Neither the technology nor showcases for camera magic will change radically in the upcoming decade, but we will see developments in the "real" world lead film to a point where, in the early fifties, content will be forced to take a back seat to technical sophistication.

5
The Forties and Fifties

We never utilized a trick for its own sake.
 —Ernest B. Schoedsack
 Director, *Dr. Cyclops*

World War Two forced the development of new and sophisticated technology. Film stock was improved for the taking of reconnaissance movies, and advances in radar and communications helped make home television a marketable reality by the end of the decade. Until the first regularly scheduled programs began broadcasting in 1947, movie fare was much the same as it had been in the thirties. Only when competition from the home screen started taking its toll on box-office receipts did Hollywood begin to tailor their product for such screen processes as 3-D, Cinerama, Smell-O-Vision, and so forth. However, there were some notable special effects productions in the forties despite the fact that only a handful of them featured improvements on existing techniques.

Alexander Korda's remake of Douglas Fairbanks's *Thief of Bagdad* was perhaps the most incredible of these, since it required that every effects process

then extant be made practical in Technicolor. As an industry observer noted at the time, "Tricks in color require more precision than in black and white, for the Technicolor camera is a discerning instrument and faulty composite printing is apparent on the screen." Broadly, four distinct effects techniques

John Justin (left) and Sabu with the huge plaster and canvas hand of the djinn from *Thief of Bagdad*.

formed the basis of the film's impressive visual scope, and were often used in conjunction with one another. There were the glass shots to show such wonders as the skyline of the legendary Arabian Nights city; the miniatures, used to represent an idol hundreds of feet tall, and the skyscraping Temple of the Dawn; the mattes, which sent a wingless horse galloping over glass paintings; and giant props such as a huge hand and foot of the picture's towering djinn. Like Cecil B. DeMille, Korda—producer of *Things to Come*—was an advocate of using special effects to increase the grandeur and wonder of motion pictures. Accordingly, he took no chances with *Thief of Bagdad* and had an expert on hand for every area of production design. William Cameron Menzies was in charge of the art direction and glass paintings. Tom Howard handled the optical work and, indeed, executed the

first traveling matte shots in Technicolor. For *Thief of Bagdad* he did over a hundred such mattes. John Mills supervised the miniatures, replacing Korda's *Things To Come* expert, Ned Mann, who had gone to Hollywood to make movies. And, not surprisingly, the magic in Korda's *Thief of Bagdad* is breathtaking. The picture won that year's Best Special Effects Oscar, defeating such films as *Dr. Cyclops, Typhoon,* and *One Million B.C.* In other years, there is no doubt but that all of the above would have copped the award.

Dr. Cyclops was the brainchild of *King Kong's* co-director Ernest B. Schoedsack. Although Willis O'Brien wasn't on hand to oversee the special effects—there wasn't the money to weather a year of stop-motion photography—Schoedsack had excellent technical support from Farciot Edouart and Gordon Jennings. Edouart was one of the men who,

From left to right: Victor Killian, Janice Logan, Albert Dekker, Charles Halton, and Thomas Coley on the set of *Dr. Cyclops.*

From left to right: Charles Halton, Thomas Coley, Janice Logan, Victor Killian, and Frank Yaconelli with a few of the huge props seen in *Dr. Cyclops*.

in the early thirties, had pioneered the practical utilization of rear-screen projection. Jennings was a brilliant craftsman whose career we will study in chapter 7.

Dr. Cyclops is a madman (Albert Dekker) who, in his Peruvian laboratory, shrinks six visitors to doll size. Like *Thief of Bagdad* the film was shot in color to increase its box-office potential, although the effects work was restricted primarily to static mattes, rear-screen projection, and oversized props. Indeed, like *Lady Nicotine* (1906) and *Devil Doll* (1936) before it, most of the picture's budget went to the building of huge sets, one of which was a re-creation of the near-blind scientist's bedroom *in its entirety*. Other such constructions included Dr. Cyclops's enormous hand and boot, plants, books, chairs, a rifle, and so forth. And although the miniature peoples' encounters with a huge cat, dog, and alligator were made somewhat pedestrian by the limited budget, the film did feature one very resourceful use of rear screen, a shot Schoedsack borrowed from *King Kong*. The scene called for one of the shrunken prisoners to struggle against Cyclops' grip while the latter measured him with a caliper. Dekker and the gauge were enlarged by rear projection, while the normal-sized Charles Halton and a giant prop-hand performed in unison with the doctor's prefilmed action. In *Kong*, the trick had been reversed: Kong was placed before a miniature screen on which footage of Fay Wray and the full-scale ape paw were rear projected.

Somewhat more spectacular, even in black and white, was *One Million B.C.*, the first dinosaur film in seven years. Conceived by D. W. Griffith—who conceded to use special effects since not even *he* could produce a living dinosaur—the epic tells of cavemen who, when they're not having at one another, are busy fighting prehistoric mammals and dinosaurs. Alas, while the film's production values are impressive, the dinosaurs are not. A mastodon was, as the *New York Times* called it, "an elephant in a bright wig," while such distinctive creatures as the ankylosaur and glyptodon were impersonated by their modern-day descendent, in this case the armadillo. Further technical shortcuts saw a stiff, lacquered costume used to portray an allosaur, while the expedience of living lizards ousted the stop-motion monsters that had made *King Kong's* Skull Island so awe-inspiring. Frills and fins were glued to these reptilian performers who, because of a natural lethargy abetted by hot studio lights, had to be cruelly prodded into action by the staff of technician Charles Oelze. Nonetheless, what the picture lacks in common sense and creative precision, it makes up for with enthusiasm. The petty squabbles involving Victor Mature, Lon Chaney, Jr., and the nasty

There is no camera trickery here: Janice Rule is climbing props that were built to scale for *Dr. Cyclops*.

native fauna move with vitality until the film's peak, an awesome volcanic eruption. Lava swallows up extras, earthquakes consume dinosaurs, and the display is easily the highlight of the film. It is, in a word, a brilliant holocaust.

Another catastrophe was unleashed that year in *Typhoon*, the tale of a female Robinson Crusoe (Dorothy Lamour) who, with a stranded pearl diver (Robert Preston), survives the whims and rigors of a harsh tropical island. However, angry natives prove too much for our stars, and the elements must come to their rescue with a storm that includes a gale, mountains of churning water, and walls of fire.

With these films all appearing in 1940, the following years seemed anticlimactic. The sixth film to win the now-annual special effects Oscar was *I Wanted Wings* (1941), a bland Air Force story used to introduce Veronica Lake to the public. Then, in 1942, Farciot Edouard and Gordon Jennings won a much deserved Academy Award for Cecil B. DeMille's *Reap the Wild Wind*. A tale of nineteenth-century ocean-going salvagers, the film featured some remarkable shipwrecks and an exciting fight between John Wayne, Ray Milland, and a giant squid. This monster was the first mechanical sea beast built for a film since 1938. In that fateful year, Warner Brothers had lost a papier-mâché whale that they were mooring in a backlot riverbed. It was washed out to sea during a storm. However, DeMille's cephalopod was not a limited-movement plaster mockup. The creature cost over $11,000 and was made of sponge rubber. Inside the red, ten-foot-long body was a network of hydraulic pistons that activated cables extending the length of the thirty-foot tentacles. The entire system was operated by a twenty-four-button keyboard. The sea creature was positioned in a sunken wreck, and the scene was shot in Paramount's 800,000-gallon tank. To direct the scene, DeMille actually went underwater with his actors, issuing instructions via cables that ran through their life lines.

The years that followed saw *Crash Dive, Thirty Seconds Over Tokyo, Wonder Man, Blithe Spirit* and, in 1947, *Green Dolphin Street* take the Oscar. Cecil DeMille had special effects nominations in two of those years, in 1944 for *The Story of Dr. Wassel* and in 1947 for *Unconquered*, a significant honor when we consider that, by now, the nominations had been pared from ten per year to two. Of course, this precluded the placing of many noteworthy films in the awards race, one of which was the Norman

Taurog production about the development of the atom bomb, *The Beginning or the End* (1947). Stock footage of nuclear tests was of an understandably poor quality, this being only two years after Hiroshima, and would never have held up on the big theater screen. This forced MGM special effects head A. Arnold Gillespie—unable to escape his reputation as a disaster master—to devise a means of creating mushroom clouds in the studio. To create a fitting aura of intrigue around the production, Gillespie's experiments were conducted behind closed doors, which naturally prompted unit publicists to call it "a veritable Manhattan project of its own." In fact, however, the special effects man was toying with substances no more volatile than H_2O. He was busy pouring various powders and liquids into a tank of water in such a way as to form upside-down mushroom clouds. After weeks of experimentation, he was able to duplicate the New Mexico Alamagordo detonation with dyes, but found the Nagasaki blast more taxing. He captured the nuclear test in three takes, but repeated the Japanese explosion twenty-five times before he was satisfied. Finally, however, with seven weeks of work behind him, Gillespie had his megaton displays in the can and superimposed them over the necessary background to gripping effect. Viewing the film, Col. Charles Sweeney, the man who dropped the bomb on Nagasaki, was moved to comment, "I don't know how you did it, but that is what I saw from the plane."

As if typhoons and atom blasts were insufficient to supplement the filmgoing diet of the disaster-filled forties, *Gone With the Wind* producer David O. Selznick stirred up a tidal wave for the climax of his fantasy romance *Portrait of Jennie* (1948). This was the field's next Oscar-winner, although the dazzling finale points up an interesting fact about the use of special effects to *support* or simply *flavor* a film. First of all, Selznick spent a quarter of a million dollars on the brief sequence, using all the techniques at his disposal to make it realistic and terrifying. He succeeded. What separates *Portrait of Jennie* from the equally stunning *Typhoon* or *Hurricane* is that, at long last, audiences had *more* than magnificent visuals to enjoy. The storm wasn't a contrivance, an easy means to resolve what had gone before; it was announced far in advance of the climax. The ghost of Jennie (Jennifer Jones) is fated to repeat the accident in which she drowned during a coastal storm. Her lover, played by Joseph Cotton,

Ernset B. Schoedsack, Merian C. Cooper, and Willis O'Brien seated from left to right on the set of *Mighty Joe Young*. Actor Ben Johnson is directly behind them.

hastens to her rescue, but is doomed to fail. Thus, as a confluence of *both* the pictorial and dramatic high points of the film, this was a dramatic break with the past. Too, the players went to meet the storm, which made their destiny a romantic and personal tragedy. This is quite unlike the earthquake or volcanic eruption where everything, problems, characters, and city, are done away with in one, impersonal fell-swoop. Clearly, though, special effects man's Clarence Slifer's pictorial eloquence was not asked to support the climax single-handedly, which is as it should be.

The next year, 1949, was a landmark year for stop-motion photography. Not only did *Mighty Joe Young* win Willis O'Brien a special effects Oscar, but it introduced the name of Ray Harryhausen to theater-goers. Thirty years later, Harryhausen has become a living legend, perhaps the most respected and individualistic name in the history of motion picture special effects. Since chapter 6 is dedicated to Harryhausen's career, suffice it to say that the

twenty-nine-year-old model animation buff received his most important tutelage under Willis O'Brien on this film.

O'Brien and Merian Cooper had intended to collaborate on many pictures after the completion of *Last Days of Pompeii* in 1935, but such projects as *War Eagles*, about giant birds attacking New York City, and *Gwangi*, the tale of a tyrannosaur captured by cowboys in the American Southwest, were never to be. The war caused studios to be extremely selective about their properties, and executives were reticent to invest a year and nearly a million dollars in *any* production, let alone a fantasy film. However, when the conflict was over and backers could once again count on the vital European box office, Cooper and O'Brien were allowed to return to Kong territory. This time the monkey was Joe Young, a gorilla content to obey rather than dominate his leading lady, Terry Moore, who had raised him from babyhood. The African pair is brought to Hollywood where, after seventeen weeks in a spectacular nightclub, Joe breaks free. Although the police try to shoot him, the "good" ape rescues a

Mighty Joe Young is fed liquor by a trio of drunks . . .

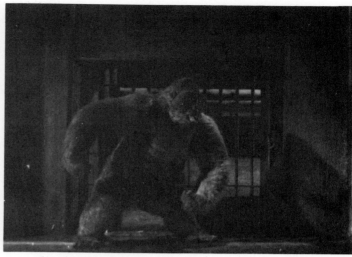

. . . and, inebriated, breaks from his cage.

baby from a burning orphanage and is allowed to return with his mistress.

Mighty Joe Young gave O'Brien ample opportunity to show off the dazzling potential of the stop-motion camera. In terms of personality, Joe exhibited a wider range of emotion than his human co-stars. Especially versatile were expressions that O'Brien and his team worked from the ape's face. Much of the credit for this must go to Marcel Delgado, who constructed four identical and incredibly realistic monkey models by molding dental dam, cotton, and foam rubber atop technician Harry Cunningham's metal-jointed skeleton. Taxidermist George Lofgren gave Joe his rubberized fur. And, although Harryhausen did eighty percent of the animation, it was O'Brien who planned and supervised the many intricate set-ups. These included scenes of cowboys trying to lasso Joe in Africa, where they had been sent to capture animals for the Golden Safari Club. Obviously, live actors cannot rope a foot-high stop motion model. Instead, they were simply roping a tractor that was roughly the size of the ape. Back in the special effects studio, the model's body blocked this edifice from the camera during miniature screen projection and animation. Miniature "ropes" were tied to the ape and carefully positioned so that, to the two-dimensional lens, they appeared to be continuations of the cowboys' lariats. In some of these shots, O'Brien went so far as to animate model horses and riders. A case in point is when Joe was struggling with a live, miniature projected antagonist and a stop-motion cowboy galloped quickly between the ape and the camera.

This created both a sense of depth and realism: O'Brien gave us the impression that Joe was being hounded *and* surrounded by presenting other than straight forward long-shots. But men and their mounts were not the only stop-motion support Joe received. Later, as the gorilla runs amok in the nightclub, O'Brien had him tangle with lions that had escaped from decorative dioramas. The stop-motion creatures, built to scale with the foot-high model of Joe, were seven inches long. These beautifully animated scenes were skillfully laced with shots of real lions running loose on the nightclub set, which made for many dramatic close-ups.

Superb though these two sequences are, the highlight of the film is the orphanage fire. Flames, of course, cannot be animated, so O'Brien had Joe perform his heroics before miniature screen projected footage of a burning orphanage model. Ledges on the miniature set were carefully matched to projected portions of the burning building, while shadows of the flames were cast on Joe by stencils rotated a frame at a time before studio lights. In each case, these scenes had to be carefully planned since several steps went into the production of every shot. For instance, in certain set-ups, actors would perform against rear-screen flames, after which this footage was miniature projected and rephotographed adding Joe to the picture. Brilliantly conceived mattes and split-screen effects were also employed to put people and stop-motion models in the midst of the inferno.

After *Mighty Joe Young*, O'Brien and Harry-

Ray Harryhausen animating *Mighty Joe Young*. The small metal gauge in front of Joe is to assure that his eyeline remains constant throughout animation.

hausen were to collaborate on *Valley of Mist*, the story of dinosaurs discovered alive in Mexico. Once again, after six months of preproduction work had gone into the project, it was abandoned. Harryhausen became involved in his own projects, while O'Brien made four more films: *Animal World* (1955) with Harryhausen, *The Black Scorpion* (1957), *The Giant Behemoth* (1958), and a color remake of *The Lost World* (1960). This last film, for producer Irwin Allen (*The Poseidon Adventure, The Towering Inferno*), used lizards instead of stop-motion monsters, and had to be a painful experience for the master animator. Two years later, while working on the special effects for Stanley Kramer's Cinerama film *It's A Mad, Mad, Mad, Mad World*, the seventy-six-year-old Willis O'Brien died of an heart ailment.

A far cry from the jungles of *Mighty Joe Young* was the biblical splendor of Cecil B. DeMille's *Samson and Delilah* (1950). Unlike the producer's previous period epics, *Samson and Delilah* boasted a poor script and colorless performances. However, it did feature a stunning re-creation of Samson's bringing down of the temple at Gaza. As with the barge in *Cleopatra*, the term *miniature* is hardly applicable to this spectacular set. Built at a cost of $30,000, the temple stood eighty feet square and sixty feet high. Lodged in one wall of the structure was a forty-foot-tall statue of the deity Dagon. It was this icon that Samson caused to topple and crush the collected hosts of his enemies. One must suspect, however, that the Old Testament hero had an easier time felling Dagon than did the special effects crew at Paramount. They had set small charges of TNT in the idol's base, which were detonated from a nearby control board. Five cameras were filming the scene at high speeds when the dynamite went off. Unfortunately, the blast failed to dislodge the statue completely. The figure wobbled, tipped over, and finally came to rest against a shoulder of the wall to its right. Hardly the destructive display called for in the script! Luckily, DeMille understood the problems one encounters with this kind of effects work and loosed up $15,000 to rebuild the set. The next time around, Dagon was destroyed as planned. However, it is quite inexplicable how DeMille, who demanded perfection in this climactic show of Samson's might, let a glaring technical mistake work its way into the finished film. When the Danite superman grabs an attacker by the wrist and swings

Ray Harryhausen and one of the four models of *Mighty Joe Young*.

him above his head, the wire that was holding him aloft is plainly visible. This slip-up was insufficient to keep the film from grabbing one of the two nominations for the special effects Oscar of 1950, although it lost to *Destination Moon*, a modest effort from an unassuming new feature film producer named George Pal. We will look at both the picture and the career of this noted filmmaker in chapter 7.

DeMille followed the hugely profitable *Samson and Delilah* with *The Greatest Show on Earth* (1953) for which he totally demolished two miniature circus trains in spectacular fashion. After this, the filmmaker produced what would be his last motion picture, a remake of *The Ten Commandments* (1956). Although this retelling of the story of Moses is better than *Samson and Delilah*, it is still a flawed, technically spotty motion picture. Certainly the film did little to justify DeMille's reputation as the master of the film extravaganza.

Three huge scenes highlight *The Ten Commandments:* the building of the city of Goshen, the exodus from Egypt, and the parting of the Red Sea. Only the exodus was "authentic," executed with eight thousand extras and full-scale sets. The Pharaoh's city of Goshen, raised on the broken bodies of slaves was, in fact, a miniature set raised by the hardy staff of John P. Fulton and matted to location footage taken in Egypt. Even the dramatic focal point of this sequence, the erecting of a huge obelisk, was filmed primarily with models. Like the *Samson and Delilah* miniatures, these sets were built on a rather large scale, and would have been acceptable had the mattes been executed with some precision. But poor registration between the background and foreground elements, when run through the optical printer, caused the ever-present nemesis known as the *matte-line:* a composite image in which the opaque matte overlaps the edges of the foreground image, causing it to have a thick outline. This was especially obvious in shots of the slaves hauling a huge statue of the Pharaoh Sethi (Sir Cedric Hardwicke) through the city. The sculpted figure was a miniature that, again, through faulty matting, had heavy black lines around it and was seen to jiggle on the life-size cart.

Worse than these infractions, however, was the Pillar of Fire and subsequent parting of the Red Sea. Advertised as "The Single Most Spectacular Sequence Ever Filmed!," it most certainly was not. Ironically, DeMille *builds* the scene with supreme skill. The Hebrews are resting on the shores of the

The closing of the Red Sea from *The Ten Commandments*. This scene was executed with considerably more care than the parting. Only faint matte lines are in evidence, around Yul Brynner's arm and on the outcropping of rock on which he is standing.

sea, with Joshua (John Derek) and Caleb (Lawrence Dobkin) standing watch on the periphery of the encampment. The two guards hear the distant pounding of hooves and realize that the Pharaoh is coming to recapture his erstwhile slaves. The sentries run to alert Moses (Charlton Heston) who calmly tells them to gather the people together. De Mille then cuts to Pharaoh (Yul Brynner) who halts his chariot to observe, "The God of Moses is a poor general, to leave them no retreat." The viewer, of course, knows better, and is looking forward to seeing the cocky potentate humbled. He advances his forces while Moses tells his own people that they should, "Fear not. Stand still and see the salvation of the Lord." With the audience at a fever pitch, filled with anticipation for the promised wonders, De-Mille drops his first bombshell. The snaking, cyclone of flames created by Moses is an animated cartoon. Although the superimposition is flawless—there was no need for a matte, since fire is supposed to be transparent—this cartoon is *not* a Pillar of Fire. Hopes for an effective parting of the sea begin to fade. Back at the edge of the water, matte lines have surrounded the Hebrews since the sea is actually a studio tank. Moses takes to a promontory and is chastised by the people. They want to know what he intends to do when the fire dies down. With the clouds gone suddenly black and rolling dramatically about the rear projected sky, Moses exclaims that, "The Lord of Hosts will do battle for us. Behold His mighty Hand!" The clouds form a funnel, and drill into the sea. Waves appear, they begin to heave, and suddenly matte lines abound! A new pictorial element sweeps across the

picture: the prefilmed dumping of over 300,000 gallons of water into twin waterfalls which, when printed in reverse, give the illusion of the waters opening up. Matted over the tank footage, the waters part and the clear sea-bottom is matted into their midst. Of course, the sea didn't actually *part* as much as it *tore* awkwardly down the middle. Thus, despite the precision tooling of every element from music to costumes to drama, the scene falls flat. Indeed, over a half-century later, DeMille's first encounter with the Red Sea remains the better of the two.

Somehow, *The Ten Commandments* won the special effects Oscar over the infinitely superior *Forbidden Planet*. *Forbidden Planet* was Hollywood's first try at an expensive science fiction film. The fifties was an era littered with cheap, spurious pictures that capitalized on either the Red scare, the bomb scare, or fear of what man might uncover in outer space. While some of these pictures, like *The Thing* (1951) and *This Island Earth* (1955), were adult and well produced, most were not. And certainly none was as spectacular as *Forbidden Planet*. Filmed in the ultra-widescreen Cinema-

A frame blow-up of the monster from the id as seen in *Forbidden Planet*.

Scope process, the film was set on the world of Altair-Four and pit a crew of earthmen against an invisible monster from the id. Born of one man's subconscious hatred for those who have come to inhabit a world he colonized, the monster drew substance from power sources deep within the planet, remnants of a civilization long-dead at the hands of their *own* subconscious monsters. One scene in particular featuring the monster is nothing short of awesome. The spacemen have built an electric fence around their ship to keep the invisible beast from sneaking up on them. When the monster finally attacks, he is caught in the beams and his crackling outline, that of a huge, lionlike creature, becomes visible. The monster picks up men in its mighty paws and hurls them through the air before vanishing at the summons of its host. The creature itself was created and drawn by Walt Disney artist Joshua Meador, and the cartoon footage was superimposed on the desolate alien set in an optical printer. Scenes where the men were lifted bodily by the monster were done with careful coordination of the animated nightmare and stuntmen suspended by wires. As with the Pillar of Fire, no mattes were necessary since the beast was transparent.

Another of *Forbidden Planet's* twists on an old special effects standby was when the ship's commander, J. J. Adams (Leslie Nielsen), was forced to shoot a tiger with his ray gun. Eons before, the aliens had brought samples of earthly life-forms to their world, but the animals have grown suddenly hostile. The feline leaps from a cliff at Adams and is vaporized. The trick was accomplished with a very simple split screen. Actor Nielsen was photographed with one side of the lens masked. The film

Anne Francis and a crewmember with the Robby the Robot costume from *Forbidden Planet*.

was then rewound and the lens cover flopped. When the feline jumped, it vanished behind this mask. The composite, then, showed the animal disappearing into thin air when it reached the middle of the picture. To get the vapor effect, Meador enlarged every frame of this footage and drew a realistic cartoon animation of the tiger disintegrating as it entered Nielsen's portion of the frame. The animation was combined with the split-screen footage in an optical printer, with the effect that the tiger progressively evaporated from head to tail as the ray beam struck.

During this period of the science fiction boom, there were, in addition to Harryhausen, Pal, and another filmmaker whom we will discuss in chapter 7, Walt Disney, two prolific centers of special effects oriented production. One was the Toho Studios in Japan, and the other was the work of American moviemaker Bert I. Gordon.

In 1954, the Japanese released a film entitled *Godzilla*, and it was a huge box-office success. Godzilla was a dinosaur roused from millennia of hibernation by the Bikini bomb tests. Effecting a metaphoric re-creation of Hiroshima and Nagasaki, the mindless behemoth with radioactive breath razed Tokyo. Although the monster had none of the personality found in O'Brien's creations, this worked to its favor. Godzilla comes across as a mindless engine of destruction, supported by superb special effects. Godzilla was a man (Haruo Nakajima) in a rubber monster suit, filmed at high speed to give him bulk and to cause collapsing miniature buildings to crumple in slow motion. For extreme long-shots of the monster's onslaught, a foot-high mechanical model and hand puppet were both used. This enabled a panorama of the ruined

The late, legendary Toho special effects genius Eiji Tsuburaya, here instructing his monster actor how to level a building. Note Tsuburaya's assistants as they prepare the Angorous costume in the background. From *Gigantis, the Fire Monster* (1959).

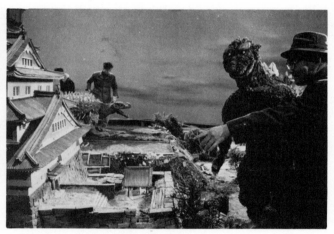

Eiji Tsuburaya on the set of *Gigantis, the Fire Monster*.

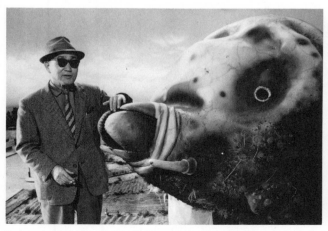

Tsuburaya with the model of his monster caterpillar known as *Mothra* (1962).

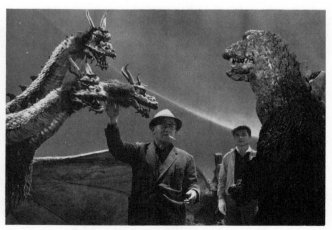

Tsuburaya checks the Godzilla (right) and Ghidrah costumes on the set of *Ghidrah, the Three-Headed Monster* (1965).

city to be built on a scale of 1/15″ to the foot rather than 1/3″ to the foot. The creature's incendiary ray was created, for close-ups, by forcing steam through the mouth of the mechanical Godzilla. Long-shots featured cartoon animated beams superimposed over the live actor.

Godzilla spawned over twenty sequels or companion films. The special effects in these were all created in much the same fashion, and were spearheaded until his death in 1973 by Eiji Tsuburaya. However, by the time Godzilla tangled with a man in a monkey costume for *King Kong vs. Godzilla* (1963), the high-speed photography was gone. A costly process requiring high intensity lighting, it was something these monster movies could no longer afford. Thus, the creatures moved at speeds normal for human mass and ended up looking rather ludicrous. Gone, too, were the careful low-angle shots that had given the monsters a profound sense of giantism. The films subsequently fell prey to tongue-in-cheek slapstick, and the skillful illusions wrought for *Godzilla* became naught but a fond memory.

On another front, it is quite possible that, during 1957–58, Bert I. Gordon made more motion pictures than any other filmmaker in history. Among his many efforts were *The Cyclops* (1957), *The Amazing Colossal Man* (1957), *Beginning of the End* (1957), *War of the Colossal Beast* (1958), *Attack of the Fifty Foot Woman* (1958), and *Attack of the Puppet People* (1958). On most of these films Gordon served as director, producer, scenarist, and special effectsman. What is interesting—indeed, admirable—about Gordon is how he was able to turn extremely low-budget fare into goldmines by exploiting camera magic in *theory* if not in *practice*. A seeming paradox, this public relations aspect of moviemaking is crucial to the industry. Through

Behind-the-scenes on William Cameron Menzies' *Invaders from Mars*.

THE WORLD'S BIGGEST SENSATION!

ATTACK OF THE 50 FT. WOMAN

starring ALLISON HAYES · WILLIAM HUDSON · YVETTE VICKERS

Produced by BERNARD WOOLNER · Directed by NATHAN HERTZ · AN ALLIED ARTISTS PICTURE

An example of the provocative advertisements used by Bert I. Gordon to lure patrons into theaters.

The leader of the *Invaders from Mars* (1953). The domed head and body were sculpted; the tentacles were wire-operated.

A matte shot from Bert I. Gordon's *The Spider*. The people, cars, and buildings are real; the spider and the buildings behind him are less than two inches tall. Unfortunately, the matte is flawed: a black matte-line can be seen where the spider is passing behind the structure on the corner. Too, the matte cuts into the roof of the car, just above the door on the passenger's side.

dramatic newspaper advertisements, Gordon capitalized on the known ability of film to work technical wonders, although he seldom delivered the goods. His monsters were generally oversized men or women double exposed against a prefilmed background. This rendered them *literally* transparent, but it provided Gordon with very marketable, if not very *good*, motion pictures. And these commercial properties did, indeed, pack theaters with kids who were not so discriminating about the quality of their special effects. Even if they *did* shout "Fake!" at the screen, and toss popcorn at the Fifty Foot Woman, they were having a good time and would come back for more. For our critical purposes, however, the pictures show a remarkable dearth of initiative. Only on rare occasion did Gordon use a matte or place his monster performer

in a scaled-to-size set. Indeed, many of these films featured incredible blunders that illustrate the haste with which they were made. For example, *Beginning of the End* is the story of grasshoppers grown huge by scientific experiments. In one scene, the giant bugs crawl up the side of a Chicago office building. The effect is marginally convincing until one of the insects crawls from the structure onto the sky. The camera witlessly follows its progress, and we see that the building was simply a photograph filmed horizontally. Gordon's shortcuts also hampered the dramatic latitude of his visuals. In *The Cyclops*, the tale of a flier downed in a radioactive field and mutated to Odyssean proportions, the creature reaches into a cave to grab his one-time fiancée. In a long-shot, she is seen standing and screaming while the Cyclops' hand wraps around her waist. The shot ends, the camera angle is changed, and the monster lifts a lifeless doll into the air. The first shot had used depth perspective to show giantism, with the girl in the background and the monster's hand only inches from the lens. While

there is nothing wrong with this process, per se, it was inappropriate here. Unlike *King Kong* or *Mighty Joe Young* where, using stop-motion figures of human beings, the grabbing and raising action were accomplished in single takes, the sudden substitution of an unmoving doll for the girl destroyed whatever credibility the scene might have had. It *looked* like a staged special effect that, as we noted in the Introduction, defeats the entire purpose of creating illusions for the screen.

One of the most popular motifs within the science fiction genre was the recurring giant insect. Beyond the locusts in *Beginning of the End,* other film-bugs of this period included *Them!* (1954), *The Tarantula* (1955), *The Spider* (1957), and *The Deadly Mantis* (1957). Each picture had its own method of creating monsters. For example, *The Tarantula* and Bert Gordon's *The Spider* both featured live arachnids. *The Tarantula* used superb matte work to enlarge its creature, while the Gordon monster was magnified by split screen and miniature projection used in conjunction with small sets. The Oscar nominated *Them!* and *The Deadly Mantis* were both mechanical models. However, while the mantis was only several feet in length and operated by overhead wires, most of the giant ants in *Them!* were full-sized. They were run by complex wire and tackle mechanisms both within and without the creatures, harking back to the grand days of *Der Nibelungen* and its incredible dragon.

Beyond applying their skills to science fiction, Hollywood's technical wizards spent a good deal of time in the fifties fighting a strange war. By 1952, film attendance had dropped from 76,000,000 to 50,000,000 per week, and producers blamed this on the competition from "free" home television. Thus, studios ordered their magicians to come up with gimmicks that would get people back into the theaters. Ironically, the financing for these experiments came from selling old films to television. The natural first step was to do something special with the projected picture itself. Although there had been experiments with wide-screen processes in the twenties, thirties, and forties, it wasn't until September 30, 1952, that the first really successful format was made available to the public. That was the day Fred Waller, Merian Cooper, and Lowell Thomas premiered Cinerama. Cinerama was an instant sensation, for it literally surrounded the viewer with sight and sound. Three 35mm projectors running simultaneously created a screen image which enveloped 146° of the viewer's 180° range of vision. With eight-track stereophonic sound, and the utilization of peripheral vision, Cinerama created a unique sense of audience participation. The first Cinerama film, a travelogue entitled *This is Cinerama,* ran for over two years on Broadway, and was followed into release by such films as *Cinerama Holiday* and *Seven Wonders of the World.*

The problem with Cinerama, of course, was that not only did theaters have to be completely remodeled to accommodate the huge, curved screen, but they had to bear the expense of installing and running three projectors from three booths in back of the theater. In this respect, both 3-D and CinemaScope offered a distinct commercial edge. 3-D had its debut on November 27, 1952. The film was Arch Oboler's *Bwana Devil,* and it thrust lions and spears into the laps of theater-goers. It did this by photographing its images with two cameras that corresponded to the position of our own right and left eye. In the theater, the pictures, printed on one strip of film, were thrown on the screen. In front of the lens were two polaroid filters. One filter passed the light waves vertically to the screen; the other horizontally. The picture arrived in a jumble and bounced into the theater. However, viewers who were wearing corresponding polaroid glasses were able to see the horizontal image in one eye, and the vertical picture in the other eye. Since these had been photographed in such a way as to simulate human stereovision, the bespectacled theatergoer saw the unscrambled picture in the same perspective, or in 3-D. Unfortunately, while hordes of the curious flocked to theaters to see *Bwana Devil,* 3-D proved to be a flash in the pan. Whether the novelty was good for a once-only experience, or the public felt inconvenienced by having to wear the special glasses, they abandoned the process and it was generally extinct by 1954. CinemaScope, introduced in 1953, had a longer life. When the CinemaScope image was photographed, it was squeezed vertically to fit on one strip of 35mm film. In the theater, a special anamorphic lens stretched this back to its almost 3:1 ratio, and audiences had a huge screen picture without the three projector Cinerama system.[12] While CinemaScope could not cover the 146° of Cinerama, due to the range of the latter's three projectors, which allowed for a deeper screen and crisper image, audiences in the smaller towns, where Cinerama was inaccessible, didn't seem to mind. They liked the sweeping image that

CinemaScope offered. Heartened by improved box-office figures, studios rushed out with duplicate processes, such as Todd-AO in 65mm, Camera 65, CineMiracle, and others. CineMiracle, incidentally, was Cinerama's only direct competition, a three-projector system that bounced its images off mirrors, thus eliminating the need for three *booths,* although not three projectors. Thus, only one operator was necessary. However, after one film, *Windjammer* (1955), the process disappeared.

Ultimately, of course, the market became saturated with huge, often grotesque images. Even filmmakers were annoyed with these giant pictures, since it was extremely difficult to position actors for an aesthetic composition. Director George Stevens (*Shane*) complained of *CinemaScope* that it "pictures a boa constrictor to better advantage than a man." Producer Samuel Goldwyn concurred, adding, "The only important dimension is the story." Not surprisingly, by the mid-sixties most of these processes had become relics of the past and, in 1970, even the durable old Cinerama, with its new one-projector system, went the way of the dinosaur.

Studios learned that the answer to surviving the challenge of television was to join the enemy camp by leasing studio space to television producers, selling old films to the network, upping prices at the box office, and keeping closer watch of the monies being spent on new films. In the main, this was the beginning of the situation that exists to this day, where the film industry is ruled by businessmen who are simply serviced by the creative filmmaker. Yet, even in this miasma of dollars and directorial depression, there are a handful of independent filmmakers who manage to make their product distinctive regardless of fiscal pressures. Stanley Kubrick, Francis Ford Coppola, and Alfred Hitchcock are names that come immediately to mind; Ray Harryhausen is another. With a budget large or small, or a plot that is trite or adult, Harryhausen's work is among the most fascinating in the industry. This is all the more remarkable when one considers that Kubrick and the others are directors; Ray is a special effects man. Clearly, his career deserves our closest attention!

6

Ray Harryhausen

3-D animation must be an art: a creation of something out of nothing; a projection for an hour and a half of pseudo-reality of the most bizarre stretches of the imagination; the injection of the illusion of life into the basically inanimate.

—Ray Harryhausen

While this struggling for entertainment supremacy was going on, a few filmmakers were comparatively unconcerned with the problem. Men like Pal, DeMille, and Harryhausen were already giving the public the kinds of movies that were beyond the scope of television.

Ray Harryhausen was born in 1920 and first saw *King Kong* when he was thirteen. This film fired his imagination, and the young boy began sculpting monster masks and drawing dinosaurs. Indeed, Ray's lifetime friend, author Ray Bradbury, recounts in his Introduction to Harryhausen's *Film Fantasy Scrapbook* (A. S. Barnes, 1973) that when they were both in their teens, "Ray and I went to an All Hallows Midnight Show at the Paramount Theatre in Los Angeles to see Bob Hope in *The Cat and the Canary,* and in the middle of the show I put on a Harryhausen mask and caused the people in the seats in front of us to jump a foot." This mask, as Bradbury describes it, was a "pure green horror."

When he was seventeen, Ray got his hands on a 16mm camera and started experimenting with various special effects scenes reminiscent of *King Kong.* Although the camera was not equipped to release only one frame at a time, Ray very carefully approximated the exposure and achieved some very impressive results. His first footage was that of a prehistoric bear. This creature had a wooden skeleton about which Ray had stretched his mother's fur coat. After stretching *Ray* over a wooden skeleton, Mrs. Harryhausen forgave him. The model *was* magnificent, and the processed film was even better. Unfortunately, this reel, along with the camera on which it was shot, was soon thereafter returned to the friend from whom Ray had borrowed it, and his first animated movie is lost to us forever. However, the remainder of his films survive. Indeed, a subsequent effort showed this same bear

lumber from its cave, go poking about some foliage into which Ray has matted himself and his dog Kong, and return to its lair. A stegosaur was his next subject, followed by test scenes featuring a triceratops and an agathaumus. These latter creations boasted Ray's first metal armatures.

The young animator's next film featured an allosaur that grabs a stop-motion model of Harryhausen by his arm and, while the poor fellow is convulsed with agony, proceeds to devour him. While one might be tempted to conclude that Ray took sadistic delight in such scenes, it should be pointed out that they provided an interesting challenge, the effective communication of pain. Understanding the movements involved enabled Harryhausen to increase the expressiveness of his models. The fact that his *people* were the ones to suffer rather than the monsters may be seen, not unfairly, as Ray's retribution for what mankind had done to King Kong.

After his tyrannosaur reel, Ray created a tentacled beast from Jupiter—his favorite of these early animated monsters—which, in different adventures, tangled with a pesky spaceship, a brontosaur, a monoclonius, a nosy Harryhausen, and a beautifully sculpted mastodon covered with goat's hair. By this time, of course, Ray had obtained a stop-motion camera and was busy refining the movements of his monsters. This growing proficiency, compounded by his mounting skill in creating realistic monsters, striking backdrops, effective glass paintings, and surprisingly effective mattes, led, in the early forties, to Harryhausen's undertaking a "feature-length" spectacular known as *Evolution*. A great deal of work went into this documentary of life in the Mesozoic age, but it was abandoned after a year when Harryhausen was offered a job by Uncle Sam. Ray spent the next three years in the Army Signal Corps, after which he returned to Los Angeles and produced a series of four two-minute fairy tales. These included *Little Miss Muffet, Old Mother Hubbard, The Queen of Hearts,* and *Humpty Dumpty*. Upon completing these, he strung them together with a framing story featuring a stop-motion Mother Goose. Thus, *Mother Goose Stories* was the first of Ray's five famous ten-minute fairy tales. It was followed by *Little Red Riding Hood,* with narration written by Harryhausen's future story collaborator, Charlott Knight, *Hansel and Gretel, The Story of Rapunzel,* and *The Story of King Midas*. Ray began a sixth film, *The Tortoise and the Hare,* but it was never completed. These films remain in release, after thirty years, and are popular features in schools and libraries the world over.

During this period, Harryhausen also worked for George Pal on the Puppetoons, which we will discuss in chapter 7, but his heart was in feature-length fantasy films. Thus, in 1946, after showing his work to Willis O'Brien and Merian Cooper, Ray gained a position on *Mighty Joe Young*. As we mentioned earlier, the twenty-six-year-old Harryhausen did almost eighty percent of the film's animation, during which time he made an interesting discovery about the nature of his chosen profession. As Ray wrote in *Film Fantasy Scrapbook,* "I had my favorite model of the four. It was the only figure I really felt at home with and which I could successfully manipulate into the many complicated poses I visualized in my mind. It is really quite fascinating how one can become attached to a mass of metal and rubber. It may be that it was all in my own mind, but there was something about this one model that seemed to reflect the very essence of gorillahood. As incredible as this may seem to the layman, this can make all the difference in maintaining character values and their corresponding harmonious action patterns."

After *Mighty Joe Young,* Ray did some preproduction work for O'Brien on the ill-fated *Valley of Mist,* after which he was introduced to producer Hal Chester. Sensing a fast profit in the genre, Chester was interested in making a monster movie, and Ray suggested a film version of Ray Bradbury's short story *The Beast From Twenty Thousand Fathoms* (later retitled *The Fog Horn*), which had recently appeared in *The Saturday Evening Post*. The original tale told of a dinosaur that rose from the ocean in answer to the call of its "mate": a lighthouse. Using this as a springboard, Ray devised a unique sequence in which the monster responds to the tower's cry and, no doubt confused by this nonsaurian pretender, rips it to pieces. Ray drew storyboards illustrating this and other scenes and Chester was impressed. He bought the Bradbury tale and commissioned a screenplay.

The storyline of *Beast From Twenty Thousand Fathoms* established the format for almost every monster-on-the-loose film to follow. In fact, the story of *Godzilla* was lifted almost directly from this scenario about a dinosaur roused from eons of sleep by an atom bomb test in the Arctic. The creature, a fictitious rhedosaur, makes its way south, stopping

The *Beast from Twenty Thousand Fathoms* comes ashore in New York. The foreground elements are a part of the miniature set; the Brooklyn Bridge and river are rear-projected.

along the Canadian and New England shores to trample coastal villages underfoot. As it develops, the monster is heading for the Hudson River submarine canyons where, according to Cecil Kellaway's delightful paleontologist, the only known fossils of the creature have been found. The Beast, however, is not yet ready to die. It comes ashore and, while razing Manhattan, is met by the Army. Bazooka fire wounds the animal whose blood, it develops, is the harbinger of a prehistoric disease against which our systems have no immunity. Thus, a means is sought to destroy the monster without spilling its blood. Ironically, it is the science that "created" the creature that also destroys it. Wreak-

A front-screen shot from *Beast from Twenty Thousand Fathoms*.

ing havoc at the Coney Island Amusement Park, the Beast is shot with a radioactive isotope and is poisoned to death in a matter of minutes.

The fact that the rhedosaur manifested a cold, reptilian air severely hampered any attempts Ray made to evoke sympathy from the audience. Too, the Beast destroys the lighthouse, fishing boats, a diving bell, and New York City with a disturbing lack of purpose other than to create an awesome hail of destruction. There's nothing wrong with this, since we must recognize that the film was created to showcase this decimation and not to explore the character traits of a rhedosaur. However, realizing that the death throes of any living creature are a pitiable sight, Ray managed to end the film with a large dose of pathos. The monster is shot and bursts through the roller coaster to the beach. Roaring painfully, it crumples in a heap, tries to rise, but cannot. Bellowing a tragic roar at the night sky, the one-time lord of the earth falls dead. Of course, Ray was *considerably* less merciful with his human players. One of the film's little "Harryhausenisms" has a police officer open fire on the Beast as it marches down Wall Street. The monster clamps its jaws on the young man in a close-up—via matte, with the actor drawn aloft by wires—and, in a long-shot, gulps down the wildly kicking stop-motion patrolman. Whether or not Ray was still avenging Kong or simply creating a very commercial bit of grotesquery, this snacking scene did not help make the monster more sympathetic!

Personality aside, the film was a remarkable debut for Harryhausen as a solo artist. The picture's entire budget was $200,000 which, you will recall, is one-third what it cost to make *King Kong* some twenty years before. Keeping this in mind, the spectacular quality of the film's effects are amazing. To create the jungles of *Mighty Joe Young*, Harryhausen and O'Brien had done glass paintings used in conjunction with miniature projection. However, the cost of this set-up was great which made its use in *Beast From Twenty Thousand Fathoms* prohibitive. Thus, Ray had to find new ways of placing his monster model in real settings. He did, of course, use straightforward miniature and rear-screen work along with scale models. The roller coaster, for instance, was a miniature, as were many of the city streets. The monster's first appearance, to a startled Paul Christian on an Arctic studio set, was rear projected. However, these processes were of no use when Ray wanted his monster to pop from

The miniature lighthouse destroyed by the *Beast* from *Twenty Thousand Fathoms*.

between two buildings with people rushing madly about. Thus, Harryhausen created his composite by combining the static matte with a technique known as *front-screen-projection*.

Although front-screen projection had been around since 1942, it was not widely used until the mid-sixties, when Stanley Kubrick refined the process for color and used it extensively in *2001: A Space Odyssey* (1968). To create a front screen projection, the projector and camera are arranged so that they are each resting on different bases of a right angle, pointing toward the vertex. A two-way mirror is placed in front of the camera, with one edge on the vertex of and bisecting the angle. In the distance, beyond the two-way mirror, a highly reflective screen made of millions of small glass beads is positioned perpendicular to the optical axis of the camera. The model and miniature set are placed on the table-top before this screen. Background footage is then projected on the reflective side of the mirror and is bounced onto the screen. However, since the mirror's surface is transparent from the camera's point of view, it sees through it to both the prefilmed background and the model. There is no problem with the model casting a shadow on the screen or reflecting the projected image itself, since the light is not strong enough. Only the glass beads reflecting the projection make it seem to be intense. The advantage of this process over rear-screen projection is that, since the image is bouncing *from* rather than being passed *through* a screen, it is less dispersed, and is therefore in stronger and sharper focus. The next step is to add the foreground element: in this case, the building from behind which the monster is to step. Before the camera

starts rolling, a white, highly reflective matte board is placed close to the screen, between it and the mirror. If there is a building on the background film that the animator wishes to place in *front* of his model, he simply cuts the matte to the shape of the structure. When he flicks on the projector, the two-way mirror bounces the image on both the matte board and the screen, with the monster sandwiched between them. The animator then films the set-up as he would any stop-motion project, advancing his projector one frame, manipulating the model, and exposing a frame of film. A common variation of this process is to substitute a slide for the front-projected film, matting the crowds of people in when the monster and city have been composited.

In addition to the front-screen static matte system, Harryhausen used a form of double exposure in at least one sequence. He did this to create a foaming, sudsing effect as the monster rose from the sea to lunch on a small fishing vessel. The ocean was real, with scenes of the beast and ship added through a variety of superimposition methods. Shots of the frothing whitecaps in the creature's wake were photographed separately and combined with the monster footage in an optical printer. This is a process Harryhausen would also use in his next picture, *It Came From Beneath the Sea* (1955).

When *Beast From Twenty Thousand Fathoms* proved to be the surprise moneymaker of 1953, another young producer, Charles H. Schneer, got in touch with Harryhausen to help him make a monster movie. Schneer wasn't sure what he wanted: all he knew was that, as *King Kong* had exploited the newly completed Empire State Building in 1933, *he* wanted to destroy the recently erected Golden Gate Bridge. Although intrigued, Ray was reticent to work on the new film. What he really wanted to do was complete *The Tortoise and the Hare*. However, there was no denying the challenge of this new project, and Harryhausen agreed to do it.

As in *Beast From Twenty Thousand Fathoms*, atom bomb tests are responsible for bringing the wrath of nature down upon mankind. A Navy submarine, weaving its way through the Pacific, is grabbed and held by something huge and radioactive. Eventually, the craft works itself free. Analysis of alien matter found in its exterior mechanisms shows that the ship had, in fact, been attacked by an octopus. It develops that atom blasts have been killing the primordial monster's food supplies, thus forcing it to leave the ocean's deepest recesses to

prey on man. Hard upon this discovery, the monster strikes again, sinking a freighter and, several days later, coils its way into San Francisco Bay. The creature's first attempts to come ashore meet with disaster. It wraps itself around the Golden Gate Bridge and, trying to haul itself up, hauls the awesome suspension bridge *down*. Slithering inland, the monster takes hold of the Ferry Building Clock Tower and likewise pulls it into the sea. Sensing that it will have to operate from the Bay, the octopus sends its tentacles roaming through the streets, trapping people in its huge suckers. Flame throwers drive the animal back into the sea. There, the beast's old nemesis, the submarine, is waiting, armed with an electric torpedo that it fires into the creature's brain. The warhead is activated and the monster is blown to pieces.

Although it is not readily apparent to anyone watching the film, the octopus had, in fact, only five tentacles. Thusfar, little has been said about the cost of stop-motion models, but it is exorbitant. Reducing it to an appropriate unit of measure, the "quintopus" with its metal-jointed armature and carefully crafted foam-latex exterior, cost $10,000 *per tentacle!* With the film's budget roughly equivalent to that of *Beast From Twenty Thousand Fathoms*, this bizarre mutilation is understandable.

Harryhausen's next project was a radical departure from his first two films. Schneer saw the potential for a marketable film in the abundant media coverage of flying saucer "sightings," and thus was born *Earth Vs. The Flying Saucers* (1956). Creatures from another planet are faced with extinction unless they find a new home. The emaciated, metallic-suited aliens elect to take up

Ray Harryhausen's Capitol Building dome from *Earth vs. the Flying Saucers*.

residence on earth and demand that a favorable decision be returned from the responsible governments. If not, our cities will be reduced to rubble. Working feverishly, scientists headed by Hugh Marlowe devise a beam that will upset the saucers' delicate gyroscopic controls. The showdown between earth and the invaders takes place in Washington D.C. where, before the saucers are downed, they succeed in decimating such landmarks as the Washington Monument and the Capitol Building.

Earth Vs. The Flying Saucers was an unusual film for Harryhausen in that he didn't have a living creature to animate. The aliens were costumed extras. Thus, Ray worked hard to make the saucers themselves interesting. The ships' design was more or less in keeping with contemporary legend, which conceived of them as concave discs. They were imparted with basic movement in the form of rapid and constant horizontal rotation around a central hub. Ray also took pains to *tilt* the saucers whenever they took to the air. For instance, if the craft were shooting skyward, it would angle up rather than rise parallel to the earth. However, Harryhausen had more to tax his genius than simply sending his saucers spinning in circles. The climactic destruction of the aforementioned landmarks was done entirely in stop-motion, the miniature models prebroken to facilitate their collapse. *Every falling brick and rafter was manipulated a frame-at-a-time!* This was accomplished with an aerial brace, a device used to suspend objects in off-balance positions during animation.

Ordinarily, as we have seen, a stop-motion model is held upright on a miniature set by screws or bolts driven up through the table-top and into the monster's feet. Often, however, as in the case of *Mighty Joe Young's* galloping horses, the models must be positioned in the air for several frames. While this could be accomplished with a traveling matte, the aerial brace method eliminates costly optical processing. Simply put, the rigging consists of wires—usually nylon thread or certain brands of fishing line—that hold the models aloft before a miniature projected image. These strands are invisible in long or medium shots, although close-ups often require that the frames be enlarged and the faintly visible supports hand-painted from the picture. If the model is to be airborne only a few frames, then this thread can be knotted around the body. Flying creatures, such as those we will

encounter in later Harryhausen films, or even the saucers, require that the cord be tied to the armature itself before the muscles and skin are added. These wires are then attached to a spindle that is set on overhead tracks. The spindle allows for rotary motion, while the supports are structured for either horizontal or vertical movement. Thus, both the debris in Washington and the balsa wood saucers in flight owe their remarkable mobility to this versatile stop-motion tool.

Harryhausen's next picture was *Animal World* (1956), a documentary about evolution. It was Ray's first color film and offered a happy reunion with Willis O'Brien. Despite the fact that their contribution amounted to only twenty of the film's eighty-two minutes, *Animal World* had its greatest impact in relating the story of the dinosaurs. This segment was shot entirely in miniature, with painted backdrops and model sets that are reminiscent of those which had been used in the original *Lost World*. While the prehistoric narrative features some marvelous animation, including the hatching of a baby dinosaur, life and death struggles between the monsters, and a superb earthquake, the film's most dramatic shot is one in which we see a brontosaur eating quietly in the distance when a ceratosaur leaps *feet-first* over the camera and into frame. After snapping its tail angrily at the audience, the dinosaur charges its prey. The jump, of course, was done with an aerial brace. Unfortunately, the film too often resorts to close-ups of large, limited-motion mechanical models, which tends to intercut poorly with the liveliness of the stop-motion figures.

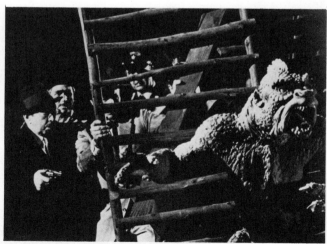

William Hopper and the Italian police try to capture the rampant Ymir in *Twenty Million Miles to Earth*.

71

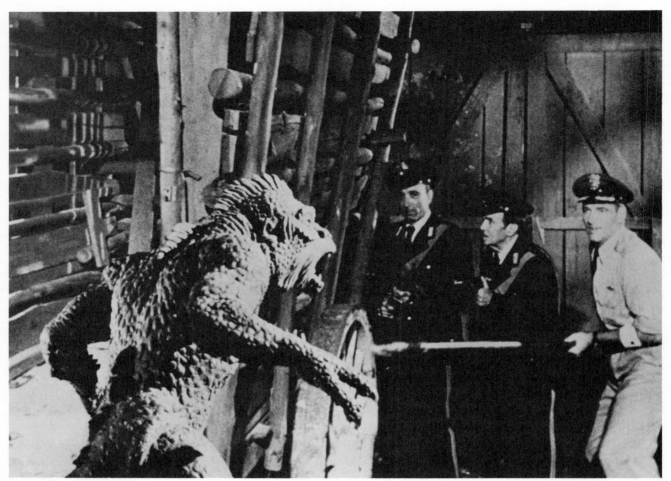

Twenty Million Miles to Earth.

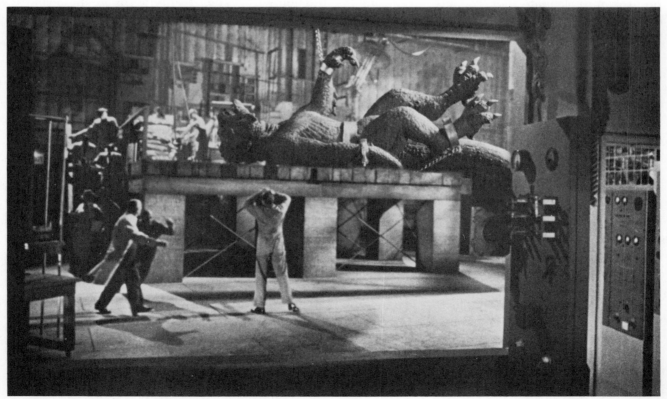

A short circuit causes the shackled Ymir to awake in *Twenty Million Miles to Earth*. These shots were accomplished through a combination of rear projection and split screen.

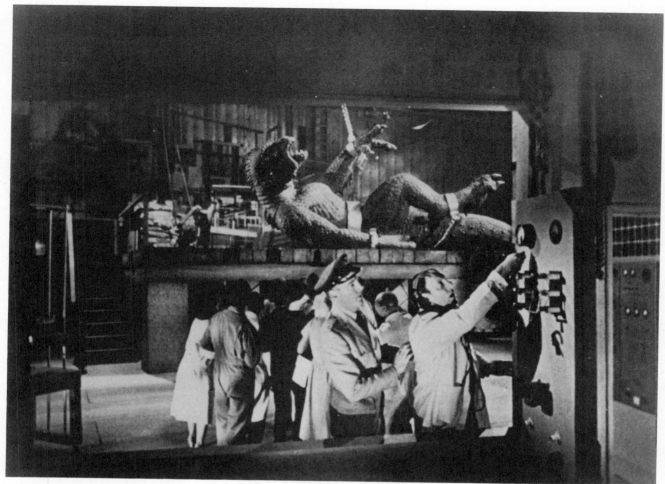

Twenty Million Miles to Earth.

As Harryhausen himself said, "I feel a more realistic effect can be obtained by using a good, detailed stop-action model."

Twenty Million Miles to Earth (1957) contains what many genre buffs and historians consider to be Harryhausen's finest animation. The "star" of the film, the monster Ymir, certainly has more personality than any of his stop-motion kin since Mighty Joe. A spaceship returns from Venus and crashes into the Mediterranean Sea. Although there is one survivor, he is unable to rescue a small container in which there is an unborn specimen of life from Earth's sister world. Later that day, the cannister washes ashore and is found by a young boy who sells it to a scientist. The professor opens the jar and, that night, the creature hatches from its jellylike egg. It grows quickly huge in earth's atmosphere and, frightened, goes roaming about the Italian countryside. The army subdues the Ymir with an electrified net and the monster is sent to the Rome Zoo where it is fed a steady dose of current to keep it comatose. While the creature is being studied, a short circuit brings it to defiant life. The alien smashes from the zoo, does battle with a hostile elephant, and makes a shambles of the metropolis. Climbing the Colosseum, Ymir is shot from the summit by bazooka fire, thus ending its brief taste of earthly hospitality.

Despite its reptilian appearance, the Ymir wins audience support due to its inenviable lot and many human characteristics. Thematically, the tragedy of the animal is that, despite its enormous size, Ymir is less than a few weeks old when it is shot to death. This, after being chased about our confusing world and forced to lash out in fear and self-defense. In terms of Ymir's personality, Harryhausen gives him little mannerisms that do much to soften our feelings for the devilish-looking creature. The first of these touches comes as the Ymir hatches in a darkened room of the scientist's trailer. The foot-tall alien is seen walking across a table when the light is switched on. Its brilliance startles the Venusian and, pivoting toward the camera, he buries his face in his arm. Turning slowly, he rubs his eyes as they

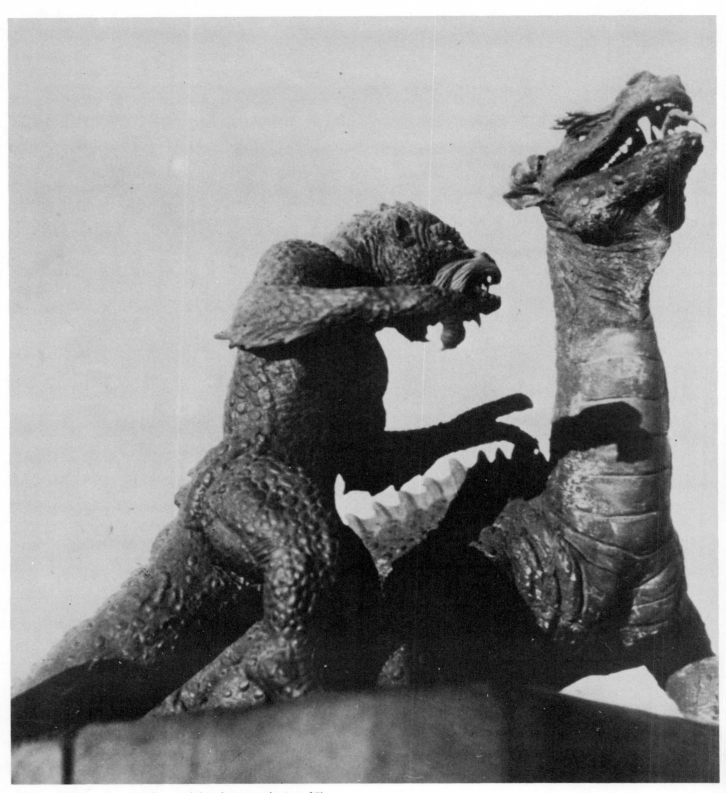

Harryhausen's Ymir in a specially posed shot during production of *The Seventh Voyage of Sinbad*. Ymir was subsequently dismantled and his armature used as the basis of the Sinbad cyclops.

Two views of the *Monster from Green Hell* (1957). For the battle between a python and the giant wasp, a stop-motion model was employed . . .

. . . whereas a full-scale model was used in conjunction with live performers.

become gradually accustomed to the light. Another example of Ymir's acting ability occurs after he is attacked by a dog and a pitchfork-wielding farmer. Ymir kills them both and vanishes into the country-side. He hides in a cave until lured out by what seems to be a peace offering: bags of sulpher, the dietary staple of Ymir's home planet. He comes out with considerable caution and, after a while, scoops up and feeds on the powder. He ignores a helicopter flying overhead until it is too late. A net is dropped and the trusting creature is imprisoned. And, in the end, Harryhausen once again milks the Ymir's death for all its potential drama. He wounds the monster first in the abdomen and arm, leaving it writhing on top of the Colosseum, after which he delivers the

coup de grace: a bazooka shell that tears away part of the landmark, and Ymir with it. The wreckage plunges to earth, burying the monster beneath fragments of stone. The Colosseum, of course, was a miniature model and its destruction was once again executed brick by brick with an aerial brace.

Putting aside Harryhausen's attention to detail, and his ability to wring a dramatic performance from his masses of metal and sponge, one of his steady weaknesses is the traveling matte. During Ymir's frenzied attack on soldiers stationed in an ancient temple, there is a traveling matte shot of falling columns with some of the most awkward and painful superimposition the field has ever seen. This was also true in *Earth Vs. The Flying Saucers*, when huge chunks of the Washington Monument landed atop crowds of tourists. Whether the expense or technique itself is beyond him, it is fortunate that Harryhausen used the process sparingly. More effective was a subsequent scene in the Colosseum when stone pieces made of lightweight plaster were dropped on actors rather than poorly superimposed.[3]

Twenty Million Miles to Earth marked the end of Harryhausen's involvment with black-and-white motion pictures. It had been his third film for Charles Schneer, and the duo was ready to embark on a more ambitious project, a full-color Arabian Nights fantasy. While Ray's processes had never been tried in color, miniature screen animation had been used in one previous color film, *The Beast From Hollow Mountain* (1956), an adaptation of Willis O'Brien's *Gwangi* story. Indeed, the tyran-nosaur armature used in the film had originally been built by Marcel Delgado for that earlier film. *Beast From Hollow Mountain* was executed in a process dubbed by special effects man Edward Nassour as Regiscope—for "register" and "scope"—the basis of which was allegedly animation using electricity to perform the incremental movements of the model. Although the technique had been used before, this sounds very much like a publicist's fabrication to arouse interest in an otherwise bland product. However, the film *was* the first to use stop-motion in conjunction with miniature screen photography in color. Harryhausen's method was not as incomplex as simply rear-projecting models and actors. Using precision lenses and carefully chosen film stocks with his standard special effect techniques, Ray experimented for almost a year with Electrolitic Dynamation. For the release of *The Seventh Voyage of Sinbad* (1958), only the Dynamation tag was retained.

Edward Nassour's stop-motion *Beast from Hollow Mountain*. The head of cattle is also a stop-motion miniature.

One of the important special effects systems in Dynamation is the process known as *blue-backing*. An actor or model is photographed in color before a blue screen, and the negative is printed on black and white film that records *only* blue. The positive and negative of this black and white strip serve as the matte and counter-matte for the master footage. An optical printer is responsible for the final composite. The drawback of this technique is that it takes many processing steps to remove the blue screen and add a background, which runs up quite a bill. Accordingly, in subsequent films, Harryhausen used a *yellow-backing* process that creates an instantaneous, in-camera matte. It does this by running two strips of film through a *split-beam camera*. This mechanism uses a prism to expose both rolls simultaneously, each of which has been specially treated to be insensitive to monochromatic yellow.

The camera is also fitted with two filters, one for each stock: one lens shade is coated with a chemical known as *didymium* to record the actor or model, while the other role is exposed through a monochromatic filter, to create the matte. Meanwhile, the subject is lit by yellow sodium vapor lamps that have a didymium coating that prohibits monochromatic yellow from striking the actor. Thus, the matte reel is unexposed to the subject, which renders its motions opaque when the footage is printed. Contrarily, the other roll of film has recorded the subject but filtered out the background screen. The resultant matte reels are perfectly rendered. Clearly, this method is superior and cleaner than the arduous blue-backing procedure.

The Seventh Voyage of Sinbad had a tenuous history for a great many years. Harryhausen had long wanted to film an Arabian Nights story, and

Kerwin Mathews leads the blinded cyclops toward the edge of a cliff in *The Seventh Voyage of Sinbad*.

over a two-year period drew dozens of sketches to illustrate key scenes in the proposed film. He took these drawings and his enthusiasm to a half-dozen producers, all of whom told him that the public would never pay to see a film about Sinbad. Sometime later, he happened to mention the project to Schneer, who saw its commercial possibilities and agreed to do the picture. When it was released, the picture returned a huge profit of several million dollars.

On the eve of their wedding, Sinbad's fiancée, Parisa, is reduced to several inches in height by the magician Sokurah. The wizard, feigning innocence of the deed, says that the princess can be restored only with a potion mixed in his castle on the Isle of Colossa. The sorceror's ulterior motive is to return to the home from which he was chased by an angry cyclops. Sinbad assembles a crew and sets sail. The men encounter, blind, and destroy the cyclops, battle a huge two-headed Roc—the eggshell of which is an ingredient in the potion—and, surviving

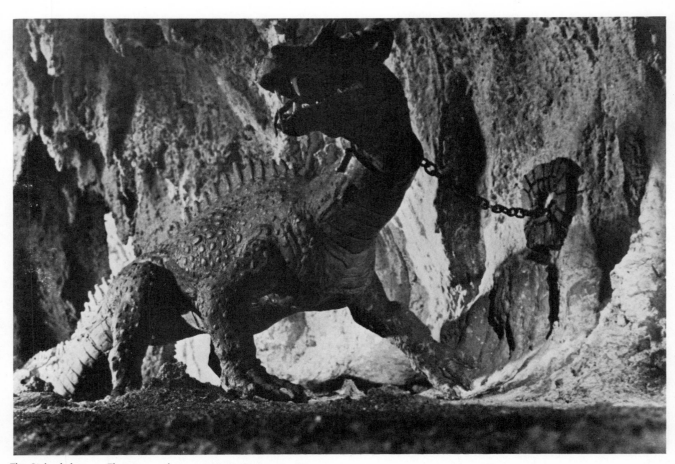

The Sinbad dragon. The cave and monster are miniature models.

these, Sinbad, the diminutive Parisa, and the magician assemble in his castle. Sokurah restores the princess, whom he covets, and sends forth a skeleton warrior to kill Sinbad. The prince defeats his hellish adversary and, running with Parisa from the castle, is met by a second cyclops. The pair free Sokurah's dragon and the monsters fight. The one-eyed creature is slain, and the magician leads his fire-breathing servant after Sinbad. On the beach, the prince's men have constructed a huge crossbow. When the dragon appears, it is speared by the yards-long arrow and falls dead, crushing Sokurah in the process. The lovers sail into the sunset, and all ends happily.

There are seven stop-motion creatures in *The Seventh Voyage of Sinbad*, all of them outstanding in their fluid motion and designed with an impeccable eye for fantasy. The first of these beasts is the cyclops, from whom Sinbad rescues Sokurah in the opening scenes. The monster is a huge, orange-brown satyr, built on the armature of the Ymir. This, of course, meant the virtual destruction of Ray's

Venusian beast. However, the high cost of these skeletons made the armature's reuse a necessity. On the other hand, the fact that the models dry, crack, and decay in a matter of a few years makes this butchery seem less severe. In any case, Harryhausen gave us one of his greatest performances in animating the monster. It is one of his most expressive creations, a monster that is both sadistic and highly excitable.

The second of the monsters was a blue-green snake lady created by Sokurah to entertain the wedding party on the eve of the nuptials. The five-foot-tall tentacled serpent with a woman's torso did an exotic dance before the creature's tail-end tried to strangle its human element. While the dance itself is quite good, close-ups of an actress in greasepaint being choked by a rubber tail do not intercut well with the stop-motion model. These shots, without the writhing arms or slithering motion of the body, do not uphold the illusion by suggesting that there is a reptilian form below the performer's neck.

Ray Harryhausen poses beside his miniature of the Isle of Colossa from *The Seventh Voyage of Sinbad*.

The return to Colossa and showdown with the cyclops follows, as Sinbad and his men invade the monster's treasure-filled lair and are imprisoned in a huge wooden cage. This sequence features perhaps the most riveting of Harryhausen's effects. The monster reaches into his cave from an opening in the roof and grabs the prince by his foot, lifting him through the crater. This was done with the miniature monster and the live actor—not a stop-motion double. Star Kerwin Mathews was over-turned and borne aloft by invisible wires. This footage was then miniature-screen projected and the cyclops' hand placed before it. Between its thumb and index finger Harryhausen placed a miniature boot that was an exact duplicate of the one Mathews was wearing. This was positioned in such a way so that the camera saw *it* instead of the real boot. The cyclops was then animated and photographed with the live action, the projector and camera being advanced a frame at a time.

After the death of the horned giant, Sinbad and his party scale the peaks of Colossa to the nesting grounds of the roc. There, they kill and eat a golden-haired "baby" bird—which is itself quite large—and are attacked by the vengeful parent. While we have stressed, all along, that each movement of a stop-motion model must cover no more than a fraction of an inch to be fluid, the flapping of a bird's wings is quite another matter. To simulate their rapid motion, accretions of *over* an inch-per-frame are not uncommon. The creature's flight was accomplished with an aerial brace.

The next monster we meet is the dragon that Sokurah keeps chained to a wall outside his castle. The creature protects the magician's dwelling from cyclopes and breathes flame at Sinbad when the adventurer seeks to gain entrance. The fire was added in an optical printer. Sneaking past the monster, the Arabian Knight does battle with the living human skeleton. This segment was an extremely difficult one for both Ray and Kerwin Mathews. For the actor's part, he had the problem of slashing at nothing, since the skeleton wouldn't be added through miniature screen projection until months later. Thus, every one of Mathews's moves had to be exhaustively rehearsed with Italian fencing master Enzo Musumeci-Greco. When the actor had his every move down pat, Enzo would step away and Kerwin fought thin air for the cameras. In addition to remembering his moves, Mathews also had the problem of stopping his sword *cold*

A yellow-backing shot from *Three Worlds of Gulliver*.

whenever it was supposed to make contact with the opponent's weapon. As the actor later recalled, this was especially difficult because the scene was done in twenty-four hours of solid shooting, and his arm eventually went numb from the weight of the sword. Harryhausen, too, had more than the usual share of problems with this sequence. Since it was important that he get a feel for fencing to properly animate the skeleton, Ray worked out with Enzo. However, this dedication was nipped in the bud when the animator threw his hip out of joint and ended up limping through several days of shooting. As for the skeleton model itself, it was eight inches tall and made of painted rubber molded atop a wire armature.

The Seventh Voyage of Sinbad, like Har-ryhausen's other films, employed a unique special effects aide known informally as the *monster stick*. While this tool is certainly not in the same technical class as a sodium vapor lamp or an optical printer, it does work to preserve the illusion in stop-motion sequences. While filming on Colossa—in reality, a Spanish beach—it was necessary for the actors to have a tangible object on which to focus when they're supposed to be looking at a monster. Accordingly, Harryhausen employed long, thin poles, usually thirty feet in height, notched where the creature's facial features, arms, and waist would appear in the completed film. In this way, not only was the actor able to convince the audience that he was, in fact, staring at something, but the perform-ers' eyelines would all be focused on the same spot. During special effects photography, the stop-motion model was positioned so as to block the monster stick from the camera. In other instances, it was necessary to hand-paint these poles from the picture.

The next Schneer-Harryhausen Dynamation project was *The Three Worlds of Gulliver* (1959), an unpretentious interpretation of Jonathan Swift's *Gulliver's Travels*. The film concerns itself with only the physician's two most popular voyages after he has been swept from the deck of a storm-tossed ship. Gulliver swims, first, to the world of the infinitesimal Lilliputians, who are at war with neighboring Blefescu over which side of the shell to break their breakfast eggs, and subsequently journeys to the land of the giant but proportionately petty Brobdingnagians, who believe the English doctor to be a warlock. Not surprisingly, the bulk of the film's effects involved giantism, using split screen, yellow backing, or rear- and miniature-screen projection to make star Kerwin Mathews appear large or small. There were, however, two stop-motion creatures on display in Brobdingnag, a huge crocodile that Gulliver fights to prove that he is not a witch, and a monster squirrel, which he and fiancée Elizabeth meet while on a picnic. One amazing sequence in the crocodile fight was reminiscent of the scene in

The Seventh Voyage of Sinbad where the cyclops raised Mathews by his boot: Gulliver smacks the reptile with his shield and the crocodile grabs it in his teeth. The two wrestle with it for several seconds, after which the monster tugs and the disk goes flying into the background. This time, star Mathews was pulling against wires that had been attached to the other end of the shield. These were yanked at the appropriate moment, and the hero lost his defenses. Back in the special effects studio, Ray covered the crocodile's half of the life-size disk with a scale replica, stuck this in his model's mouth, and placed the creature before Mathews's miniature projected struggles. When the monster was supposed to rip away the shield, Ray animated his crocodile and the duplicate piece of shield to conform with the footage that had previously been filmed. When the shield went flying into space, Ray simply removed the miniature of the crocodile's half and let the "real" prop continue along its course.

Like *The Seventh Voyage of Sinbad*, *The Three Worlds of Gulliver* found a large audience and was

Kerwin Mathews on one of the miniature sets for the Lilliputian sequence of *Three Worlds of Gulliver*.

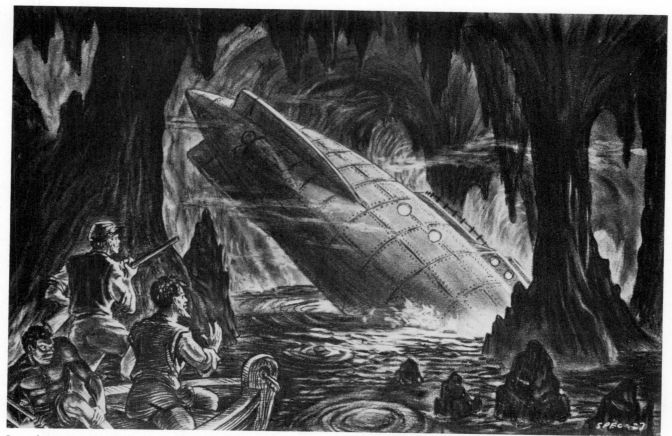

One of Ray Harryhausen's preproduction drawings for *Mysterious Island*, showing the Union soldiers' discovery of the *Nautilus*.

followed by another classic tale, Jules Verne's sequel to *Twenty Thousand Leagues Under the Sea, Mysterious Island* (1961). This was the first project that was assigned to Harryhausen and Schneer from a completed script. Walt Disney's 1954 film version of the first novel had been a tremendous box-office success (see chapter 7) and the studio for which Schneer worked, Columbia Pictures, was understandably anxious to exercise their option on this follow-up property. Schneer had the scenario reworked to incorporate Ray's Dynamation effects, so the story now told of Civil War soldiers balloon-wrecked on a Pacific Island that is inhabited by animals such as a giant crab, a prehistoric phororacos, gargantuan bees, and a monster snail. These, it develops, were bred by Captain Nemo, the heroic villain from *Twenty Thousand Leagues Under the Sea* who was no longer using his submarine, the *Nautilus*, to end warfare by sinking warships. Rather, he sought to weed out the root of war by solving the world's food problem. Unfortunately, the island is destroyed before he can give his

discovery to the outside world. The castaways manage to escape on a refloated pirate ship, but Nemo is destroyed along with the crippled *Nautilus*.

The film's nonanimated effects, such as the use of glass paintings, were a disappointment. Although these were matted with the live action shots in an optical printer, rather than photographed on location with the painting mounted in a frame, the results are basically the same. However, Harryhausen is not the glass painter that he is an animator, and these sprawling vistas of the island have a touch of flat unreality about them. Too, the volcano is not as convincing as it might have been: some unsteady matte shots and overstated "fireworks" betray the fact that it's only a model some six feet tall. Still, the stop-motion photography is, as ever, most impressive, and it is interesting to note that Harryhausen went so far as to fit a jointed armature into the remains of a real crab in order to animate a more convincing crustacean. And, in conjunction with our observation about the roc's flapping movements in *The Seventh Voyage of*

Ray Harryhausen and one of the harpies from *Jason and the Argonauts*.

As the Argonauts flee from the natural harbor of the Isle of Bronze, Talos straddles the bottleneck entrance. In a long shot, with the life-size ship sailing toward the superimposed giant, he slowly stoops to grab it. There is a cut to a close-up as, through what appears to be a yellow-backing shot, men scurry about the deck of a studio mock-up and Talos's stop-motion hand reaches for the vessel. No contact is made, however, and after a quick shot of a frightened oarsman, we return to the first camera

Some of Ray Harryhausen's creations on display in his London home. From top to bottom, left to right: the stop-motion squirrel from *Three Worlds of Gulliver*; the plateosaur and pteranodon from *Valley of Gwangi*; the Grand Lunar from *First Men in the Moon*; the miniature double for Ben Johnson from *Mighty Joe Young*; the miniature Acastus and Jason from *Jason and the Argonauts*; a selenite; two of the *Jason and the Argonauts* skeletons; the Gwangi styracosaur; the *One Million Years B.C.* allosaur and a Raquel Welch model; a smaller model of the Gwangi plateosaur, which the monster devours; the *One Million Years B.C.* rhamphorhyncus; a stop-motion man from *Twenty Million Miles to Earth*; the wing of a pteranodon; the *One Million Years B.C.* brontosaur; the Gwangi elephant and Gwangi himself (note sized relationship between Gwangi and the second plateosaur model); and Talos from *Jason and the Argonauts* (note the decay that has taken place on Talos in the ten years since *Jason*); and on the bottom shelf, the *Mysterious Island* bee, *First Men in the Moon* lunar calf, and *Mysterious Island* crab.

Sinbad, the arc of each move of the bee's wings covered over two inches per frame!

Mysterious Island was followed by the film that remains Harryhausen and Schneer's most impressive Dynamation production, *Jason and the Argonauts* (1963). This retelling of the Greek myth pits the Golden Fleece-seeking Thessalians against live actors portraying the Gods of Olympus, and stop-motion monsters in the form of a living bronze giant named Talos, a pair of devilish winged harpies, a seven-headed hydra, and an army of living human skeletons. A reported three million dollars was spent on the film, most of which went to special effects.

Of the film's animated monsters, Talos is the most extraordinary, for he carries the *pococurante* attitude of Ray's early dinosaurs one step further. His sole purpose in life is to kill those who tamper with the treasure cache of the Gods of the Isle of Bronze. The Titan's face is utterly without expression; this makes him quite impersonal, which is always an effective element of terror. And, since Talos is constructed of bronze, Harryhausen made certain to give him a halting gait and the grinding sounds that would be incumbent on any metallic giant. This slow but deadly pace serves to heighten our awe of the monster, for even at this leisurely speed, Talos overtakes the Argonauts. "It is somewhat ironical," Ray later observed, "when most of my career was spent in trying to perfect smooth and lifelike action . . . it was necessary to make his movements deliberately stiff and mechanical." The Talos sequence also gives us some insight into the way that Ray's use of film editing is as crucial to many of his illusions as the special effects themselves.

placement and find Talos just having grabbed the bow and hauling the craft from the water. The intermediary shots of the deck and Argonaut gave Ray the opportunity to substitute a model for the real ship, thus eliminating the need for an expensive optical effect. For by showing the action that occurs before and after the "taking hold," Harryhausen was able to simply *suggest* the action.

Although lacking the grandeur of Talos, the balance of the stop-motion creatures are all unique and entertaining. The "human" special effects, the Gods and Triton, who saves the Argonauts from the clashing rocks, are also well-done. Jason's conference with the enormous Greek deities on Olympus was filmed with simple composite techniques, while the Sea Lord was an actor wearing a merman's tail. He was summoned to hold apart two mountains that crush all who attempt to pass between them. The problem with this scene—as with any work involving water and miniatures—is the nagging presence of water beads. These tiny droplets are caused by anything that splashes about in a studio tank. They indicate a lack of mass for, in reality, a large object moving in or striking the "real" ocean would cause billowing swells. Although high speed photography and low camera angles did much to slow the Triton actor's motions and give him bulk, they could do nothing with the pesky beads.

Since *Jason and the Argonauts* was released at the end of a six-year Italian sword-and-sandal cycle, exhibitors and moviegoers assumed that it was just another in the ever-deteriorating series. As a result, it did rather poorly at the box office and, looking for a less shopworn piece, the filmmakers turned to H. G. Wells's *First Men in the Moon* (1965) as their next screen project. Surprisingly, it was also a commercial disappointment due, one must suspect, to its fanciful approach to a very topical and precise subject. The story sent a manned diving bell to the moon in 1899, courtesy of an antigravity paint. In terms of special effects, the film presented Harryhausen with problems he had never before encountered. For reasons of imagined box-office appeal, Schneer decided to shoot the film in Panavision, a widescreen format not unlike CinemaScope. This meant that Harryhausen had to scrap most of his miniature screen and composite processes, since they were imcompatible with the distorted anamorphic "squeeze" image. He relied, instead, on traveling mattes to create his superimpositions, even using them uncharacteristically to

combine live actors with the few stop-motion characters in the film. This latter grouping consisted of a giant centipede known as a mooncalf, and the Grand Lunar, insectlike ruler of the selenites.

Fortunately, Harryhausen's next film, *One Million Years B.C.* (1966), found a wide audience due to the ballyhoo accorded its star, newcomer Raquel Welch. This remake of the 1940 standard was sponsored by Hammer films, the world's foremost producers of quality horror pictures, and was only the third time in eleven films that Harryhausen did not work with Charles H. Schneer. *One Million Years B.C.* is a steaming, sweltering look at prehistoric earth, and certainly one of Harryhausen's most evocative works. By and large, the dinosaur sequences are exciting, especially the allosaur's raid on a prehistoric settlement. After tearing the village apart, the monster charges hero John Richardson. Thinking quickly, the caveman grabs a sharpened timber from one of the fallen huts and lets the beast run into it. Thus impaled, the monster's momentum carries the spike perpendicular to the ground. Richardson rolls away and the squirming, agonized carnivore slides slowly down the weapon. Once again, a small prop-spoke was inserted into the dinosaur and matched with the miniature projected pole held by Richardson. The monster was borne aloft, skewered on the pike, by an aerial brace.

For some reason, while Harryhausen did a remarkable job animating the allosaur, a tortoiselike archelon, a ceratosaur-styracosaur fight, and an aerial braced pteranodon-rhamphorhyncus struggle, his first two "monsters" were living creatures optically enlarged to menace our hero. When

A frame blow-up showing the death of the allosaur from *One Million Years B.C.*

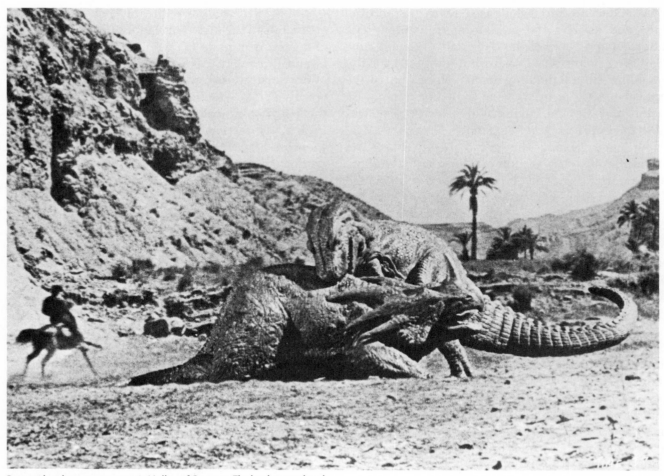

Gwangi battles a styracosaur in *Valley of Gwangi*. The background and cowboy footage are miniature projected images, while the foreground terrain was added in an optical printer to hide the table top on which the dinosaurs were animated.

Gwangi runs amok in Mexico. As in the fight photograph, the background is miniature projected and the foreground composited in an optical printer.

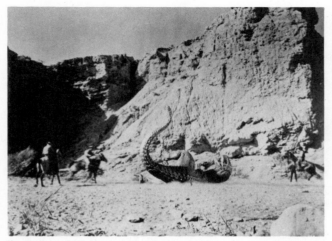

The *Valley of Gwangi* roping sequence. The ropes attached to the tyrannosaur are miniatures, carefully aligned with their life-size counterparts.

Richardson is banished from his tribe for having struck the leader, he crosses a desert and is attacked, first, by a giant iguana, and then by a huge tarantula. These animals are listless when compared with the stop-motion beasts, and their familiarity as standbys of cut-rate monster films tends to cheapen the overall product. Since they appear but briefly, one can only question the wisdom of having included them in the first place.

Harryhausen was unable to handle the special effects for Hammer's next dinosaur epic *When Dinosaurs Ruled the Earth* (1970) since he was busy working with Charles Schneer on *Valley of Gwangi* (1969). Thus, the assignment went to Jim Danforth, whose career we will study in chapter 7. *Valley of Gwangi*, of course, is the old Willis O'Brien project that was planned, cancelled, and ultimately shot by Edward Nassour as *Beast From Hollow Mountain*. The film contains all the high standards one had come to expect from Dynamation, although the animation of Gwangi, the tyrannosaur found in a time-forgotten valley and made to perform in a

circus, boasts the most natural movement Harryhausen has ever achieved. Other excellently rendered creatures were a charming foot-tall prehistoric horse known as the eohippus, a not-so-charming styracosaur, a docile plateosaur that is eaten by the title character, a circus elephant that is also attacked and killed by Gwangi, and a rambunctious pteranodon. This last creature performs one of the film's slickest tricks when it swoops down, plucks a live actor from his horse, and wings skyward. The actor had been harnessed with wires, attached to a crane, and hoisted aloft. Later, Harryhausen simply coordinated the movements of his aerial braced monster with this miniature projected footage.

Valley of Gwangi was lost in the shuffle of the contemporary rage, the so-called permissive X-rated film, and it was clear that Harryhausen and Schneer would *have* to come up with a winner for their next film or face possible retirement. Logically, the route to follow was the one that had brought them their greatest success. They returned to the

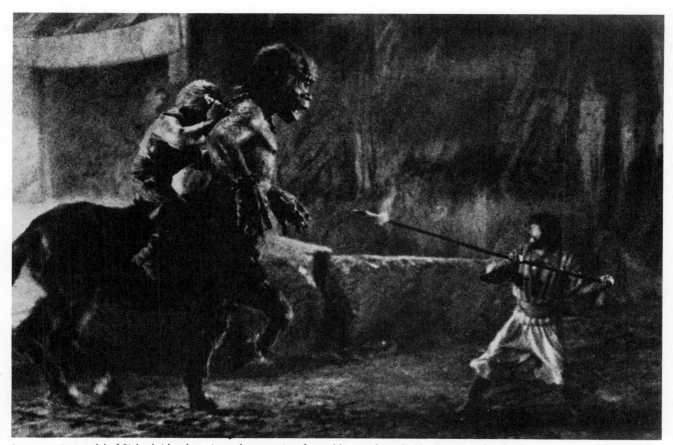

A stop-motion model of Sinbad rides the animated centaur in a frame blow-up from *Golden Voyage of Sinbad*.

85

territory of *The Seventh Voyage of Sinbad* and came up with their biggest hit, *The Golden Voyage of Sinbad* (1973). According to *Variety*, the picture was one of the most profitable films of that year. It features a top-notch crop of Harryhausen histrionics: a ship's masthead that rips itself from the prow and attacks the crew, a six-armed statue brought to life for a duel with Sinbad, a one-eyed centaur that does battle with a golden gryphon, and a small, batlike homonculus through whose eyes the evil sorceror Koura spies on Sinbad as the two men race to possess a fabulous golden crown. Wisely, Columbia's publicity department created television and newspaper advertisements that played up the special effects. They redubbed Harryhausen's process the more energetic Dynarama and there is no doubt but that youngsters, as well as adults, packed theaters *because of* the magic promised by this "new" screen miracle. While this does not speak well of the film as a whole, it does serve to illustrate the power that remarkable special effects can wield at the box office. Indeed, so popular was the picture that the studio re-released *The Seventh Voyage of Sinbad*, which again showed formidable muscle at the box office.[1] At the present time, Harryhausen and Schneer are wrapping up their eleventh collaboration, *Sinbad and the Eye of the Tiger* (1977) and, according to Columbia, there will be more Sinbad films to come. Harryhausen told me recently that he would prefer to involve himself in a more contemporary project, but one can imagine that he will be satisfied in either eventuality.

It has been a long and arduous road for stop-motion photography, and there is no promise that the Sinbad films will cause a boom in the field. Willis O'Brien suffered incredible financial hardship eking out a living between his all-too-few films, and many of the current model animators must supplement their occasional motion picture work with television commercials for such companies as Chuckwagon, Pillsbury, and Swiss Miss. While these are excellent works, they offer a sadly transient showcase for many talented people. Thus, we must acknowledge the remarkable place that Ray Harryhausen holds in the field of special effects. Not only has he made the types of films he has wanted to make for over a quarter of a century, but he has done them with absolute dedication, remarkable creative resource and innovation, and an infallible sense of showmanship. In anyone's lexicon, this is the definition of a film artist. That Harryhausen has carved this niche for himself in the very scientific field of movie special effects, is one of the amazing stories in all film history.

7
Disney, Pal, and Company

It was the most natural thing in the world for me to imagine that mice and squirrels might have feelings like mine.

—Walt Disney

Thusfar, we have said very little about cartoon animation. Although the medium abounds with technical sophistication, this does not usually involve live actors or three-dimensional props. Since our study has been roughly defined by these parameters, we must limit our look at "stop-motion drawings" to the field's highlights, and as they pertain to the special effects work created by one of the industry's most respected citizens.

We do not know who first drew a series of progressive cartoons and put them on film, although credit for creating the first narrative cartoon is usually accorded the French jeweler Emile Cohl. His debut film, *Mr. Stop,* appeared in 1905. Cohl's drawings, as those of his ambitious American counterparts Winsor McKay, James Stuart Blackton, and others, were usually done on paper and photographed a sheet at a time, with the

backgrounds redrawn for every frame! In the case of McKay's *Gertie the Dinosaur* (1906), this necessitated rendering the same background *over four thousand times!* It was not until 1913 that New York animators John Bray and Earl Hurd offered an alternative with the introduction of celluloid sheets or *cels*. The animators' drawings were traced in ink onto these transparent cels, beneath which a single painted background was used over and over again. This remained the standard process of cartoon animation for decades to come. In recent years, animators have taken to placing progressive cels of moving mouths and limbs atop stationary bodies. Another of the Bray-Hurd team's contributions, and one of more immediate interest to us, was the first commercial combination of live action and animation in a single picture. In 1921, *Johnnie Out of the Inkwell* stepped from the cel on which Hurd was working and shimmied up his arm. The first step in achieving this effect was to film Hurd and project his image, a frame-at-a-time, on a drawing board. The animators lightly traced the outline of his arm onto squares of celluloid. With this as their guide, they

The steps in creating an animated cartoon. Almost a year before the rest of the animation department is assigned to a film, storyman and art director Ken Anderson come up with preliminary character designs and "gags." From *Robin Hood* (1974). © *Walt Disney Prod.*

Animation director Ollie Johnston makes faces in a mirror to help him capture subtleties of expression for *Robin Hood*. © *Walt Disney Prod.*

After the storyline and dialogue are established, voices for the animated characters are recorded. Here, Peter Ustinov plays Prince John in *Robin Hood*. © *Walt Disney Prod.*

Technician Janet Rea transferring an animator's drawing directly to a cel through Xerography. © *Walt Disney Prod.*

Colorist Cherie Miller paints a Xeroxed cel. © *Walt Disney Prod.*

Over four hundred separate colors are used in an average animated feature-length film. This is the room where the paints are mixed and processed. Disney studios uses a special brand of paint that possesses a brightness and richness not found in commercial paint, and that adheres well to cels. © *Walt Disney Prod.*

drew the Johnnie character on each transparency, after which the tentative sketches of Hurd's arm were erased. Using the standard matting techniques of the era, they combined these cartoon cels with the Hurd footage. The short proved so popular that when one of Hurd-Bray's animators, Max Fleischer, formed his own studio later that year, he initiated a similar and long-lived series called *Out of the Inkwell* starring Koko the Clown. Fleischer would later be responsible for the successful Betty Boop and Popeye cartoon series.

By the mid-twenties, most of the American animation houses had moved to Hollywood. Un-noticed in this migration was the down-and-out advertising and motion picture cartoonist Walt Disney. Walt moved to California from Kansas City in 1923 and set up a studio in his uncle's garage. Two months later, he was producing *Alice's Wonderland* shorts for a New York based distributor. Reversing the concept of the popular Koko series, Disney put a real girl in cartoon settings. These pictures were initially well-received, but quickly became stale and redundant. Since this was Walt's bread and butter, he sent a frantic summons to an old advertising buddy, Ub Iwerks, to come West and help the

The multiplane camera invented by Ub Iwerks. © *Walt Disney Prod.*

Background master Al Dempster completes one of the nearly 500 different painted backgrounds used in *Robin Hood*. © *Walt Disney Prod.*

Sound effects man James MacDonald and aide Wayne Allwine coin a phrase or two for *Robin Hood*. © *Walt Disney Prod.*

Disney sound technicians mix and synchronize the different vocal, musical, and effects soundtracks for *Robin Hood*. © *Walt Disney Prod.*

struggling outfit. Iwerks arrived and streamlined the entire operation, simultaneously increasing the quality of the animation with his considerable drawing skills. The shorts regained their former glory, and became a marginally profitable enterprise for the small Disney organization. By 1927, after over sixty adventures, the Alice shorts finally gave way to an all-animated Oswald the Rabbit series. These proved so popular that their producer and distributor, Charles Mintz, decided to abscond with the property. Cutting the budget on each film, he literally forced Disney out of the picture and took the account to a cheaper house. In retaliation, Disney and Iwerks came up with a character to give Oswald some competition: they called him Mickey Mouse. The unique contribution of Iwerks's artistic ability and Walt's knack for character development shot Mickey to the fore of animated personalities, where he has remained for over fifty years.

Throughout his career, Walt was hypnotized by technological developments and gimmickry, and was always looking for new techniques or film-making tools. And because of his willingness to take a chance, Walt was the first producer to make sound, color, and finally feature-length cartoons. He was unafraid of progress, and always made it work for him. Even television didn't scare Disney as it had the other major studios. Walt held on to his old films, and produced low-budget programs for television in which, carefully hidden between the lines, he plugged upcoming productions as well as Disneyland.[1]

Many of the technical innovations that came from the Disney studios over the years were the work of Iwerks, including such devices as the *multiplane camera* and the process known as *xerography*. The multiplane camera was a means to work an illusion of three-dimensional photography. Created in the

Film Editor Jim Melton checks his handiwork on *Robin Hood*. © *Walt Disney Prod.*

Walt Disney and director Richard Fleischer on location in Jamaica for *Twenty Thousand Leagues Under the Sea*. © *Walt Disney Prod.*

thirties, it shot the cels with inches between them, rather than stacking them one directly atop the other. This allowed the camera to move into the scenery, and for characters to perform on different planes, thus suggesting depth. Xerography, which was first used in the fifties, was a means of transferring the animators' paper drawings directly to a cel without the costly intermediary step of inking-on. Iwerks also contributed enormously to Disney's live-action films. These latter productions were begun in the forties when, after the war, Disney wanted to make movies that could be done more quickly than his animated cartoons, and thus generate an immediate profit. After bringing out a successful line of low-budget action pictures such as *Robin Hood* and *Rob Roy*, he was ready to produce a live-action feature that would have all the charm and innocence of his cartoons. He selected, as his first subject, Jules Verne's *Twenty Thousand Leagues Under the Sea* (1954). To tell the story of Captain Nemo required every special effects facility at the studio's command. Areas of responsibility were carefully delineated to suit the talent already on-hand for cartoon production. Iwerks was in charge of the static and traveling mattes, background painter Peter Ellenshaw handled the

glass paintings, and technician Robert Mattey oversaw the model-making. These included miniature reconstructions of the submarine *Nautilus* that ranged in length from one foot to several yards. One of Mattey's greatest challenges, however, was the famous attack of the giant squid. The battle begins underwater, but ends on the surface as Nemo and his men harpoon the creature that has attacked their vessel. The scene and its monster were enough to make even DeMille's *Reap the Wild Wind* sea beast seem pale by comparison. Sixteen men were needed to operate the full-sized, two-ton cephalopod, which was powered by hydraulic pumps and electricity. In its basic engineering, the model was not unlike the dinosaurs Disney built for the 1964 New York World's Fair Ford exhibit, or the Pirates of the Caribbean ride that is a part of Disneyland (see Conclusion). As if the fight were not an enormous task under any circumstances, there was a particular pressure on the technical crew, for this was the second time they had to film the scene. Their first crack at it, with a different monster model, failed to impress the meticulous Disney. He thought that the squid looked fake and that the quiet setting of dusk was all wrong. Thus, the monster was rebuilt, and the scene reshot during a simulated storm; the result is a magnificent part of a classic film. It was one of the factors that contributed to the picture's special effects Oscar.

Twenty Thousand Leagues Under the Sea cost five million dollars to produce but, like most of Disney's productions, the CinemaScope film was a money magnet. This inspired the studio to press on with other live-action features. Although only a few of these contained special effects on the scale of

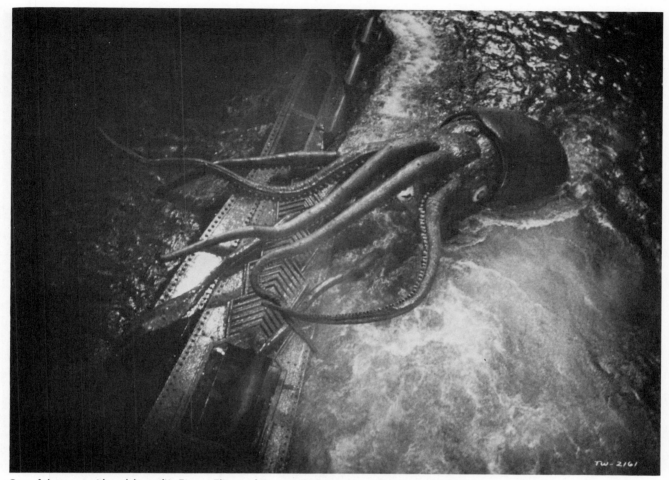

One of the two squid models used in *Twenty Thousand Leagues Under the Sea*. This one is a miniature . . .

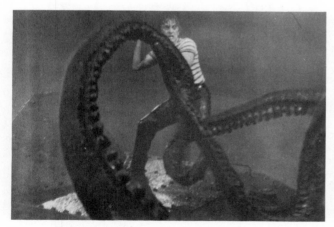

. . . while this one, giving Kirk Douglas a run for his money, is full-sized. © *Walt Disney Prod.*

Twenty Thousand Leagues Under the Sea, they are well-worth mentioning.

Darby O'Gill and the Little People (1958) is among the few flawless special effects films ever made. The story of an old man who stumbles upon a colony of leprechauns, it challenges the viewer to pick apart its magic. Beyond the use of mattes and split screen in scenes where O'Gill interacts with the little people, there is a grazing mare that, through the use of filters, turns suddenly to an irridescent spirit horse; a green-glowing and translucent banshee; a headless coachman who pilots his hearse through the churning night sky; and much more. Indeed, so convincing are the film's effects that they carried through to the cast billing: the king of the leprechauns was listed, in all advertising material, as having been played by himself!

More spectacular, though less impressive overall, were the tricks in *Mary Poppins* (1964), a film that hardly deserved the special effects Oscar it won over George Pal's superior *Seven Faces of Dr. Lao*. The film fooled the public, however, and no one seemed

Specially equipped underwater cameras photograph the men of the *Nautilus* from *Twenty Thousand Leagues Under the Sea*. © *Walt Disney Prod*.

One of the remarkable composites from *Darby O'Gill and the Little People*. Actually, it is a "simple" split screen: the picture is divided along the beam in the wall and down the table. A perfect illusion is betrayed by the fact that the two edges of the table are not perfectly joined. Everything on the right side of the picture was, of course, built on a large scale to "shrink" the leprechaun. © *Walt Disney Prod*.

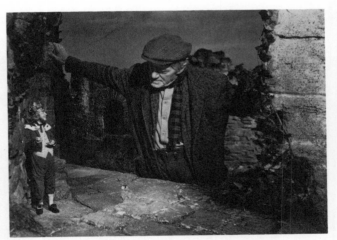

Another interesting split screen sequence from *Darby O'Gill and the Little People*. The foreign elements are the leprechaun, the stones on which he is standing, and the wall behind him.

Setting up a shot for *Mary Poppins*. Director Robert Stevenson checks the camera angle while star Julie Andrews looks on. © *Walt Disney Prod*.

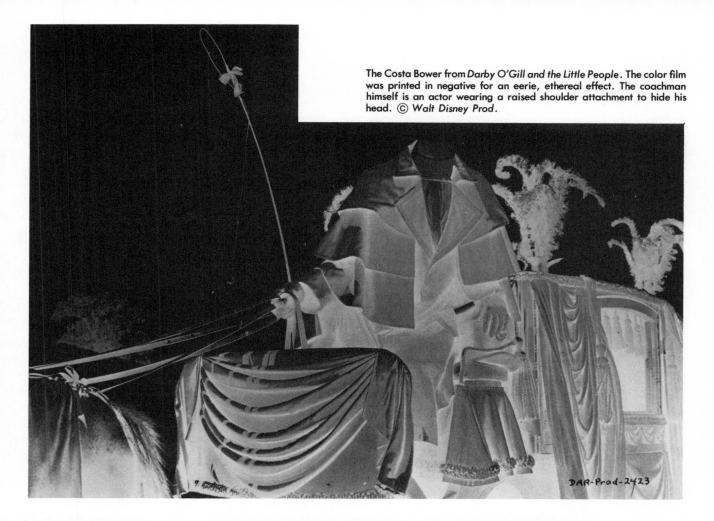

The Costa Bower from *Darby O'Gill and the Little People*. The color film was printed in negative for an eerie, ethereal effect. The coachman himself is an actor wearing a raised shoulder attachment to hide his head. © *Walt Disney Prod.*

DAR-Prod-2423

A rear-screen shot from *Mary Poppins*. A matte would not have allowed the cartoon background to be seen through Julie Andrews's veil. © *Walt Disney Prod.*

in most scenes. Indeed, the finale of "Let's Go Fly a Kite" features a miniatrue set as full of visible wires as it is spotted with kites. When one considers that Disney's animators could easily have retouched individual frames to remove the offending supports, the crime becomes doubly heinous. Equally frustrating is the jerky, uncertain quality of the stop-motion work, especially when our heroine orders the children's bedroom to clean itself. However, the most disappointing effects of all are the yellow backing and other matte shots, used to place the live actors in cartoon settings. The matte lines are so heavy in places that the stars look literally to have been outlined in crayon. Too, there are severe color changes in the performers' clothing from shot to shot in these sequences, owing to the different processes used to achieve each illusion. Obviously, the sodium vapor process will cause a greater shift in the picture's yellow element than a different type of matte. Yet, there was no attempt to rectify this discrepancy in the laboratory. This is where Harryhausen's use of film editing has helped alleviate such problems. Seldom does he jump from

to mind its shoddy workmanship. Ms. Poppins, of course, is the preternatural nanny who flies, works inexplicable magic, and takes her young charges on trips through cartoon fantasy lands. The flying effects that carry the nanny about were accomplished with wires, which are painfully evident

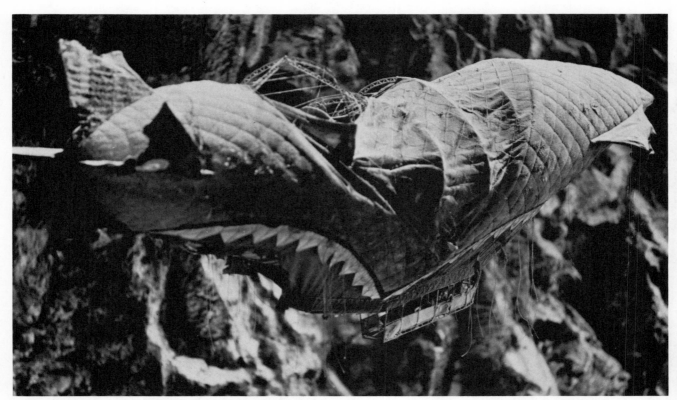

The airship *Hyperion*, crippled by a blizzard, lands on the *Island at the Top of the World* (1974). The fact that the airship is a miniature model is painfully evident in this shot. © *Walt Disney Prod.*

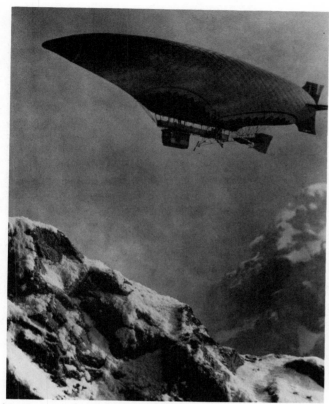

In contrast to the previous shot, this perspective of the *Hyperion* is excellent. The low angle and miniature mountain peaks give the model the illusion of giantism. © *Walt Disney Prod.*

a yellow backing shot to miniature projection, for example, without first inserting a shot that *does not feature* the object of his effects work. In this way, any change in his subject's color is not obvious, nor is costly color-correcting necessary. Ironically, Disney's *Mary Poppins* imitation, *Bedknobs and Broomsticks* (1971) did not do nearly as well as its predecessor, although the special effects were better and copped an Oscar over the more deserving *When Dinosaurs Ruled the Earth.*

Despite these disappointments, however, there is no denying Disney his due. Like Harryhausen, he popularized a cinematic art form without compromising on its integrity or professionalism. Only toward the end of Walt's life, when too many hands became involved with the product—bankers who held the purse-strings, stockholders who dictated production schedules, and an organization geared more to completing product than dealing with the creative challenge of making it ever-better—did the work become stale and not up to the standards of Disney's films in the thirties, forties, and fifties.

If, by 1939, Mickey Mouse had not already become "the character to beat," then George Pal's Puppetoons might have taken that honor. Like Disney's trend-setting product, the Puppetoons were distinctive and executed with great care. Pal had graduated as an architect from the Budapest Academy of Art in 1928, but had a strong fine-arts background. Unable to get a job erecting buildings, he used his drawing ability to work as a cartoon animator in Hungary's Hunia Studios. During this time, he married long-time sweetheart Szoka, and the pair struggled along on Pal's meager wages. Three years passed with no change in his lot, so Pal migrated to Berlin. There, he was fortunate to find employment at the famous UFA studio, and quickly became the head of their animation department. However, Hitler came to power during this time, and the gestapo kept Pal under surveillance because of his Hungarian background. When the spying became constant harassment, the cartoonist saw the writing on the wall. He fled to Praque where he was unsuccessful in his attempt to establish a cartoon studio in Czechoslovakia. Moving to Paris the following year, he convinced a cigarette manufacturer to finance a theatrical commercial using stop-motion photography. The businessman gave him $1,000 and Pal delivered a film in which cigarettes stepped from their packs and marched about the stage.[2] An enormously successful promotion, the film gained Pal an offer from Dutch advertising executive Sies Numann, who promised a constant flow of work if Pal could produce similar films for under $8,000 apiece. So it was that Pal once again packed his belongings, moving this time to Einhoven, Holland. Among the prestigious accounts he managed to land were Phillips Radio and Horlick's Milk.

In 1936, Pal toured the United States, testing the market for the application of his process to short, fully animated story-telling properties. Everyone from the New York film critics to Disney offered Pal substantial encouragement and, on his return to Holland, he began producing these films, which he called Puppetoons. Initially, these saw limited American release, but Pal intended to solve that problem later. Unfortunately, within three years, Hitler was moving on Holland and Pal decided to leave. Closing up the forty-man studio he had worked so hard to build, the animator pulled up roots and, with his wife and young son, moved to the

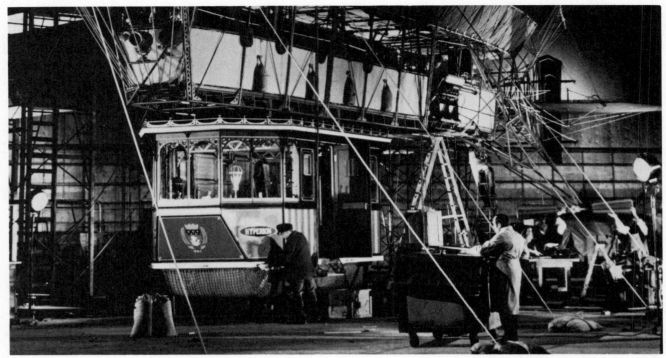

This is as much of the full-scale *Hyperion* as was built . . .

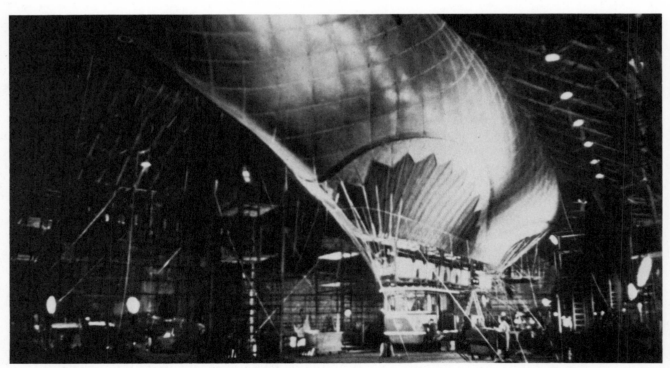

. . . and this is how it looks with the miniature balloon superimposed. ©
Walt Disney Prod.

The 1954 RKO production of *Hansel and Gretel* was done entirely with stop-motion puppets, reminiscent of George Pal's Puppetoons.

United States. No sooner had Pal arrived in New York than Paramount Pictures offered him an exclusive contract to finance and distribute his Puppetoons. The animator agreed and, like Disney before him, set up shop in a small garage in Los Angeles. He hired the two dozen technicians—one of whom was Ray Harryhausen—necessary to produce his short subjects, and Puppetoon production began anew.

The Puppetoons were, in essence, cartoons done with stop-motion dolls. Composed of thirty-thousand frames each, these films ran some eight minutes and required one and a half months to make. Among the many pictures that Pal would produce during the next eight years were the famous antiwar films *Tulips Shall Grow* (1942), *Bravo Mr. Strauss* (1943), the more fanciful *Truck that Flew* (1942), and Dr. Seuss's *And To Think I Saw It on Mulberry Street* (1944), and a series of fifteen films about a young black boy named Jasper. In 1944, Pal

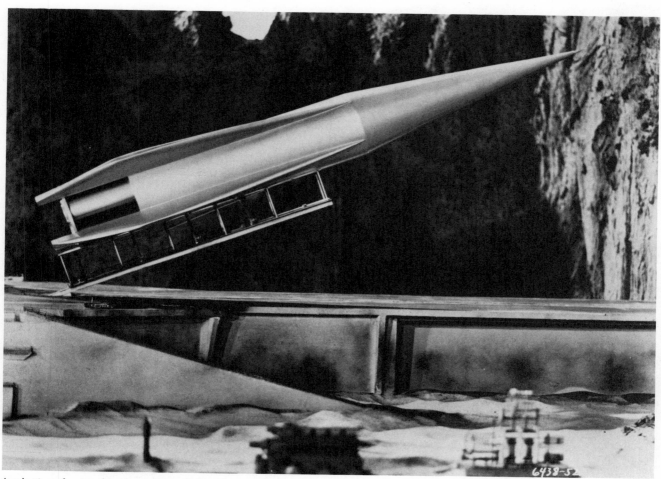

A selection of space ships from science fiction films: a poor miniature model from *The Time Travelers* (1964) . . .

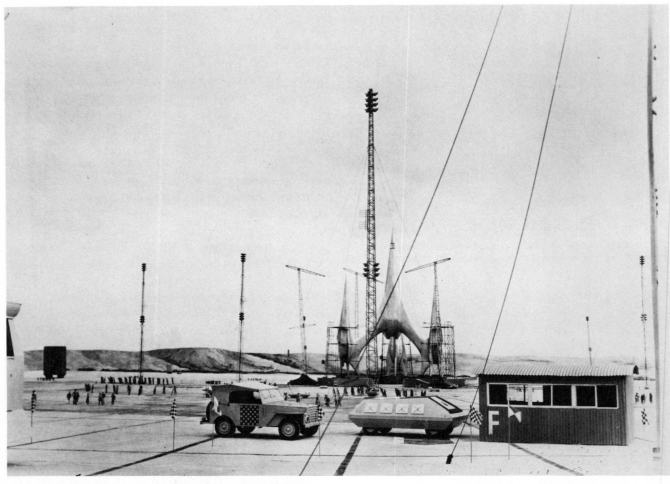

. . . a superb miniature set from *First Spaceship on Venus* (1962) . . .

. . . Toho's *Gorath* space stations, complete with visible support wires . . .

. . . a fine matte shot combining a model space ship with a sculpted earth from *This Island Earth* (1955) . . .

... and a glass painting seen in *Spaceways* (1935).

won a special Oscar for his contributions to the art and technique of motion-picture making, which included experiments in glass painting, the discovery of new materials with which to construct miniatures, and other skills that benefitted the entire field of movie special effects. Unfortunately, by 1947, production costs for all types of animation had become overwhelming. Compounding this problem was the fact that theater-owners were no longer willing to pay additional moneys for short subjects. Thus, everyone—including Disney—was forced to cut back, and the Puppetoons were discontinued entirely. Indeed, this rising cost of animation was one of the reasons Disney began live-action feature-film production. George Pal decided to follow the same route. Supporting his small company with educational pictures made for Shell Oil, he sought financing for full-length movies.

An excellent use of painted perspective. The set actually ends after the first rise in the snow, just beyond the oval of ice. The sky and horizon were rendered on canvas. From *The Thing* (1951).

In 1949, Pal found a sponsor in Eagle-Lion films. They agreed to back one of the producer's three pet projects: *The Great Rupert*. *Crime and Punishment* and *Tom Thumb* would have to wait for other times or other filmmakers.[3] *The Great Rupert* was a trained squirrel who uncovers a hidden treasure and makes down-and-out Jimmy Durante a wealthy man. Rupert, a stop-motion model, was animated with remarkable fluidity. The squirrel offered Pal and his staff subtler patterns of motion than the caricatured Puppetoon characters, and they met the challenge skillfully. The film earned itself a tidy profit, and Pal could have continued making similar family fare. Instead, he chose to produce a series of films that brought special effects the kind of recognition they had not had since *King Kong*.

Destination Moon (1950) was another Eagle-Lion production, and the first film to deal intelligently with space travel since *Things To Come*. A semidocumentary based on Robert Heinlein's novel *Rocketship Galileo*, *Destination Moon* had governmental cuts in the space budget force concerned private enterprise to put a man on the moon. The far-sighted industrialists firmly believed that whoever controlled the moon would control the earth. Although the film is, today, a scientific fossil, the technicolor special effects remain impressive. The launch was spectacular, achieved with models on wires and mattes, although stock footage was used to show the crashes of experimental rockets. The scenes in space were even more impressive, especially those in which our early astronauts were required to take walks outside their spaceship. These scenes were shot on a sound stage with the performers suspended from invisible wires. Each man's torso was rigged with one primary strand, while an additional wire attached to each limb gave technicians the ability to steer his weightless body through space. This control originated on tracks similar in design to the animator's aerial brace. A mandrel was suspended from each overhead carriage, which allowed rotational movement as the spacemen were guided along vertical courses. A heavy, trampolinelike net was stretched beneath the players at all times.

As one can imagine, these shots were a tremendous hardship for the actors. They would be dangled at dizzying heights for over an hour at a stretch, suited up and lit by lamps designed to duplicate the sun's intensity in outer space. The duration of their ordeal was dictated by the time required to coordinate the lights, camera movement, and

action. Fortunately, there was seldom the need for retakes. If the camera accidentally picked up one of the wires, it was an easy matter to retouch it from the film since the background was made of solid black velvet. The stars were simply floodlights shining through holes poked in the cloth. This process was to remain the standard means of putting a man into space until Stanley Kubrick designed more ingenious methods for *2001: A Space Odyssey*.

Other scenes in space included long shots of the rocket gliding toward the moon. These were accomplished with various superimposition processes or, wherever feasible, a miniature model suspended from an aerial brace. Sharp lighting in these scenes, as on the full-scale sets of the ship's exterior, added tremendously to their overall effect, as did the marvelous lunarscapes of renowned space artist Chelsy Bonestell. These were posed behind a life-size surface of the moon that, itself, was crafted from plaster and covered over one thousand square feet of a soundstage. The backdrops were raised or lowered on any of the four sides to allow for changes in camera positions, and were printed so as to bleed flawlessly from the three-dimensional set, thus creating the illusion of near-infinite depth.

To coin a metaphor, *Destination Moon* took off like a rocket. It made over $4,000,000 and won a special effects Oscar. Inspired by this success, and with double the half-million dollar budget of *Destination Moon*, Pal pushed ahead with the most unusual diaster film of all-time, *When Worlds Collide* (1951). The story tells of man's attempt to build a rocket that will ferry forty people to safety when the gravitational force of two stray worlds tears the earth assunder. Pal's craftsmen won another Oscar for their visual trickery, and rightfully so. Bonestell's fiery paintings of the approaching planets evoke a healthy respect for the holocaust to come. And when it arrives, Pal gives the audience its money's worth. Through glass paintings, 1:180 miniatures, and mattes, he submerges Manhattan beneath four hundred feet of water. While matte lines weaken shots of the Hudson River cascading through Herald Square—it is difficult to match every splash and crest with absolute precision, a problem that also plagued *The Ten Commandments* crew half a decade later—the rest of the deluge is well done. Forests and rustic vistas buckle convincingly beneath earthquakes, fires, and additional floods, all of these filmed at high speeds and to great effect.

The launching of the Space Ark was done with

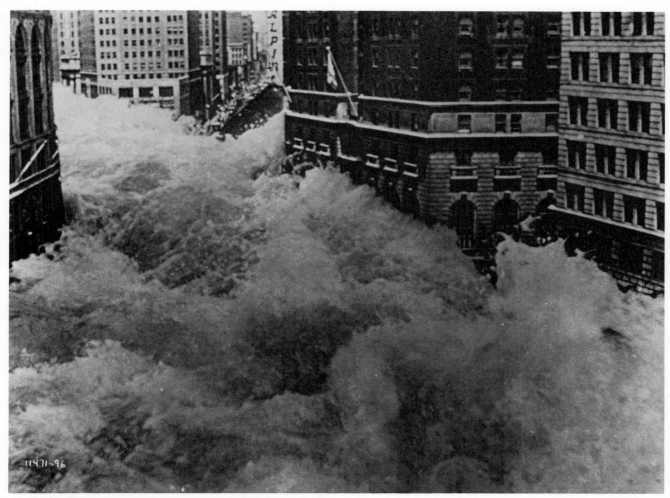

New York's Herald Square is flooded in a matte shot from *When Worlds Collide*. Note the matte lines around the right fringes of the deluge.

wires. Five filaments attached to the spine of the four-foot-long model guided it along a ramp that scaled the side of a miniature hill. Small butane fires were effectively shot from within the rocket's body to simulate the main thruster and a pair of pitch-and-yaw jets under each wing. Only when the craft was airborne did Pal's magic tapestry pucker at the seams. After lift-off, the ship's ascent from earth is shown via simple and remarkably crude double exposure. One can see Bonestell's beautiful painting of earth right *through* the superimposed model. Worse than this brief shot, however, is the landing on Zyra. Not unlike a dive-bomber, the spaceship comes screaming through the air and skids madly across the planet's snowy surface. Sadly, the horizon of this miniature set is obviously a two-dimensional backdrop. Compounding this weak display are the similarly flat landscapes that the survivors see when they step from the ark. In all, these few scenes serve

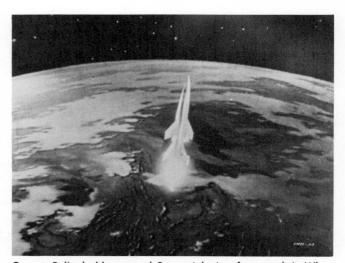

George Pal's double-exposed Space Ark rises from earth in *When Worlds Collide*.

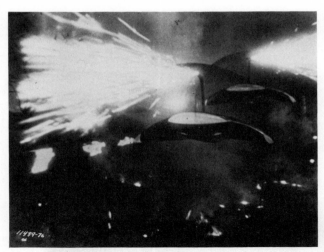

The war machines from *War of the Worlds*.

to dissipate much of the awe that viewers should have taken with them from the theater.

Regardless, *When Worlds Collide* is an impressive show that caused a deluge of box-office receipts for Paramount Pictures. The producer seemed to know what he was doing, so the studio gave him what would once have been an undreamed of two million dollars to film H. G. Well's *War of the Worlds* (1953). Not surprisingly, $1,400,000 of this money went to the creation of special effects, which won Pal his fourth Oscar in this category. However, the honor was tinged with sadness. The man to whom the award would have gone, chief technician Gordon Jennings (*Reap the Wild Wind, When Worlds Collide, Samson and Delilah*), died shortly after the picture was completed.

Pal had screenwriter Barre Lyndon transpose Wells's story from England of 1894 to contemporary Southern California. While the update eliminated the story's period charm, it allowed Pal to pit tanks and atomic weaponry against the Martian invaders. This, however, was not the only change. In the novel, the octopod aliens arrive on earth in huge cylinders and emerge to construct tripod-legged war machines. Pal's crew was anxious to be faithful to the author's conception, and expended considerable effort in this direction. Of course, commensurate with the update, the filmmakers decided that the legs should be irradiated columns rather than archaic mechanical stilts. Accordingly, they built a miniature robot several feet tall and, from overhead wires, fed one million volts of electricity into the model. This charge was conducted to three thin wires suspended from the belly of each craft, and the resultant sparks were forced to the ground by off-camera fans. Unfortunately, though the results were dramatic, the possibility of starting a fire or electrocuting a crewmember were ever-present. Thus, with great regret, the designs were abandoned in favor of flying saucers that fired lethal rays from cobralike extensions on their upper shells. The technicians ended up building three miniature saucers in all, each one forty-two inches in diameter and made of copper. Fifteen wires connected to each machine supplied them with electricity, while the death ray was welding wire melted and fired through the snaking orifices by a blow torch.

The onslaught of these war machines is spectacular. Like Pal's earlier flying miniatures, the saucers were suspended from dollies and wheeled along overhead tracks. This carried the models on a slow, destructive course through Los Angeles. To make this attack as gripping as possible, Pal obliterated miniature reconstructions of the city's most famous streets and sites, including an eight-foot-tall clay model of City Hall.

Another of the picture's fearsome effects is the Martians' disintegrating rays. These green-glowing beams emanated from either end of the saucers and caused slow, hazy vaporization as opposed to the death ray's fiery decimation. To create the latter effect, it was necessary to time a preset explosion with the flashing of the ray. The atomizer trick was somewhat more complex, although it's a gimmick often seen in science fiction films. Prefilmed footage of the actor or prop to be removed is projected on an animation stand, the lightbox an animator uses to see his previous sketch through a blank sheet of paper that he may render the next progressive movement. For this film, hand-painted mattes were made of the doomed elements once they had been hit by the ray. After this had been run through an optical printer, there was only an opaque image against the background. Again using the animation stand, the ray and foggy iridescence were drawn until they and the object had almost vanished. An optical printer superimposed this dispersion over the matted footage and the effect was accomplished. An average of one to two hundred frames had to be doctored to achieve this effect. Of course, this optical process presents one obvious problem. An actor, for example, cannot run onto the set, be struck with the beam, and disappear all in one take. The matte will, indeed, remove him from the frame, but it cannot replace the background his body had

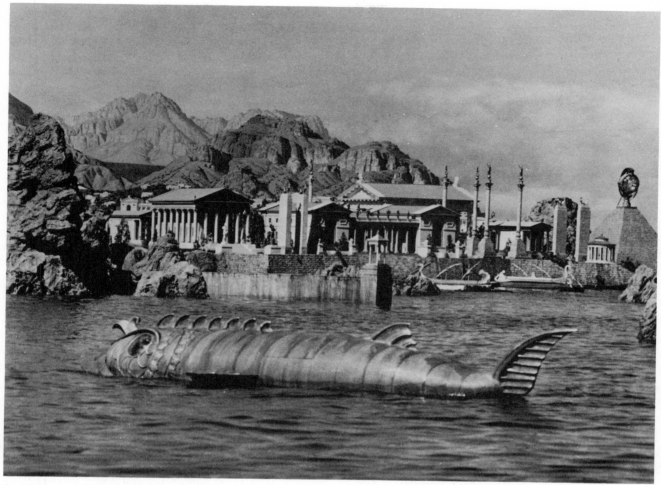

A miniature set of *Atlantis, the Lost Continent*.

blocked during the initial filming. Thus, one of four methods must be employed to run the effect smoothly. First, the actor can be photographed until it is time for him to be dissolved. The film is then stopped, the other actors remain stationary, and the victim leaves. Filming is resumed, and the animation is executed over this footage. There has been a cut in the action, however, and it may be obvious: someone on the set is bound to have changed position or moved his eyeline even slightly. Accordingly, filmmakers will often insert a close-up of shocked observers to break the shot naturally, then return to their special effect. Another "cover-up" is for the destructive light to fill the screen entirely for several frames, which also hides the break in the action. Finally, a technique employed to avoid any cuts whatsoever is to simply matte the ill-fated actor or prop against a prefilmed scene. In this way, the

background into which he has been composited has already been filmed in its entirety, and the effect can be achieved in a single, unbroken take.

This fourth feature-length picture was another blockbuster for Pal, and his batting average was destined to include three more hits in his next four trips to the plate. *The Naked Jungle* (1954) was the first of these money-makers, a nonfantasy film starring Charlton Heston as the South American plantation owner who must battle a miles-wide army of ravaging killer ants. Although the flood that ultimately drowns the insects was lifted from *When Worlds Collide*, the film does feature some interesting cartoon animation and glass paintings showing the approach of the bugs. Next came *Conquest of Space* (1955), a return to *Destination Moon* territory and a major disappointment. This trip to Mars lacked its predecessor's originality and polish, and

even the work of Chesley Bonestell, Farcoit Eduard, and John P. Fulton—the latter two new to the Pal corral, replacing Gordon Jennings—was not up to their usual high standards. The film was a financial disappointment, and Pals involvement with Paramount came to an end. He went to MGM where he produced *Tom Thumb* (1958) and *The Time Machine* (1960), both of which were hugely successful and earned Pal his fifth and sixth special effects Oscars. The former boasted a show-stopping sequence in which Tom (Russ Tamblyn) dances with a room full of stop-motion toys, while *The Time Machine* sent minutes, hours, and centuries spinning by in seconds through model animation and time-lapse photography. Time-lapse photography, as the name implies, is the exposure of one frame of film at regular intervals. In this way, clouds are made to hurry across the sky, or a candle to melt in seconds. *The Time Machine* quickly became Pal's most popular film, a fitting tribute to author H. G. Wells, but here the producer's winning record came to an abrupt halt. *Atlantis, the Lost Continent* (1961) failed to showcase the stunning visuals that had become synonymous with the films of George Pal. Stock shots of the burning of Rome from *Quo Vadis* (1951) were interspersed with new footage of the final cataclysm, while the actual sinking of the land of super-science was done with unimpressive miniatures. *The Wonderful World of the Brothers Grimm* (1962) was also unable to find an audience, despite the opulence of its production and special effects, and the benefit of Cinerama; *The Seven Faces of Dr. Lao* (1964), *The Power* (1967), and *Doc Savage* (1975) all suffered an increasingly cold reception from the public. Of these latter three, only *The Seven Faces of Dr. Lao* managed to crawl to a small profit. More on this film in a moment.

One of the ironies of Pal's career is that had he come to Hollywood at roughly the same time as Disney, he may have built himself an empire. Pal has a good business and story-telling sense; in fact, he and Disney were good friends. They shared a similar attitude toward their product: if it's impossible, let's *do* it! Unfortunately, Pal's momentum was constantly thwarted, both overseas and when his Puppetoons began in America. To date, then, the legacy of this soft-spoken, very gentlemanly producer has been to advance the art and marketability of movie special effects as much as Disney, Harryhausen, and DeMille. Critics decry the fact that in a Pal film, camera trickery often subjugates

the plot and actors, and this is quite true. Indeed, were we hosting a critical analysis of Pal's feature film work as *drama*, it would fall far short of the Disney or DeMille films. However, in a supervisory capacity, Pal has wrested some of the finest special effects work from Hollywood's top talent, and has earned the field a great deal of respect and attention.

A young man who cut his teeth on many of Pal's stop-motion films is, today, one of the most diligent and skilled technicians in the business. Jim Danforth's first professional assignment was to sculpt wooden figures for the model airship *Albatross* used in the film version of Jules Verne's *Master of the World* (1961). Subsequently, he joined the recently disbanded Projects Unlimited, a Hollywood-based special effects team featuring model-maker Gene Warren and animators Wah Chang, David Allen, and Tim Barr. Together, the group handled everything from creating stop-motion and costumed terrors for television's *Outer Limits* to animating many of Pal's movie monsters. However, of all Danforth and Projects Unlimited's work, their masterpiece is the climax of *The Seven Faces of Dr. Lao*. Lao, an elderly Chinaman, has brought a strange circus to turn-of-the-century Texas, one of the exhibits of which is the legendary Loch Ness Monster. While submerged in its fishbowl, the beast remains a small, innocuous slug. Exposed to the air, it will become a rampaging monster. When a pair of ruffians sneak into the abandoned circus and shatter the serpent's tank, they unleash a marvelous screen effect. The gastropod flops around on the ground and, in a long shot, as the encroachers cower in a far corner of the tent, the eellike creature begins

The stop-motion Loch Ness Monster sprouts the other six of the *Seven Faces of Dr. Lao*, from left to right: Pan, Lao, Merlin, the Abominable Snowman, Medusa, and Appolonius.

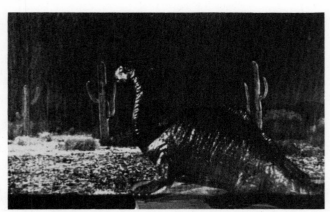

The shrinking of the Loch Ness Monster through a front-screen set-up. From *Seven Faces of Dr. Lao*.

to bloat and take shape. A ferocious, tendriled head grows from the end of an elongated neck, the body sprouts a tail and flippers, and the transformation is soon complete. This trick was accomplished by miniature screen projecting the two rowdies and moving the monster ever-closer to the camera while animating its movements. Several different stop-motion models were built to represent the various stages of growth, and a matte was used to add foreground elements and hide the table on which the monster was being animated. The special effect was repeated in reverse when Lao causes a rainstorm and the monster is shrunken to its original, unimposing size.

Danforth and his associates lost the special effects Oscar that year to *Mary Poppins* and, as we mentioned earlier, lost against Disney again in 1971. However, the Projects Unlimited alumni show great promise. Although they haven't been as active in feature film production as Ray Harryhausen, their dedication to the constant refining of special effects techniques, even as manifest in their television series and commercial work, bodes well for the field. Sadly, the magnitude of their contribution will depend less upon skill than on the climate of the industry. When the public demands more screen fantasy, perhaps Projects Unlimited will return.

8
The Sixties and Seventies

The impossible we do immediately. The miraculous takes a little longer.
— Motto on a wall of the Universal Pictures special effects department

When we last saw the major Hollywood studios, they were in a bad way. Morale was crumbling, box-office receipts were down, budgets for the epic films were skyrocketing, and the in-theater gimmicks had gotten out of hand. Indeed, before the craze was through, there was a formidable race in which producer Mike Todd (*Around the World in Eighty Days*) tried to rush his Smell-O-Vision process to theaters before Walter Reade's fly-by-night imitation AromaRama stole his thunder. Todd spent millions of dollars developing a complex network of pipes that wafted scents to each seat. These puffs flavored the on-screen image, after which they were sucked away by a sophisticated system of fans. Unfortunately, the AromaRama company hurried *Behind the Great Wall* (1959) into release, for which chemical reproductions of smells were also used but blown helter skelter through a

theater's air conditioning system. It was ineffective, and turned the public's nose from Todd's interesting—despite its tatty title—*Scent of Mystery* (1960). In any case, it quickly proved far too expensive for all but big-city theaters to accommodate the restructuring necessary for Smell-O-Vision, Cinerama, or even CinemaScope, and these formats soon flickered from view. With a ratio that could be adapted to most any theater, Panavision became the standard wide-screen format, and so it remains today.

Though the industry threw in the towel on the majority of audience participation gimmicks, Hollywood's taste for the sensational had not been dulled. They stopped shooting expensive biblical and historical epics and concentrated on the one sure way to compete with television, by giving the public what it couldn't get on the Puritan home screen: sex and violence. How many of the cinema's bared bosoms and carnal displays were special effects is, happily, not our concern. The violence, however, relied heavily on the skill of the special effects man.

Gordon Scott bends rubber bars run through with a pliable metal. From *Goliath and the Vampires* (1964).

One of the early and enduring showcases for bomb blasts, bizarre deaths, spectacular gimmicks, and sex, were the James Bond films. To date, there have been ten pictures in the series, every one of them a special effects man's dream. *Dr. No* (1962) is the now-legendary autocrat who was intent on knocking American rockets from the sky. Bond stopped him, but not before deadly encounters with the special effects department. The most unusual and least satisfying trick was when 007, abed in his Jamaican hotel, watched a tarantula crawl from under the blankets and onto his chest. Since the arachnid's sting is, in reality, quite paralyzing, star Sean Connery was understandably reluctant to suffer its whims. Accordingly, a sheet of glass was placed between the actor and the spider, and the scene was shot from above. Even though the camera and glass were parallel to Connery's reclining form,

the creature's path does not conform to any of the actor's dips and contours. The more flamboyant effects were considerably better. These included a huge, flame-throwing tank that Bond encounters on Dr. No's Crab Key Island, and the climactic explosions that reduce the villain's atomic laboratory to a flaming heap.

The second Bond film, *From Russia With Love* (1963), has the criminal organization SPECTRE whipping the Cold War to a boil by stealing a Soviet code-breaking machine, framing the British, and ransoming the device back to the Soviets. Beyond the film's requisite engineering effects, such as a watch from which a wire-garrote unreels, there is an explosive finale as Bond is pursued by speedobats armed with grenade launchers. Enemy bullets find 007's gas tanks, and their contents spill into the Gulf of Venice. Seemingly outnumbered, with the

SPECTRE fleet gaining on his crippled craft, Bond fires a flare pistol at the sheet of petrol. The resulting flames consume the villainous armada, and Bond is saved. To work this holocaust, special effects man John Stears covered almost a half-mile of sea with cellophane bags. Floating just below the surface, each package contained five gallons of gasoline. One cue, the blaze was touched off and spectacular explosions ensued. In fact, the effects were over-achieved as two boats caught fire despite asbestos coverings.

Goldfinger (1964) was an archfiend with a plot to contaminate the gold in Fort Knox via radioactivity, thus rendering it unapproachable and increasing the worth of his own vast stores. Naturally, his plan is foiled by our hero. Moreso than in previous Bond films, mechanical gadgetry was the special effects man's primary charge, especially Bond's smoke-screen and oil-slick emitting, passenger-ejecting Aston Martin. There's also the famous razor-rimmed hat of Goldfinger's aide Oddjob, which was sent flying through the air by means of overhead wires. Unfortunately, not everything airborne in the film was flown with authority. After the Fort Knox nuclear bomb has been deactivated, Bond and Goldfinger slug it out onboard a private jet. Stray bullets shatter a window, and the villain is sucked from the plane. This sudden depressurization also causes the craft to crash into the sea. Bond and ladyfriend Pussy Galore parachute to safety as a miniature plummets dramatically into a studio tank. Surprisingly, despite the attention paid to every-thing that had gone before, the aircraft's support wires were plainly visible on screen.

The three Bond pictures made an awesome profit, and the producers were determined that their next effort make even more money. It did. Filled with more girls, action, and gadgets than ever before, *Thunderball* (1965) remains the most popular film of the series. Technically, it was also the most impressive. Bond's Aston Martin had an extremely powerful water jet added to its defensive repertoire, and Bond, himself, was now capable of flight or rapid subsea travel, courtesy of a concealed rocket pack. These and other mechanisms were put to good use by the super-agent as he sought a pair of nuclear bombs stolen by the *S*pecial *E*xecutive for *C*ounter-*I*ntelligence, *T*errorism, *R*evenge, and *E*xtortion from a NATO bomber and used to hold the world for ransom. The hijacking of the plane was done, in part, with some credible miniatures—certainly

better than the jet in *Goldfinger*—but the highlight of the film was the exciting underwater battle with Bond, frogmen, spearguns, and sharks all involved in a struggle for possession of the warhead. While scenes of Connery flitting about the deep with his thruster backpack were somewhat incredible, their technical execution was breathtaking. Indeed, this sequence was responsible for winning the picture an Oscar over the puzzling competition of George Stevens's New Testament epic *The Greatest Story Ever Told*.

You Only Live Twice (1967) was a "remake" of *Dr. No* as SPECTRE busied itself with the snatching of manned Soviet and American spaceships from earth orbit. This was done by means of unlikely rockets that swallowed the capsules and returned them to SPECTRE's facilities in a volcanic creater. Each nation blamed the other for the kidnappings, which, the criminal organization hoped, would lead to world war. As ever, the plan was doomed to failure as Bond and a regiment of Japanese *Ninja* warriors destroy the impressive headquarters with equally impressive explosions. The volcano set, complete with full-size, wire-operated rockets, control rooms, and monorail system, cost more to build then the entire budget had been on *Dr. No*. Sadly, this expenditure served to dwarf the human players—who were no more than flat, comic book characters to begin with—while wrongly glorifying technical ostentation. The Bond films had become victims of very showy, very impersonal mechanical effects, the same problem that overwhelmed such films as *Things To Come* and *War of the Worlds*. Yet, with all the money that was pumped into the sets, the scenes in outer space, with their abundance of miniatures and mattes, were incredibly poor. Since the technical crew had proved that they took pride in their product with both the volcano set and a thrilling battle between SPECTRE helicopters and Bond's autogyro, only one explanation seems possi-ble: when they had finished with their more dramatic displays, there simply wasn't the money to spend on effective optical work. Fortunately, the next Bond picture steered clear of this unhealthy formula.

Sean Connery did not star in *On Her Majesty's Secret Service* (1969), dissatisfied with the character and scripts. In his place was George Lazenby, whom the producer surrounded with a truly opulent production. Filmed on location in the Swiss Alps, SPECTRE's plans involved sterilization of the

Sean Connery atop the moon buggy used in *Diamonds Are Forever*.

earth's cattle and crops, thus starving mankind into submission. There were ski and sled chases galore, in which the principals partook via front-screen projection while some very talented skiers doubled in the long shots. There were few electronic gadgets, and certainly nothing as bizarre as the *You Only Live Twice* rocket belt or the absurd moon lander in the next Bond picture, *Diamonds are Forever* (1971). In this outing, with Connery back in the saddle, Ernst Stavros Blofeld of the SPECTRE heirarchy launched a diamond-studed satellite into earth orbit. The gems were used to magnify laser beams with which Blofeld intended to level various world cities. After the standard detours, Bond blows up Blofeld's off-shore oil rig control center. To expedite matters, Her Majesty's secret service beefed up the Aston Martin's arsenal with rockets, which, although tending to stretch one's tolerance, remains one of the *less* incredible gimmicks in the

film! Bond's use of a lunar excursion module to escape from a terrestrial space laboratory must rank as one of the hokiest scenes in movie history. The functional mock-up is quite impressive, although it is doubtful that the flimsy craft could have withstood the rigors through which Bond put it. There is one excellent scene in the research center, however, that skillfully used special effects to underline the inherently droll bent of the film. We watch as astronauts explore the moon's surface in the slow, unsteady style to which we became accustomed in Apollo. There is no hint that this is anything *but* the moon. The set is superb: the lunar landscape and sky, with the earth glowing in the distance, are quite realistic. Suddenly, Bond comes bursting in, dressed in a business suit, as the directors of this simulated *eva* scream their displeasure. Once again, however, despite these excellent production values, the models and composite photography in the space

The *Diamonds Are Forever* moon set. This photograph, with Sean Connery making like *Apollo 14*'s Alan Shepard, was for publicity purposes only.

scenes, especially those involving the gem-encrusted satellite, were positively abyssmal.

After *Diamonds are Forever*, Connery again left the series, being permanantly replaced by Roger Moore. With Moore's coming, the films took on a more austere and contemporary air. Although there was no shortage of gadgets, death-traps, and special effects, the plots were far less sensational. Drug smuggling was the basis of *Live and Let Die* (1973), and the film provided several interesting special effects challenges. Not all of these were of a spectacular sort: for example, there was a scene in which Bond, locked in a girl's embrace, was supposed to unzip her dress using a magnetized wristwatch. To work this intimate encounter required the intrusion of several people. Julie Harris, the costume designer, was on her knees and out of frame, gently tugging at the hem of actress Madeline

Smith's dress, while Derek Cracknell, first assistant on the film, was also on the floor, his hands up Ms. Smith's skirt, pulling a wire attached to the "magnetically controlled" zipper. Of course, there were the more typical Bond displays, such as the full complement of cars and airplanes designed to fall apart during an epic airport chase, and the absurd demise of drug czar Mr. Big. As Bond and the smuggler fight to the death in a shark-filled tank, 007 shoves a gas pellet into his opponent's mouth. The villain bloats like a dirigible, rises to the ceiling, and explodes. It's the only really tacky effect in the film, the substitution of a balloon for star Yaphet Kotto not at all well-disguised. Happily, the most recent Bond film, *Man With the Golden Gun* (1974), shied away from these tricks concentrating, instead, on plot, action, and sex.

No matter how corny or lascivious the Bond films became, they were never obtuse about their murders. There *were* deaths, and grotesque ones at

that: people were fed to piranhas, had scorpions dropped down their clothing, suffered immolation, or were fried in atomic wastes. However, there was relatively little bloodshed in these scenes. In fact, at the height of the Bond boom in the sixties, the screen in general was still relatively free of explicit bloodletting. Then came films like *Bonnie and Clyde* (1968) and directors like Sam Pekinpah who changed all of that. Not only did they heap floods of gore at cinemagoers, but they did so with obvious relish and in careful slow motion. Objectively, of course, the quality of these effects was inarguably top-notch. Subjectively, their elegance must be left to one's affinity for such things.

Bonnie and Clyde was the trendsetter in this area of graphic slaughter, with the multiple-gun deaths of the title characters while they were seated in their car. To cause bullet holes and accompanying splashes of viscera, special effects man Danny Lee attached small *squibs* to stars Warren Beatty and Faye Dunaway. These squibs are charges that create an explosion but no smoke. Set in small metal plates, they are placed on the performer beneath his or her clothing. A wire is run from each squib to a battery powered control board; when the off-camera special effects man touches his end of the wire to the power source, the squib goes off. In the case of *Bonnie and Clyde*, one line was run from all the charges. This riddled the stars and their car with a rapid-fire barrage. Pouches of theatrical blood on top of the squibs made for a grippingly realistic flow of crimson. Complementing these attacks were bullet wounds on exposed flesh, courtesy of gelatin capsules fired at the actors from out of frame. These small pellets were filled with "blood" that burst over the skin on contact. In the case of the car, holes were drilled in the metal, squibs were placed inside, and the openings plugged. So perfectly timed were the charges that a "bullet" that pierced the car struck the actor a moment later. Naturally, all of this painstaking effort would normally pass in only a few seconds of on-screen violence. However, since the deaths of Bonnie and Clyde—or more succinctly, the *brutality* of their deaths—were so important to the timbre of the film, the massacre was prolonged by high-speed photography.

One director who has since made this slow-motion violence his trademark is Sam Pekinpah. After pioneering realistic arrow deaths in *Major Dundee* (1965)—for the most part, actual shafts were fired at pads beneath the actors' clothing while concealed harnesses yanked the victims violently from their mounts; at other times, the arrows were hollow and fired along wires that stretched from the bow to the actor—Pekinpah helmed some of the most sadistic pictures ever made. Among these are *The Wild Bunch* (1969), *The Getaway* (1972), and *Bring Me the Head of Alfredo Garcia* (1974). However, it was *Straw Dogs* (1971) that gave new meaning to the word vulgarity.

Straw Dogs is the story of how meek Dustin Hoffman strikes back at the townspeople who have taunted and abused him. After over an hour of sexual soap opera in which local men seduce his wife and butcher her cat, they raid Hoffman's home to arrest a young criminal to whom he has given sanctuary. Defending his residence from the mob, our hero shoots all comers; those who escape his bullets are done-in with a massive bear trap. While all of this is thoroughly convincing, the most inventive scenes are those in which the local constable is blown to pieces with a shotgun and when one of the aggressors accidentally shoots off his own foot. To create the first scene, special effects man John Richardson planted squibs along the actor's front and back to describe the bloody course of the high-caliber bullet. To simulate the impact of the blast, Richardson had the performer stand on a remote-controlled, compressed-air springboard that launched the poor fellow up and away when he was shot. The foot trick was less complex: a boot was fitted with raw steak, theatrical blood, and a handful of squibs. When the charges were detonated, sinew and gore tore through the shoe leather.

The slow motion sensationalism of *Straw Dogs* is the exception rather than the rule, but filmmakers manage to prolong screen violence simply by making it more severe. A case in point is the killing of Sonny Corleone in *The Godfather* (1970). James Caan donned underclothes rigged with dozens upon dozens of squibs, which exploded as the character withstood several long, gruesome seconds of machine-gunning. The film's supporting players like Sterling Hayden were more fortunate. He didn't have to wear anything like the $100,000 suit that chewed away at Caan. But he did have to gurgle convincingly as blood poured from a bullet wound that Al Pacino drilled through his throat. And perpetuating this fascination with bloodshed are pictures like *Dirty Harry* (1972), *Magnum Force* (1973), *Capone* (1974), and *The Godfather, Part II* (1974), with no end in sight. Hollywood has

achieved the goal it set for itself some twenty years before: to use man's animal passions against television. But the industry had more up its sleeve than gratuitous mutilation. Those calamity films of the thirties and forties like *San Francisco* and *Typhoon* had been comparatively tame romantic adventures. True filmic suffering had yet to be heard from, and filmmakers wasted little time turning to epics of human disaster. Thus, running parallel to the growth of violence in film was the maturation of ever more graphic forms of jeopardy as dictated by maddened birds, flaming skyscrapers, and gluttonous sharks. And, as in the James Bond and Pekinpah films, success for the bulk of these movies depended less on the performers and directors than on the talents of the special effects men.

Alfred Hitchcock made the finest film of the nature-gone-wild genre which, in addition to the *Deadly Mantis* and *Them!* ilk, included such pictures as *The Deadly Bees* (1966), *Willard* (1971), *Frogs* (1971), *Night of the Lepus* (1972), *Bug!* (1975), and *Jaws* (1975), a picture we'll study later in this chapter. Most of these efforts were unimposing programmers with little in the way of interesting trick camera work. In fact, one must imagine that the obvious miniature sets and rear-screen projection used in *Night of the Lepus*—an attack of giant rabbits—was tongue-in-cheek homage to the many equally tatty works of the fifties, such as *The Giant Gila Monster* (1959). But Hitchcock's *The Birds* (1963) was able to balance its satisfying special effects with a meaty motion picture. Ub Iwerks was responsible for the camera magic in this tale of the avian kingdom's revolt against man, and he had a demanding boss: Hitchcock's films were famous for their novel trick shots. An example of this was one of John Fulton's incredible matte shots in *The Saboteur* (1942), a down-view of the film's antagonist falling from the torch of the Statue of Liberty. The director wanted *exactly* the shots he had envisioned, and it was up to the crew to deliver.

Iwerks employed many of the tricks he had worked for the equally demanding Disney. These included the use of limited-motion mechanical models for scenes requiring contact between people and the feathered fiends; cartoon animation for performances it would have been impossible to draw from real birds; rear-screen projection; and a thin tank of glass wedged between the camera and the set. Here, the birds were let loose and stirred to a frenzy at no risk to themselves or the performers.

The result of Iwerks' labors was a tour de force that more than balanced Hitchcock's uncanny sense of drama and characterization. The fact that *The Birds* lost the special effects Oscar to *Cleopatra·* should come as no surprise: seldom, as we have seen, has the Academy of Motion Pictures Arts and Sciences placed merit before publicity hype.

Like *The Birds*, *Jaws* was a highly touted man vs. animals film. Indeed, the Peter Benchley shark story went on to become the top-grossing motion picture in history, an honor it certainly didn't deserve. This author is particularly annoyed in that the much-praised special effects are as plastic as the actors. The film's huge mechanical shark was built by Robert Mattey, whose squid in *Twenty Thousand Leagues Under the Sea* makes the *Jaws* fish look like a plastic hobby kit. Another mark against the film is that its one truly effective scene, the attack on Chrissie at the picture's beginning, is an almost shot-by-shot imitation of the Creature from the Black Lagoon's pursuit of Julie Adams in that 1954 horror classic. Even the *Jaws* music is based on the Creature's score. The only difference between the two films is the realism of the Lagoon monster—swimmer Ricou Browning in a supple, beautifully sculpted sponge rubber suit—as opposed to the artificiality of the shark.

The plot of *Jaws* revolves around a huge shark's territorial claim to the waters off Long Island's Sound city of Amity. The town fathers refuse to shut the beaches during the crush of summer tourism, and several people are ultimately devoured. The results of these attacks are shown with forthrightness and, since we must judge the special effects as to how smoothly they accomplish the director's ends, they were marvelous. Mangled corpses and limbs—a man's leg that floats lazily to the bottom of a bay, a partially gnawed head, a severed forearm and hand—were rendered with aching care in rubber and latex to nauseate rather than scare the viewer. Regrettably, there wasn't the suspense in these presentations that there had been in *The Birds* when Hitchcock artfully built to the film's one sensational sequence, the discovery of a man who had been pecked to death by the birds. In any case, after these grisly artifacts have been milked for all they were worth, it was time to get down to some serious filmmaking. After the fish sups on some Fourth of July swimmers, an oceanographer, a bitter old sailor, and the local Chief of Police set out in pursuit of the maneater. Their encounters with the shark

The mechanical shark from *Jaws*.

required the utilization of two different forms of special effects—other than bad and worse. One of these was bouts with Mattey's mechanical monster, while the second technique involved a real shark.

Unlike the bulk of the picture, which was staged in Martha's Vineyard, Massachusetts, shots of the oceanographer's struggles with the predator were photographed in Port Lincoln, Australia. Doubling for actor Richard Dreyfuss in these scenes was four-foot-nine-inch jockey and stuntman Carl Rizzo, who got the job because the great white shark of the book was eight yards in length, while the average animal is only some three to five yards long. Since it was necessary to use the fish at hand, the animal's size was doubled by roughly "halving" the human performer. The confrontation occurs underwater, with the character in scuba gear, so the substitution

went unnoticed. Rizzo and a second unit crew—the people who specialize in stunt and action sequences—went to sea with a shark cage that had been scaled to 5:8 size. Rizzo's diving equipment had been similarly reduced, and the stuntman was lowered into the water. Pieces of horsemeat were tossed around him, and a shark took the bait. With underwater cameras churning, the crew took reams of splendid footage showing the animal attacking the oceanographer. For some of the more dangerous shots, such as those in which the cage is battered open, and for sequences scheduled to be taken when Carl became ill, a 1:2 dummy was used with appropriately scaled cage and equipment. These scenes—edited at an exciting, rapid-fire clip due to the fragmented fashion in which they were photographed—were incorporated into the finished

film to great effect. Unfortunately, they were surrounded with tripe of the Pekinpah variety. As the picture blunders along, out come the buckets of blood!

Filmmakers have proven, over the years, that an inhuman menace is generally more frightening when shown in brief takes or in shadow. Movies like Howard Hawks' *The Thing* (1951) managed to scare the pants off audiences because each viewer had his own idea what the vaguely seen creature looked like, and thus supplied the details. Often, these were far more horrifying than anything that could ever be shown in a movie. Likewise, two of the most effective murders in movie history were committed more in the imagination than on-screen. In Hitchcock's *Psycho* (1960), Anthony Perkins stabs Janet Leigh to death while she is taking a shower. The scene, which runs only a few seconds, is composed of over seventy separate shots, each one edited just long enough to tell the story and imply its grotesquery, without dwelling on the noxious details. A different manner of suggestion was seen in *Lawrence of Arabia* (1962) as a wounded enemy soldier dragged himself from the wreckage of a train that the Arabs have just destroyed. He fires at Lawrence, who is not badly hurt and watches as a tribal leader sneaks up behind the boy. The chieftan raises his sword, and the soldier turns around with a look of ghastly terror on his face. The camera cuts to Lawrence's pained reaction as he sees the blade cleave the lad's skull. This is no less brutal than any of Pekinpah's murders, but it's far more tasteful and gripping. Not only does a viewer fill in the frightful specifics, but director David Lean offers the added depth of Lawrence's reaction. All of which brings us back to *Jaws*. At the climax of the movie, Roy Scheider and Robert Shaw—as the Police Chief and salty old sailor, respectively—struggle with the shark as their boat sinks slowly from the creature's battering onslaught. Finally, the fish straddles the floundering ship, gets ahold of Shaw, and chews him to gristle. In these scenes, the suspense of suggested terror is flagrantly ignored in favor of crimson tides that shoot about the deck as a grimacing Shaw slides into the monster's maw. The scene offers Shaw little to do other than make the most of his gnawing agony. In this respect, he emulates the gasping performance of Sterling Hayden in *The Godfather*, and one is not surprised to learn that Hayden had originally been slated for this part.

The life-size mechanical shark was used for these scenes and, through overexposure and a lack of technical conviction, reduces the sequence to slapstick. We watch the beast for too long in unbroken takes, and the redundancy of its movements become quickly obvious. Expeditious cutting and the shield of a rainstorm had helped prevent this problem with the squid in *Twenty Thousand Leagues Under the Sea*. Actually, the *Jaws* shark was, in fact, three sharks, built at a total cost of nearly $200,000. Although Mattey had given up active filmmaking several years earlier, the challenge of this film coaxed him from retirement. Within a week of accepting the job, he had built table-top models of the mechanism showing how the twenty-five-foot model fish would work. Producers David Brown and Richard Zanuck liked what they saw, and the bankers at Universal okayed funds for its construction. Half a year later, the cameras would begin to roll on the East Coast. The sharks' interiors were made of steel tubing with hinged joints to allow for accurate movement, while the flesh was molded of neoprene plastic, covered with polyurathane and nylon—this latter to allow the skin to stretch when the joints moved—and blow-covered with sandblasting sand and paint. This mixture accurately duplicated the coarse, gritty texture of real shark skin. Assembled in a special facility outside the studio, the sharks were built so that one of the models was completely open on the left side, while another was bared on the right. This helped facilitate their operation. Only one of the monsters was fully covered for the necessary head-on shots. Shipped to the Massachusetts location, the robots were personally manipulated by Mattey and his fifteen-man crew.

If building the models were difficult—and it *was* difficult, with such problems as peeling paint and the teeth having to be dulled or replaced because they glistened unrealistically when photographed —then floating the creatures was an even bigger problem. The models, which weighed two tons each, were powered pneumatically, with thirty motors and an equivalent number of air hoses running from each model to a barge stocked with generators. Through this power source, Mattey and his men controlled the fish's dives, fins, eyes, tail, and, of course, its jaws. In addition to the barge, there was also a twelve-ton steel platform with a

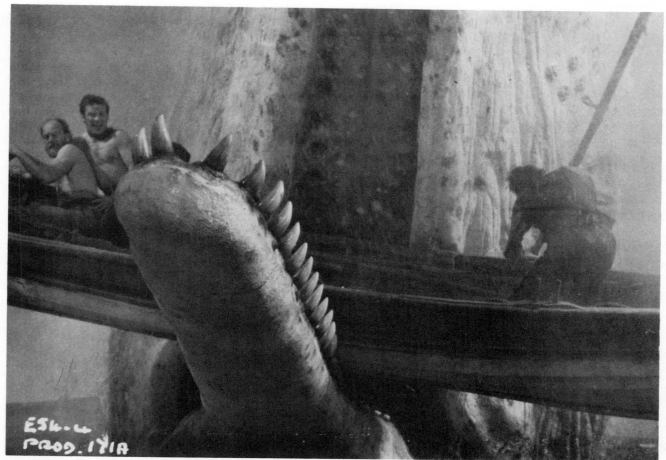

More awesome than the *Jaws* shark is this scene from *Moby Dick*, as the life-size mock-up of the Great White Whale splits a harpoon boat in twain. Star Richard Basehart is second from left. Is the similarity between this photograph and the *Jaws* poster a coincidence?

twenty-foot mechanical arm mounted on top of it. One of the two "open" sharks was secured atop this device while the platform was run along sixty to seventy feet of steel tracks that had been laid on the ocean floor. Through this undersea railroad, the shark was made to swim. The one fully constructed fish was attached to a sea sled, a skeletal submarine that was operated by divers. Specially rigged hoses and cables were responsible for sinking the ship brought down by the shark.

Clearly, a great deal of work, money, and dedication went into these special effects. But the work just doesn't show on-screen, and this is largely the fault of the director. He should have known when enough was enough. Perhaps the *Jaws* crew would have made a better film had they studied the

more skillful use of special effects in *Moby Dick* (1956). This second screen version of Herman Melville's classic novel also used full-scale mock-ups of the great white whale, but to much better effect. The mechanical model of the monster's head could shoot from the studio tank and swallow up harpoon boats, while reconstructed portions of its powerful tail and humped back were used in scenes of pursuit in the open sea. Shots of the beast ramming Ahab's ship, *The Pequod*, were done with an eleven-foot-long miniature. However, comparing the overrated *Jaws* to the underrated *Moby Dick* offers further evidence of how pacing and editing are as important as technical acuity to believable special effects. The whale is introduced after Gregory Peck, as Ahab, delivers a somber soliloquy about Moby Dick's might. He finishes by telling the crew that, "You'll smell land where there is no land." Then he observes the gulls. They're circling a calm swatch of sea. "The birds," he shouts. "Watch the birds!" The ocean begins to swell and, moments later, as Peck

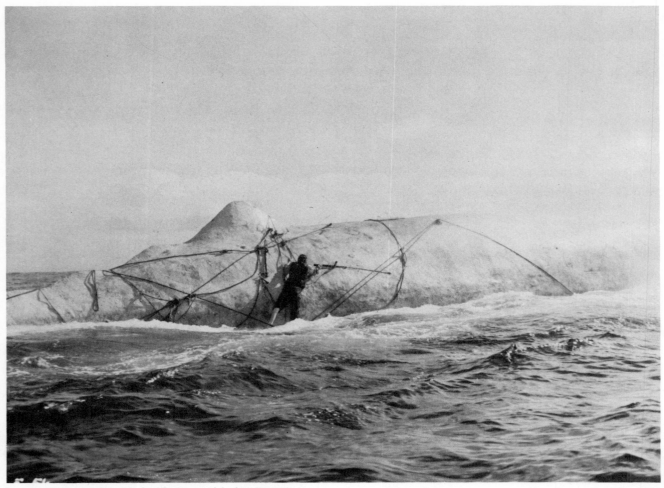
Gregory Peck struggles with the life-size model of *Moby Dick*.

screams a passionate, "He rises!," the monster literally explodes from the ocean in a cacophony of sound, drama, and magnificent screen trickery. In any case, the visuals were certainly made more impressive by this buildup. Indeed, the power of the players and the intensity of John Huston's direction keep the film from being overwhelmed by its title character. This is a balance missing, for example, from many of the disaster films that have been made over the past few years. These are not unlike the movies in which animals lash out at mankind, except that the aggressors are the elements and they invariably give the director no time to develop his characters. This is a telling break from earlier films of this type, such as *Last Days of Pompeii* or *Hurricane*, in that the holocaust is no longer saved for the final reel! Only in Robert Wise's *The Hindenburg* (1975) was tradition sensibly upheld as pro- and anti-Nazi factions exchange

words and blows, the zeppelin is sabotaged, and the plot, per se, is over before Wise pulls the rug from under his players' feet.

The Poseidon Adventure (1972) was one of the films that shook the genre free of mothballs, overturning a ship with a huge wave, then having a handful of survivors pick their way to freedom through the topsy turvy vessel. Producer Irwin Allen, who had learned a great deal about effective movie magic in *Animal World*, *The Lost World*, and *Voyage to the Bottom of the Sea* (see chapter 10), employed a miniature ship for all the exterior long-shots, and wisely photographed it from above. This eliminated the need for a painted backdrop, the flat nature of which would have detracted from a satisfactory illusion. The arrival of the wave itself is awesome, filmed in slow motion from the same high angle. The waters overturn the ship while, inside,

we see the terrified passengers being flung about the main dining room as the craft is upended. These interior scenes were shot on a full-size set that was one hundred and eighteen feet long, sixty feet wide, and twenty-eight feet high. Modeled after the dining hall on the Queen Mary—where many exterior scenes involving actors were shot—this set was built to be tilted almost thirty degrees, causing tables and extras to slide realistically about. The remainder of the capsizing was accomplished by severely angling the camera or dropping stuntmen to a ceiling set that had been built on the floor. Scrupulous editing structured these scenes in astonishing fashion. And, showman that he is, Allen followed the cruiser's inversion with an explosion that sends the ocean pouring into the great hall of the ship, drowning most of the occupants. The deluge was provided courtesy of six air-operated cannons. About the only complaint one is obliged to make about the special effects is that, like countless filmmakers before him, Allen ruined his picture by falling down on the final shot. This scene shows the survivors being rescued through a hole in the ship's hull, for which the *Poseidon* was an obvious miniature placed close to the camera with the people off in the distance. However, it's a minor flaw in a hugely impressive film, and the effects won a richly deserved Oscar.[2]

When *The Poseidon Adventure* became one of the top-grossing films of all-time—it remains fifteenth on the list—Allen went ahead with *The Towering Inferno* (1974). The picture's budget was itself towering: it cost over fourteen million dollars, as opposed to the six million spent on *The Poseidon Adventure*. The drama involves dozens of people trapped by a fire in a nightclub atop the world's tallest building. The blaze erupts on the eighty-first floor of the one-hundred-and-thirty-eight-story sky-scraper, and cuts off all avenues of escape on its flaming climb to the top. After all attempts to extinguish the inferno prove fruitless, the party-goers explode water tanks on the roof and drown the flames. Before this happens, however, helicopters are sucked into the holocaust, people are roasted in slow motion, burning bodies plummet through windows, and fragments of collapsing building shower the street below.

The building itself was a nine story-tall model, and in the opening scenes of the film was abysmally superimposed over the San Francisco skyline. The composite element jiggles and shakes within heavy matte lines, which is an ominous start for a special effects film. Fortunately, the optical work is kept to a minimum. The mechanical and fire effects are better, but again leave much to be desired. The inferno fails to persuade the viewer that it is ever anything more than specially set butane fires, which is not to belittle the images themselves: the fire and carnage are all very real. But while the fires puff, billow, and roar with awesome realism, they do not convey the impression of a rampaging blaze. Nor do they flow smoothly from scene to scene. It remains for the characters to say, "Look! The fire has spread from this room to that room!" for us to follow its progress. No matter how well they are executed, special effects that require this kind of support can *awe*, but never really *convince*.

Putting this aside—which is a somewhat specious approach, since the fire *is* the film—it should be observed that in terms of its physical logistics, *The Towering Inferno* was a massive and dangerous undertaking. As Allen noted during production, "Fire and water are the most unpredictable elements to work with in danger scenes. Once you let them go, they can't be recalled." The fires were kept under control with hoses and by maintaining a diligent check on the gas that was feeding the blaze. The climactic flood required an entirely different set-up. Allen planned to pump one million gallons of water on the performers, so he built the nightclub twenty-five feet off the ground to allow for drainage. Seven Panavision cameras recorded the scene, along with five videotape machines to enable the producer to view the action as soon as it had been concluded. In this way he could be certain that everything looked authentic on film. Not that it mattered: "There was no chance for a second shot," Allen observed, "because the set was destroyed by that deluge."

We mentioned earlier that several characters are burned to death in the film or, in many cases, catch fire and plunge blindly through windows. Stuntmen were used for these scenes, all of them clothed in garb that differs according to individual preferences. Basically, however, the fire outfit consists of an asbestos padded jumpsuit, unflammable woolen gloves—the wool is to absorb perspiration before it turns to scalding steam—and a fireproof face mask with the actor's features molded in heat-resistant plastic under which is a small oxygen tank. This enables the performer to breathe after he has been doused with gasoline and set ablaze. Over this he

Eiji Tsuburaya with a miniature ship from *Gorath* (1964) . . .

wears street clothes or the requisite costume. However, even in full regalia, the maximum time that a stuntman can stand the fire's heat is about fifteen seconds. For this reason, Allen shot many of the scenes at high speeds. Unlike Pekinpah's slow-motion shots, these were used to accent the drama rather than exploit it. As for the glass through which many of the stuntmen went tumbling, it was standard *breakaway glass* made of specially treated resins and designed to shatter realistically upon impact. This formula was an improvement over the less authentic sugar compound that had been used in previous years.

Despite its many weaknesses, *The Towering Inferno* is still an admirable achievement. With a crumbling set at every turn, and fire on-screen for most of the picture, Allen did an incredible job just getting it all on film. Thus, in the tradition of *The Ten Commandments* or *Samson and Delilah*, the

. . . and how that same ship looked on-screen. The *Poseidon* was of a considerably larger scale.

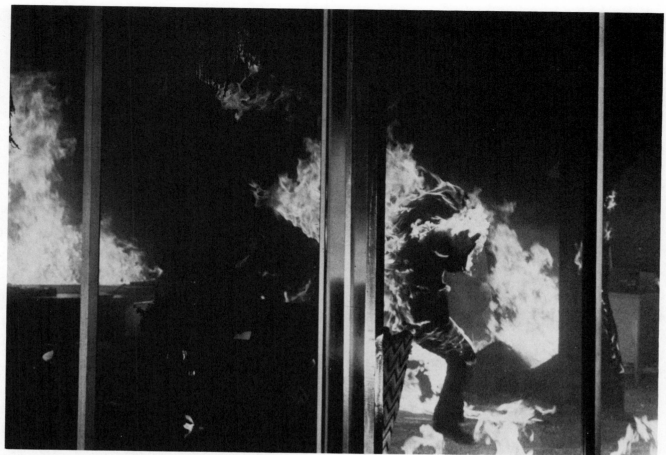

A stuntman doubling for Robert Wagner in *The Towering Inferno*.

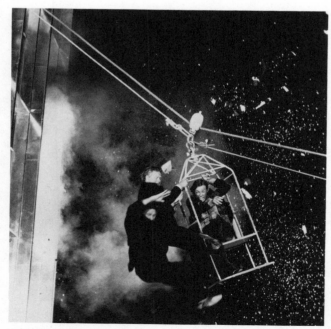

Richard Chamberlain (right) and companions are spilled from a rig linked between a neighboring building and *The Towering Inferno*.

picture's hubris, if not its polish, makes for substantive entertainment. Meanwhile, for seven million dollars less than it took the combined efforts of Twentieth Century Fox and Warner Brothers to burn up a skyscraper, director Mark Robson and Universal Pictures razed Los Angeles in *Earthquake* (1974). Presented in Sensurround, the first major new film gimmick since the smellies, *Earthquake* demanded so wide a variety of special effects that no one working in Hollywood had the ability to bring them off. Thus, the studio called some old pros out of retirement and went to work on an effort that was to present the special effects man at his pristine best—and at his abject worst. Like a bunch of Christmas elves given millions of dollars with which to build toys, the Universal technical people began looking for new ways to do old tricks better, starting with the camera itself. In the past, the vibrations caused by a tremblor were simulated by jiggling the camera. Unfortunately, this caused the film and the apeture gate to bob about haphazardly, resulting in a blurry image and unrealistic quake effects. To

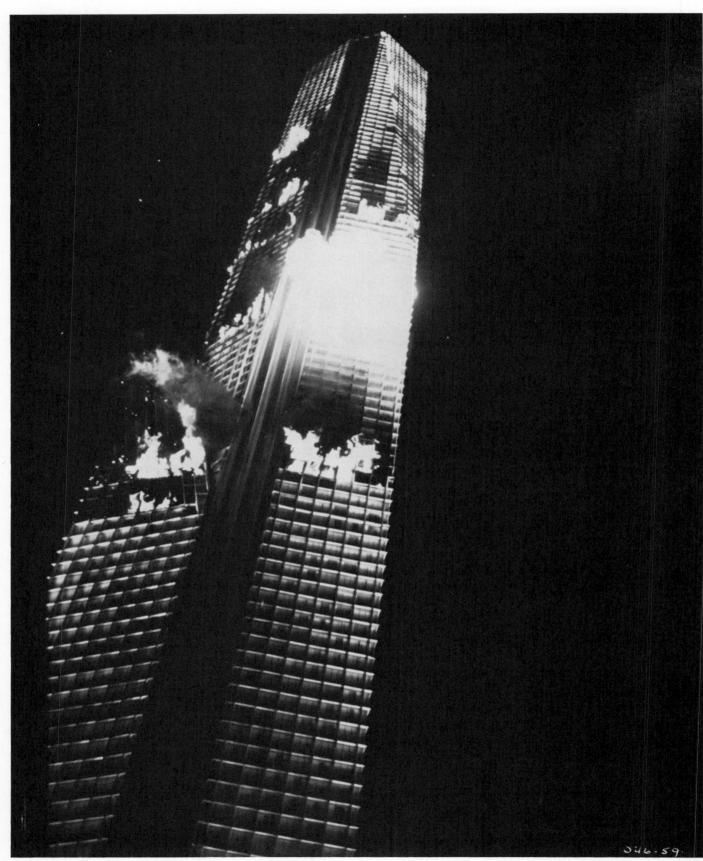

The miniature building seen in *The Towering Inferno*.

Director of Photography on *Earthquake*, Philip Lathrop, and a camera mounted on the shaker platform.

Earthquake director Mark Robson (left) discusses the design for a ruined skyscraper with Art Director Preston Ames.

embellish whatever destructive effects were being worked for any given scene, the studio machine shop built a special *shaker platform* on which the Panavision camera was secured. This mounting consisted of a motor-driven plate that caused the camera to oscillate horizontally. A rheostat control enabled the cinematographer to select speeds that were appropriate for the scene at hand. Before and below the camera, on the same shaker foundation, was another plate responsible for vertical movement. This second motion was of a staccato nature so that the librations were never the same. None of these patterns affected the delicate balance of the camera's inner mechanisms.

The camera was not the only thing to shake on screen. Like the sets in *San Francisco*, *Earthquake's*

mock-ups of a seismological institute, a police station, a bar, and so forth, were all built on rocker platforms, with huge motor-driven springs and hydraulic rams shaking them back and forth. This device not only made for a realistic earthquake motion, but conditioned the actors to fall and react with accuracy when the filming went outside the soundstage where only the camera was rocking. Another interesting set was an elevator carriage. With the fourth wall missing for camera placement, the compartment was required to break from its cable and fall twenty-three stories. This was accomplished by using water-driven pumps to drop the floor of the carriage and spill the passengers awkwardly about, after which the preweakened walls and polyethylene ceiling came sandwiching down. Unfortunately, the nerve-wracking scene is spoiled with one of the most pitifully inane and obvious special effects shots in film history. When the elevator hits the ground, cartoon animated blood, thick with matte lines, comes spurting from the twisted mass of humanity and coats the lens. Whoever okayed this trick should have been on that elevator.

The most imposing set in the film was a reconstruction of five and one-half stories of an office building atop which dozens of people are trapped. The base of this set was an excavation dug twenty feet in the floor of Universal's tallest soundstage. Stuntmen were required to fall from the top of this forty-foot structure onto air bags in the pit. These mattresses were subsequently matted from the picture with glass paintings of the rubble-strewn street, while in the background was an enlargement of a glass painting showing the stricken metropolis.

In addition to the shaking sets, the script called for buildings and props to collapse. While a number of these were miniatures, there were many full-scale buildings destroyed for the film. Taking over the standing New York street set on the Universal backlot, the special effects men and art directors transformed it into Los Angeles. These buildings, of course, are facades, multistoried fronts braced from behind with wooden supports. Naturally, it was easy enough to rig marquees and signs to fall from the faces of these buildings, but the film called for structural materials such as concrete and steel girders to come crashing down. Since these were not a part of the existing set, it was necessary for fifty-five special effects men to man huge cranes and shower this wreckage from above. It was very tricky

This is how Ames's model looked when built to scale for *Earthquake*.

One of Albert Whitlock's renderings has been enlarged to serve as the backdrop for a scene in *Earthquake*. The pit on the right is where technicians erected the top floors of a skyscraper . . .

. . . and the result of their labors looked something like this. Charlton Heston in a scene from *Earthquake*.

Preproduction drawing from *Earthquake*.

Preproduction drawing from *Earthquake*.

A collapsible house from *Earthquake* . . .

Huge cranes prepare to shower tons of debris on the Universal backlot
in *Earthquake*. Before . . .

. . . and after.

. . . and the leaking gas segment.

work, due to the weight and mass of the debris. Six-ton cement blocks were responsible for crushing automobiles, and there was no cheating here: the falling slabs were real. Then there were chunks of concrete that struck near the players. These blocks were cut from styrofoam and run through with metal strips to give them the necessary weight. Breakaway glass was also a part of the downpour, which led to another of the movie's ill-conceived effects. A woman, her back to the camera, is struck by a huge window pane. She turns to face us, screaming, as blood pours from shards of glass that protrude from her face. Besides being unwarranted and sadistic, the shot is flawed in that when the woman looks up at the fragmenting pane, we see the slivers *already in her face*, just as they had been applied in makeup.

During the earthquake, the suburbs are also hard-hit, and the special effects department rigged several houses to collapse near exhaustively rehearsed performers. Everyone knew his or her

Director Mark Robson (on ladder) and one of the giant wind machines used in *Earthquake*.

127

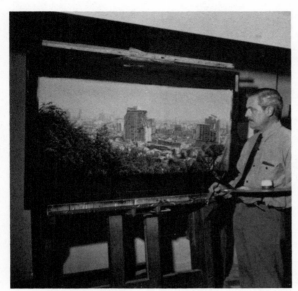

Albert Whitlock, the world's foremost glass artist, works on a painting for *Earthquake*.

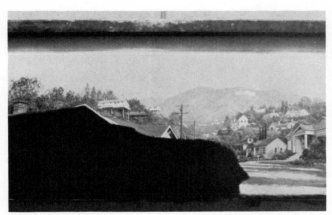

Close-up of one of Whitlock's glass paintings. The blackened area is where the live-action will be fitted in an optical printer.

marks, so that when cables holding breakaway walls and supports were tripped, there were no injuries of any consequence. Cantilevered houses were built in miniature and edited with shots of full-size rubble rolling down hills past residents. There was even a *Towering Inferno gag*—the term used to describe a single stunt or special effect—in which a man runs back into his house to shut a broken gas pipe. There is a cigarette dangling from his mouth; moments later, an explosion sends the hapless gentleman somersaulting through an area that was once the wall.

Miniatures were also a vital part of the *Earthquake* special effects repertoire. These were built under the direction of Clifford Stine, the man responsible for the camera magic in many of Universal's science fiction films, including *The Deadly Mantis*. He was summoned from retirement in Mississippi to work on *Earthquake*. The biggest problem Stine faced with these models—all of them built on a scale of from three-quarters of an inch to two inches per foot—was to give the impression that they were being shaken down rather than pulled down. Accordingly, they were prebroken, placed on electronically controlled mounts not unlike the oscillating platforms used for the cameras, and shaken apart. Naturally, most of these models were shot at very high speeds to give the illusion of mass. But there is a problem with this kind of photography. Every trick requires the participation of several technicians. For instance, to film the collapse of an elevated section of freeway, it was the job of one special effects man to pull away the support struts with hidden wires, while other craftsmen shook the terrain and yanked cars, scenery, and sections of turnpike to the ground. Obviously, in a scene like this it is possible for an operator's timing to be off, even by a fraction of a second. When shooting at high speeds—up to one hundred and thirty-two frames per second as opposed to the normal twenty-four—this delay is magnified sixfold and slows down the pace of the sequence. For this reason, it was necessary to have several cameras photographing the same scene. This gave the film editor an opportunity to cut from one angle to another, thus deleting "dead" footage without it being obvious. Too, this multiple coverage is an contingency against one of the cameras failing in the midst of a scene.

While these various processes and crafts consumed a great deal of time and energy, they would have been of little value without the skills of Albert Whitlock. Whitlock is one of the uncontested kings of the glass painting, and this title is more than justified with his contribution to *Earthquake*. The master rendered over *forty separate paintings* for the film, each one measuring five feet long by two and one-half feet tall, and the lot of them were completed within twelve weeks. However, this three-month period is not just a matter of rendering the painting and moving on to the next assignment. Whitlock begins by carefully coordinating his artwork to the f-step—the aperture setting that controls the flow of light—used by the cinematographer when he shot the live-action scenes. This requires two to three hundred feet of test footage in

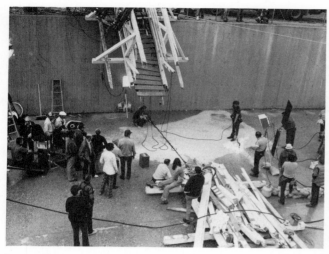

Crewmembers prepare to flood a waterway after the collapse of the Hollywood Dam. Right now they are setting the charges on fallen electrical wires so that they will crackle realistically when the waters hit. Actress Genevieve Bujold, who figures prominently in the scene, is seated on the debris of a fallen overpass. From *Earthquake*.

This is how the scene looked in the finished film.

Huge water tanks spill their contents into the dry floodway as Miss Bujold hangs on for dear life. From *Earthquake*.

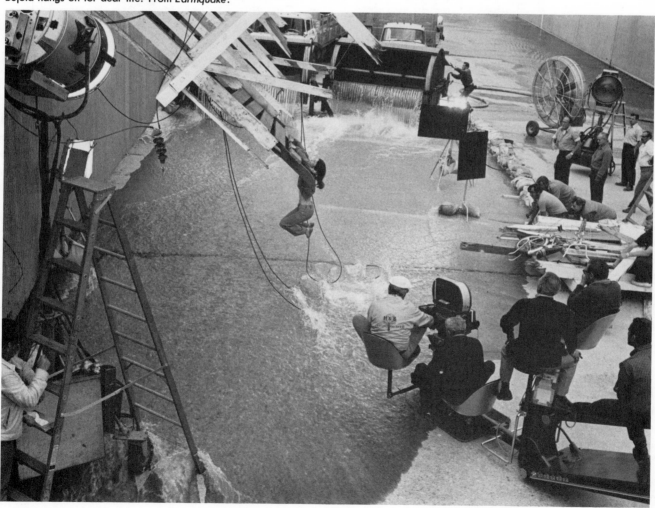

A preproduction sketch showing the collapse of the Hollywood Dam from *Earthquake*.

Technicians film the Hollywood Dam break-up for *Earthquake*.

which his rough painting, on glass, is combined with the prefilmed footage. If the lighting is subdued, then Whitlock must be certain that his finished illustration is also subdued. In addition to these straightforward glass shots—which are matted with the live-action scenes in an optical printer, and not by shooting through the pane itself—there were scenes that called for fires to be dropped in the midst of the paintings. To do this, Whitlock placed transparencies of his paintings in the reflex eyepiece—what you see is what the camera sees—of his camera. He had the special effects men arrange fires on a stage so that they blazed in perfect register with the artwork. Photographing against a black velvet background, he combined this fire footage with his original painting in an optical printer. The live-action elements were then matted in, and as many as seven different layers of painting-fire-performer composites were combined for a single on-screen image.

Surprisingly, to study Whitlock's work is to find it not unlike that of the French Impressionists. Since he is often required to complete a painting in only five hours, Whitlock hasn't the time to do a finished, detailed rendering. Fortunately, he long ago realized that he didn't *have to*. While making the test shots from his roughs, he discovered that the work had life and sponteneity and suggested almost enough detail to serve as a finished painting. Polishing his craft, he found that it was much more important to be concerned with the painting's mood elements—the way the light reflected, glowed, faded, or infused the pictured objects—than with meticulous, photographic rendering. Of course, Whitlock does not work entirely with impressionism: he puts great detail in windows, cars, and so forth, to give his work the effect of a finish. To create these paintings, Whitlock usually copies photographs, sometimes projecting an illustration onto the easel-supported glass and simply tracing it

Universal Pictures executives Richard Stumpf and W. O. Watson examining a prototype of the Sensurround unit.

Toho's answer to *The Towering Inferno* and *Earthquake,* all rolled into one: *Tidal Wave!*

to expedite matters. Most of the time, however, he simply has the picture in hand, along with his pallet of paints, and copies it by eye.

As if these earthquake, explosion, and fire effects were not enough to keep the crew busy, the script called for a climactic break-up of the huge Hollywood Dam, which spills untold tons of water over the city. The actual crumbling and collapse of the almost nine-hundred-foot-long structure was done with a fifty-six-foot-wide model, showing the dam, the surrounding hills, and nearby residential areas, and was filmed with nine cameras rolling at speeds from ninety-six to one hundred and twenty frames per second. The different camera speeds, which gave the water a churning mass, were dictated by the angle from which each particular cinematographer was shooting. If the flood were coming straight at the camera, the distance it covered was less obvious, so it naturally gave the impression of slower movement than waters flowing cross-screen. Set-ups alongside dump tanks were responsible for close-ups of the damage being wrought by the onslaught, washing cars into buildings, stuntmen over rooftops, and so on.

We noted that *Earthquake* was presented in Sensurround, billed as a gimmick that "thrusts the viewer into the epicenter of the earthquake." Although Hollywood publicists are wont to exaggerate, the claim was a fair one. The audio system literally "surrounds" the viewer's "senses" by vibrating the air with low frequency sound waves. These waveforms are the same as those of an actual earthquake, and issue from huge electro-acoustic traducer horns placed near the screen and in back of the theater. And, since the trembling sensations are transmitted through the air rather than through the theater itself, there is no danger of structural damage. Complementing the Sensurround effect are low, rumbling noises on the soundtrack; the consummate accuracy of the process is awesome. A pair of special Academy Awards went to the technicians who created Sensurround, while the film's special effects and art direction snared two more awards. Recently, Sensurround has been applied to Universal's World War II epic *Midway* (1976), and their suspense film *Roller Coaster* (1977).

In theory, if not in practice, the supreme disaster film should have been *The Submersion of Japan* (1975), released in the United States as *Tidal Wave.* Produced by Toho International, the studio responsible for the Godzilla films, three million dollars was spent on earthquakes, an erupting Mt. Fuji, and, of course, the sweeping tidal wave that completely engulfs the island-nation. Unfortunately, the film lacks the polish of the Hollywood-based productions, and the comparatively low budget shows when stacked against *Earthquake* or *The Towering Inferno.* On the other hand, lack of class or spectacle is not a problem with Robert Wise's *The Hinden-*

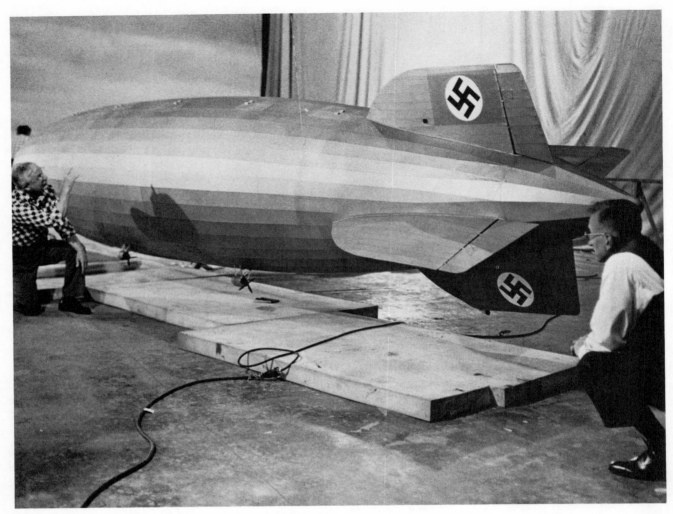

Director Robert Wise (left) shows George C. Scott the miniature model of the *Hindenburg*.

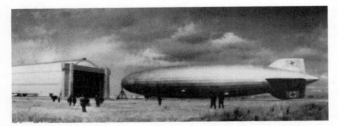

One of the seventy glass paintings used in *The Hindenburg*. The hangar is real, one of many at the Al Toro Marine air base in California.

burg, a magnificent film with splendid special effects. A Universal production, this tale of the events that led to the zeppelin's May 7, 1937 crash in Lakehurst, New Jersey, reunited many of the *Earthquake* craftsmen, winning Whitlock an Oscar and giving him the chance to paint dozens of different views of the great airship. These were used in conjunction with a nearly thirty-foot-long model of the dirigible.

The matte work on *The Hindenburg* is some of the finest the screen has ever seen. This is especially so in shots of a rigger outside the zeppelin as he patches a torn section of tail fin. The fin was a full-scale reconstruction; it was matted onto the model and then both of these were matted into the sky, all with great precision. Shots of the alternately glass and model *Hindenburg* over the airfield were also effective, with Whitlock's "fake" clouds blending flawlessly with those over the studio's Lakehurst exterior set.

Wise chose to use existing stock footage of the disaster rather than restage it with miniatures, and the decision was a sound one. The 35mm newsreel shots are gripping beyond measure, for the flaming bodies we see are *real*, and not studio stuntmen. Episodes of the cast struggling to escape the doomed

The initial explosion of the *Hindenburg,* filmed vertically as detailed in the text.

Director Robert Wise (with loudspeaker) organizes a scene showing survivors escaping the decimated *Hindenburg* . . .

A remarkable sequence showing a stuntwoman at work. In this shot, the girl has been set ablaze and dropped from the promenade set of the *Hindenburg*. This was shot on a soundstage.

. . . and how the scene looked on film, with Burgess Meredith and Anne Bancroft fleeing the remains of the zeppelin.

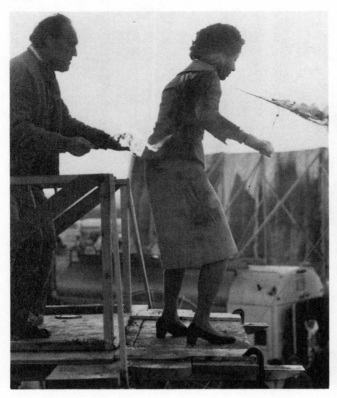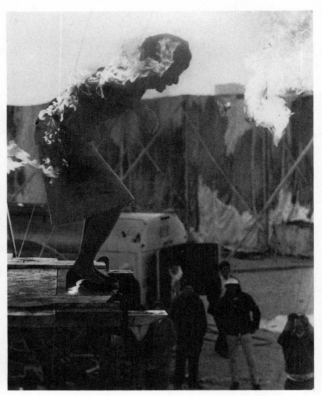

To show the woman hitting the ground, the crew moved outside, she was once again set on fire, and continued the fall from another angle. The wig and protective covering behind her neck are fireproof.

After the gag, crewmembers rush in to extinguish the blaze.

Camera magic or history? This is a shot of the *real Hindenburg* as it neared Lakehurst, New Jersey, for the last time.

This same scene as re-created in the film. The New York skyline is a glass painting, as is the *Hindenburg:* the pane with the airship was moved against the Manhattan vista to simulate flight. The clouds were superimposed in an optical printer.

airship are intercut with these scenes, the sets for which were built on angled ramps like those used in *The Poseidon Adventure*. These were tilted to spill props and players about the zeppelin interior as it fell to the ground. Of all the special effects scenes, however, the most impressive was the detonation of a bomb that Wise contends destroyed the ship. It blows up in the hands of George C. Scott, and a nearby antagonist played by Roy Thinnes is knocked from his feet in slow motion and goes flying along a catwalk in the ship's superstructure. The scene is shown from the back, and Wise told me that this was "one of the simpler tricks we did." The horizontal set was built *vertically*, with the cameras pointing *up* along the thin corridor between the zeppelin's hydrogen-filled gas bags and the fabric outer-shell. There was a harness under the stunt double's clothing, with a coiled cable running from his waist

to the far end of the corridor. When the bomb was detonated, technicians simply let the extra fall toward the camera. His body, itself, served to block the support cable from view, and the scene was filmed at high speeds.

While all of this burning, shooting, and quaking was going on, Hollywood also found the time to produce a goodly share of straightforward action-entertainment films. While each of these efforts provided special effects men with ample opportunity to display their wares, Cinerama films offered the most interesting cross-section of tricks. After co-producing George Pal's *Wonderful World of the Brothers Grimm*, Cinerama and MGM teamed to shoot *How the West Was Won* (1962). The picture was filmed primarily on location, so the need for special effects was limited. However, rear screen was used with uncanny precision during one scene,

The overturned ship suffers an explosion in *The Poseidon Adventure*.

Bob Morgan doubling for George Peppard on fiberglass logs. From *How the West Was Won.*

No miniatures here: Stanley Kramer actually drove a plane into the Airport Cafe for *It's a Mad, Mad, Mad, Mad World.*

when it was necessary to show close-ups of the raft on which stars Karl Malden, Debbie Reynolds, Carroll Baker, and Agnes Moorhead were being tossed about a raging river. In reality, the log transport was being rocked and splashed with water by studio hands. Later in the film, a train wreck was enacted using real railroad cars. Only the logs on a flatcar were fake, each timber made from one hundred and fifty pounds of fiberglass. Unlike wood, this material was not liable to break or splinter when riveted to the train and put through a vigorous routine that required them to pivot under restraining chains and dangle stuntman Bob Morgan over the tracks.

How the West Was Won was a stirring and beautifully wrought movie that grabbed a healthy profit of $12,073,000 at the box office. However, Stanley Kramer's *It's a Mad, Mad, Mad, Mad World* (1963) made even more money—$20,700,000—and was the first Cinerama film to be shot with one

effects such as a car that ran driverless along a mountain road and off a cliff, a plane that soared through a billboard, and another aircraft that plowed into a restaurant. None of these gags was executed with miniature models: the car was radio controlled, the first plane was flown into a styrofoam placard with a balsa wood frame, and the second aircraft was actually piloted into a set. For this latter stunt, a cable attached to the plane prevented it from overrunning its mark and dashing the camera crew to pieces. There were also the less staggering stop-motion scenes for which Willis O'Brien had been hired. Sadly, he died as production was getting underway and Jim Danforth was called in to handle the animation of figures who were clinging to a fire escape when it tore loose from a building and

John Wayne, third from the right, tries to free untouched sections of canvas in the fire sequence from *Circus World*.

A prop car with a dummy behind the wheel from *Grand Prix*. The vehicle was fired from an air cannon.

camera, a 65mm CinemaScope system adapted to the Cinerama screen ratio with special anamorphic lenses. This bastard offspring was dubbed Ultra-Panavision, and became the standard Cinerama format. The picture required complex mechanical

tottered at a dizzy height above the street. Six-inch-tall jointed models were used for the medium shots, the only camera position that permitted animation; foot-high dummies were photographed falling from the ladder in slow motion, while immovable one and

one-half inch figures were employed for extreme long-shots. Over two dozen glass paintings were used in this brief sequence, each one permitting a different view of the city, streets, or building itself.

Circus World (1964) was the next Cinerama Ultra-Panavision presentation, and it is the ultimate sawdust epic. Produced by movie mogul Samuel Bronston *(El Cid, King of Kings)*, it was one of the two films that caused his organization to go bankrupt. *Fall of the Roman Empire* (1964), also shot in Ultra-Panavision, was the other albatross.[3] However, inconsiderate of his business sense, Bronston cannot be accused of cutting corners in his films. For the historical picture, he rebuilt Rome on a Spanish plain, while in *Circus World* he burned a bigtop to the ground and sunk a real ship. Unlikely though the latter event is, it makes for a thrilling sequence. Circus impresario John Wayne has sailed his ship the *Circus Maximus* to Europe and holds an open house in Barcelona Harbor. When one of the show's aerialists falls from his perch and goes overboard, the spectators rush to one side of the ship and their combined weight causes it to overturn. To stage the mishap, special effects man Alex Weldon made a careful study of the newly retired, two-hundred-and-fifty-foot-long, five-thousand-ton S.S. *Cabos Huertos*. He performed experiments, such as pumping small amounts of sea water into the craft to test its balance and center of gravity. After weeks of research, he decided that the accident could be accomplished by filling the bilges with water and wrapping steel cables around the hull. These cables were tied to huge anchors sunk in cement on the pier, which prevented the ship from going over

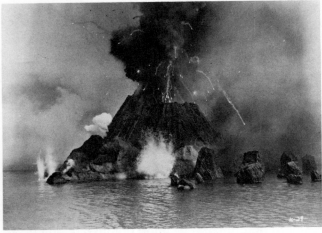

The miniature volcano as seen in *Krakatoa, East of Java*.

entirely. A massive pulley system gave Weldon his initial tilt, while a powerful tractor attached to this rigging allowed him to make spontaneous adjustments. Meanwhile, the carefully calculated flow of water that was being channeled into the ship rolled to the angling side and helped work the capsizement. Miraculously, not one of the three hundred stuntmen or crew members was injured. The fire sequence was done with similar attention to detail, but it did not come off as planned. John Wayne, performing his own stunts, was nearly killed while trying to cut away flaming sections of canvas for the cameras. The blaze went suddenly out of control and brought down the tanbark sooner than expected. Trapped in the midst of this inferno, the actor was forced to wend his way through thick black smoke and burning props while canvas was falling all around him. Of course, this works to the benefit of the viewer, who is treated to a holocaust greater than anything *The Towering Inferno* has to offer. It also illustrates why producers prefer to use rear-screen projection wherever possible!

After the Bronston picture, a vapid lot of movies made their way onto Cinerama's magnificent, curved screen. The films, which all failed to show a profit and contributed to the decline in Cinerama's popularity, were *The Hallelujah Trail* (1965), *Battle of the Bulge* (1965), *Grand Prix* (1966), *Custer of the West* (1967), and *Krakatoa, East of Java* (1969), with its poor miniature volcano and awful matte effects. Stanley Kubrick's moneymaking *2001: A Space Odyssey* (1968)—which is discussed at great length in the next chapter—gave the big screen process a boost, but the effect was vitiated by the subsequent failure of *Ice Station Zebra* (1968) and *Song of Norway* (1970) to make substantial inroads at the box office. In fact, *Ice Station Zebra* represents the low point of Cinerama's spotty history. Novelist Alistair MacLean's story of a Russian-American military confrontation at the top of the world fluctuates between technical efficiency and special effects that are abominable. Scenes of the Americans' North Pole journey via submarine are satisfactory. Miniature models of their nuclear transport *The Tigerfish* are nicely showcased, especially as it sails beneath icy Arctic expanses. The interiors of the ship were also impressive, assembled from odds and ends uncovered by Art Director Addison Hehr in marine salvage yards. The completed submarine sets covered an area of some three hundred feet, the six sections of which were built on hydraulic rockers

The infamous miniature plane shot from *Ice Station Zebra*.

The spectacular train wreck from *Lawrence of Arabia*.

allowing them to be tilted at twenty-three-degree angles when the craft was supposed to dive, or for scenes in which *The Tigerfish* is sabotaged and nearly flooded. On the other hand, the film sports one of the worst rear-screen shots in history, as five jet planes rush paratroopers to aide the submarine crew that is trying to recover a fallen satellite at Ice Station Zebra. The models were suspended before a fuzzy, rear-projected image of the terrain flashing by, a scene that invariably forces a laugh from the audience. Clearly, there were highs and lows in Cinerama's special effects career. But Cinerama was not the only refuge for camera magic on a grand scale. There were other big films produced during this period, and they are well-worth looking at.

Lawrence of Arabia (1962) was not only the finest film of this era, it is one of the greatest motion pictures ever made. At once a sweeping, romantic, and introspective study of a legendary leader of men, it boasts performances, photography, and production values that far surpass most any film made before or since. And one of the great action scenes in this film is Lawrence's attack on a Turkish train. As in *How the West Was Won*, a real train was used, all twenty cars of which were run by Emilio Noriega along a mile and a half of track laid expressly for the film in the Spanish desert of Cabo de Gata. The train was traveling at 35 mph and full throttle when the Arabs launched their attack. Special effects man Cliff Richardson used twenty pounds of explosives to effect the derailment: ten pounds to tear away the track in front of the train, and another ten to blast apart the carrier itself. While this was sufficient to send the transport careening madly down an embankment, Richardson also loaded the caboose with sand to build momentum and send it crashing into the preceding cars. These had been laden with dummies doubling for passengers. Richardson even rigged it so that the engine's boilers would explode as the train drove hard through the sand after the detonation. Noriega, of course, jumped from the engine before it struck the explosives while four cameras recorded the disaster from different angles. It should be pointed out that these explosives used in *Lawrence of Arabia* and, for that matter, in all other films, are not, as is frequently and wrongly imagined, harmless special effect charges. The only "unreal" aspect of these detonations are the chemicals added to cause a blast that will be more colorful and visually arresting. Fire, in its natural state, photographs with bland

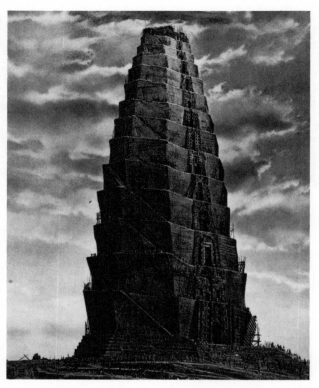

The Tower of Babel sequence from *The Bible* (1966). Everything below the midway mark of the second level is real; everything above it is a glass painting.

translucency, while full-bodied balls of smoke must be patiently coaxed from an explosion.

Tora! Tora! Tora! (1970), the story of the bombing of Pearl Harbor, was another massive film that employed large amounts of explosives. The picture was produced at a staggering cost of $25,000,000, making it the third most expensive film in history—the Russian *War and Peace* (1968) was reputed to have cost $100,000,000, and *Cleopatra* (1964) trudged to a $40,000,000 price tag—and recouped only half that expenditure. But the special effects were on the mark and won an Oscar for L. B. Abbott, the head of special effects at Twentieth Century Fox and the man who would later sink *The Poseidon*. Dozens of model ships were built for *Tora! Tora! Tora!*, the Japanese models at 1:24 scale, and the American vessels 1:16 actual size. These latter miniatures were larger because it was necessary to blow them up. The larger the model, the larger and more realistic the blast. They were made to sail through the three hundred and sixty foot square tank with underwater cables, a method also used to guide the prop torpedoes to their targets. These missiles had air hoses inside their shells to simulate a

A well-wrought explosion from *Where Eagles Dare* (1968).

frothy approach as they rode beneath the surface. The Harbor was also built in this four foot deep tank where the famous films of the destruction of *The Oklahoma* and *The Arizona* were recreated with amazing accuracy. Abbott and his crew even found a way to deal with the problem of water beads. To create a realistic spray effect, they placed gypsum near the explosives and, since the camera did not linger long enough to show the light powder subsequently hanging in the air, it all worked out very well.

It is evident that none of these films, be they detective, war, or disaster pictures, can stand as satisfactory entertainments without the support of good special effects. When the on-screen image falls apart, then there is no movie. However, if this is true of adventure movies, it is doubly so with science fiction films. And when the black-and-white fantasies of the fifties gave way to the technologically minded science fiction films of the sixties and seventies, it was necessary that the special effects be up to the task. Accordingly, as the saying goes, when they were good, they were *very* good. But when they were bad. . . .

9
Science Fiction in the Space Age

I had to invent new techniques all the time . . . to solve the previously unsolved problem of making special effects look completely realistic.

—Stanley Kubrick

Inevitably, *2001: A Space Odyssey* is the film to which all other science fiction productions are compared. The movie cost $10,500,000, $6,500,000 of which went to special effects, and showed a profit of $23,077,000. It remains a controversial film, viewers claiming that it's either a profound or boring picture. While this film fan favors the former observation, the merit of *2001: A Space Odyssey* as an intellectual or religious treatise is irrelevant to our study. We *can* state with certain authority, however, that no one who has seen the film can fail to have been impressed by its special effects.

The plot concerns an interplanetary expedition that has been assigned to pinpoint the origin of a black monolith, newly discovered on the moon and beaming signals toward Jupiter. After the huge ship *Discovery* sets out, its onboard computer goes berserk and kills all but one of the five crew

members. Lobotomizing the device, the surviving astronaut is pulled through a time-space vortex, dies, and is reborn as a Star Child: returned to earth as a guardian spirit, the product of an alien race.

There are few shots in the film that do not rely on some form of camera trickery. To better examine the vast assortment of special effects processes, let's look at the first part of the film, the section subtitled "The Dawn of Man." The picture opens in earth's Pleistocene Age as apes discover one of the aliens' monoliths and, touching it, conceive of using a bone as a club. From here, we move to the Space Age in one of film history's most exciting transitions: the ape leader tosses his new-found weapon skyward, and as it spirals toward the heavens, there is a quick cut to a cylindrical space craft gliding in earth orbit. For the next few minutes, we are treated to a ballet of several such vehicles as they float lazily through space to the tune of "The Blue Danube Waltz." From here, Kubrick takes us onboard a Pan Am space clipper as it carries Dr. Heywood Floyd (William Sylvester) to the moon. Floyd is in charge of operations surrounding the film's second black

slab, the one that has been discovered on earth's natural satellite.[1]

The scenes of man's ape ancestors cavorting about the rugged prehistoric terrain were shot in MGM's Boreham Wood Studio near London. The backgrounds were photographed in Africa and everything was composited using 8x10 color transparencies projected onto a highly reflective forty-by-ninety-foot screen with the front projection process discussed in chapter 6. The apes themselves were played by men wearing monkey suits, although these costumes were not the run-of-the-mill sort used in grade-B jungle pictures. The faces were made of plastic and had hinged jaws. These were covered with rubber and hair, while toggles inside the "mask" allowed the actors to control the apes' lip movements with their *tongues*. A false tongue and teeth were a part of the ape jaw. The body suits were made of latex and covered with hair. There had even been plans to use gangly, mechanically operated arms like those of a real monkey. A company that manufactured artificial limbs made a spiderlike ape hand that was controlled by the actor's hand just behind it and inside the costume. However, the resultant movements were stiff and unconvincing, so the project was abandoned. It took three months to produce the sixteen costumes used in the film.

Leaving earth's prehistory, "The Blue Danube" space sequence jumps to the opposite end of the special effects spectrum. Here, the work was less mechanical in nature than a matter of dealing with miniatures, paintings, and optical effects. The models of the spaceships were made of fiberglass, plexiglass, steel, wood, brass, metal foil, aluminum, and wire, with incredible detail supplied by parts appropriated from plastic model kits. Their design was based on what scientists conjectured that spaceships will look like in 2001. These miniatures ranged in size from two to six feet, and were shot and superimposed over painted backgrounds *without* blue or yellow backing. Rather, Kubrick employed hand-painted mattes, harking back to the early days of movie effects. These opaque mattes were painted on clear cels as progressive frames of the prephotographed model were projected onto an animation stand. The mattes were shot, sandwiched between footage of the stars and planets and film of the models, fed through an optical printer, and combined on a single piece of film.

After the space ballet, we follow the progress of the Pan Am clipper *Orion*, which is taking Dr. Floyd to a space station, from where he will transfer to the lunar shuttle *Aries*. In one of the first shots on the Pan Am ship, a stewardess passes along a hallway, steps onto a wall, walks with ease to the ceiling, then uses an exit therein to bring the scientist his liquid meal containers. As in the nightmare sequence of the 1906 film *Dreams of a Rarebit Fiend*, the scene was filmed by having the actress walk in place while the room and the camera rotated 270°. After this, Floyd drinks his dinner, during which sequence the film makes one of its few blatant special effects mistakes: as he drinks his repast through a straw, Floyd pauses and the liquid falls back into its receptacle. In zero gravity, of course, this would never have happened. Later in the flight, Floyd falls asleep in his seat and his pen goes drifting about the deserted cabin. For the long-shots, this was accomplished by tying the implement to a nylon thread. In a close-up, however, the stewardess is required to walk by and pluck it from the air. Since the pen's tight proximity to the camera would have revealed a wire, it was glued to a transparent disk eight feet in diameter and rotated before the lens. Thus, it was a simple matter for the actress to detach it with a slight tug. Elsewhere, in the pilots' cockpit, course grids and computer information chart the *Orion's* approach to Space Station Five, where Floyd will catch the lunar shuttle. These read-outs, done with cartoon animation, were miniature rear projected in 35mm onto small screens in the control panel. Hard upon, the clipper's sole passenger rides the *Aries* to the moon.

While many of the space shots were achieved through hand-painted mattes, a number of the vehicles were still photographs of the models moved a frame-at-a-time across transparencies showing the moon, earth, or stars. Because they were on the same plane, this process kept both elements in perfect focus. Further, it eliminated the need for mattes in shots where they would have wreaked havoc with the grain of the picture. Whenever a matte is used, the special effects man is, in essence, rephotographing both the background and foreground when he transfers them to one strip of film in an optical printer. This new composite is called a *second generation print*, and it decreases the crispness of the image. Thus, Kubrick was fortunate that he could afford the luxury of occasionally antimating the still photographs.

Arriving on the moon, the *Aries* lands on a

The excavated monolith on the Moon. The pit and men are real; the mountains and terrain are sculpted in forced perspective; the background showing earth and the stars is a painting. From 2001: A Space Odyssey.

platform that retracts two hundred feet into an airlock beneath the lunar surface. This huge chamber was actually a model fifteen feet deep, scaled to the two-foot miniature of the *Aries*. On the airlock's many levels, we notice people at work in the control rooms. Like the pilots that can be seen through the windows of the spaceships in long-shots, they were superimposed by front-screen projection. The scene would be shot with the window areas opaqued on the model. The film was then rewound, the model covered with black velevet, and reflective white cards placed in front of the blackened windows. The film was then re-exposed and the prephotographed actors were front-projected in their proper places. Again, this was a preferable alternative to mattes due to the clarity of the final composite.

Floyd's subsequent trip via airborne moon bus to the pit where the monolith has been discovered gives the special effects crew a chance to show off its superb and, as was later proven by *Apollo* lunar landings, extremely accurate vistas of the moon. The transport soars above the craggy, blue-gray lunar surface, which was actually molded on a base some six feet deep and twelve feet wide. While everything appears realistic on-screen, the terrain was sculpted using forced perspective not greatly dissimilar from the process employed by D. W. Griffith in *Birth of a Nation*—although for reasons other than a shortage

of money and building materials. Photographing a miniature model is unlike shooting a full-size set, where the focus is determined in feet rather than inches. To obtain balanced sharpness with a table-top set, it is necessary to keep the miniature within as restricted an area as possible. Thus, by distorting the perspective of these lunar expanses, it was possible to confine a set that would normally have been over twenty feet deep to an area one-third that size. As seen by the two-dimensional camera lens, however, the illusion of depth was absolute. Following a brief flight, six lunar officials arrive at the site of Tycho Magnetic Anomaly One. The monolith is in a recently excavated pit one hundred and twenty feet long, sixty feet wide, and sixty feet deep. This was an actual set, the sand for which was washed, dried, colored, and ground to resemble what *Surveyor* tests had shown lunar soil to be like. Tangentially, the long-shots, with the matted moon in forced perspective, were photographed in 1967, a year after the live-action players had been filmed. In any case, no sooner do the men arrive at the pit when the slab begins beaming signals into space.

"Eighteen Months Later" is the next segment of the film, covering the half-billion journey of the spaceship *Discovery* to Jupiter. The craft is seven hundred feet long, tubular in design with a globe in the fore. It is in this end that exploratory space pods are stored. Two models of the craft were used in the picture, one of them fifteen feet in length, for the long-shots, and another one fifty-four feet long for the close-ups. Two of the astronauts spend most of

The miniature moonbus hovers above one of the forced-perspective lunar terrains in *2001: A Space Odyssey.*

Arthur C. Clarke on the set of *2001: A Space Odyssey.* Mr. Clarke was co-author, with Stanley Kubrick, of the screenplay. Behind him are the space pods.

their time inside this spherical command section, while their three shipmates lie in suspended animation. Our first view of the *Discovery* interior shows astronaut Frank Poole (Gary Lockwood) jogging in a 360° course around the module's circular interior. Once again, as with the stewardess, the actor was running in place while the room revolved. In this case, however, the set was considerably larger, built inside a centrifuge thirty-eight feet in diameter and ten feet wide, which spun at a rate of three miles per hour. The camera and cinematographer's platform were on a gimbaled mount inside the set, so that they could stay with the actor as the room passed about him.

During the voyage, Poole is required to take several walks in space, a phenomenon with which audiences were familiar due to NASA's *Gemini* missions. To create a realistic extravehicular activity, Kubrick once again shunned the standard practice of suspending an actor before a starry backdrop. Instead, he attached his performer to cables that were suspended *from* a backdrop. The background was on the ceiling, with the camera shooting vertically. In this way, the actor was able to block his own support wires. While this sounds relatively incomplex, the mechanics of dangling from the ceiling became quite tricky when, during his second eva, Poole's lifeline was cut by a service pod that the computer turned against him. The pod, a small round "taxi," was six feet in diameter—although a foot-long miniature was used in conjunction with shots of the fifty-four-foot-long model of the *Discovery.* This life-size model was hung from the ceiling and, like the astronaut, was harnessed to a pivot so that it could be turned at the command of technicians on nearby scaffoldings. And, since these swiveling motions were being executed horizontally, they appeared vertical and quite miraculous on-screen as the objects twisted in a continuous clockwise direction. However, to coordinate the relative drift of these objects with the movements of the pod's mechanical arms required massive amounts of planning and rehearsal. As in *Destination Moon,* these scenes required that the stuntman have incredible stamina as he dangled upside down

A scene that was shot vertically, as Dave Bowman floats through a compartment onboard the *Discovery*.

in his stuffy costume for long periods at a stretch. Too, these eva scenes were shot at high speeds to simulate weightlessness: this called for extra lights that made the heat rather intense. Many of these scenes were performed around a full-scale, thirteen-foot-long mock-up of the *Discovery's* antenna system.

After Poole's death, astronaut Dave Bowman (Keir Dullea) enters a second pod to retrieve his companion's body. In his haste, however, the scientist has neglected to don his helmet. When the computer refuses to readmit the pod into its bay, Bowman is forced to enter the ship through an emergency airlock. This necessitates using the pod door's explosive bolts to blast himself into the corridor. Although he will be exposed to the vacuum of space for the time it takes to close the door and pressurize the cabin, there is no alternative. This maneuver is made, it's successful, and Bowman promptly disengages the computer. The airlock sequence was filmed in much the same fashion as the blast in *The Hindenburg* in which the stuntman was fired along a catwalk after the explosion. The *Discovery's* horizontal emergency entrance was built vertically, the explosion detonated, and the harnessed Bowman lowered at the camera from the ceiling. For several seconds, he was bounced around the room after which he worked his way to the control panel and shut the door. Unlike most sequences in the film, this scene was shot at *slow* speeds, which sped up the action. This was

necessary because the actor was raised, lowered, and twisted about the set at normal speeds while, in the film, he was supposed to be *blasted* into the airlock.

With the disconnecting of the malevolent computer, Bowman and the audience enter the third segment of *2001: A Space Odyssey* entitled "The Infinite and Beyond." Manning a pod to explore the space around Jupiter, Bowman is drawn into a dimensional warp where time and matter become completely distorted. When he has passed through this staggering gateway, the scientist finds himself in a bedroom where he quickly ages, dies, and is reborn as the Star Child. Presenting Jupiter and the other planets on-screen posed several obstacles for the special effects crew. There were clear telescophic photographs of the moon for use on the animation stand, but the other worlds were another matter. While it was easy enough to paint a detailed likeness of each planet, the problem was how to give them depth and make them look round, other than by painting on shadows. The answer was a camera that transferred the artwork to spheres, from which an 8x10 color transparency was made and photographed with the stars and models. This process was preferable to painting a globe and filming it, simply because it allowed the artist greater control over the details in his painting.

The dazzling effects of the light show at the end of the space tunnel are also different from anything the screen had ever seen, and their impact is not easily

Technicians prepare to shoot the planets for the National Film Board of Canada's documentary *Universe* (1959).

communicated on paper. There are expanding galaxies, swirling nebulae, the iridescent surface of Jupiter, long corridors of electric color through which the camera speeds, and so forth. Most of these effects were created with a device known as the *slit scan camera*. The shutter of this camera remains open for a predetermined period while the operator passes light and other stimuli before it. Since there is no shutter to record what would normally be intermittent movements of the light source, the stimulus streaks the film as it moves past the lens. For example, to create the corridors of light, the inventor of this process, Douglas Trumbull, moved his light source from the lens stop of infinity to extreme close-up, with the shutter open and one frame of film exposed for this entire transit. The process was repeated for the next frame of film. To further dazzle the viewer, the colors on the planes of

One of the *Universe* artists airbrushes a few clouds onto a model of the earth. The moon is in the background.

light were varied during each exposure, which created bizarre hues and patterns. The slit scan device worked other designs by shooting through panes of glass that, when lighted, played against each other, causing wavelike designs. The nebulae and other space phenomena were created by high-speed photography of the volatile interaction between various chemicals. Bowman's low passes over the surface of Jupiter were shots of Monument Valley, Utah, taken through filtered lenses.

The final special effect of the film was the death of Bowman and his apotheosis as the Star Child. The Star Child is just that: an embryo bathed in light that hovers in space and gazes down upon the earth. Kubrick's first attempt to create the figure proved unsatisfactory. He had filmed a young boy curled before a black velvet background, but this did not embody the ethereal look that he wanted. Instead, the director had a sculptress fashion a two-and-one-half-foot-tall clay Star Child. This was molded in fiberglass, given glass eyes, and it worked out rather well. The model was double-exposed against a white bubble airbrushed onto a black card, and a halo of light was superimposed over all.

From the film's opening shot, a production credit with the earth, moon, and sun rising above one another in dramatic symmetry, to this final image—both scenes accompanied on the soundtrack by the now-famous "Thus Spoke Zarathustra" theme—*2001: A Space Odyssey* is a film in complete control over its special effects. Kubrick does not present movie magic for its own sake; there is always emotional or narrative validity behind each effect. *2001* also makes the most of Cinerama. Photographed in the one-camera format, the picture makes its audience participants in the goings-on, rather than merely observers. And, unlike *Ice Station Zebra* or *Krakatoa, East of Java*, where the giant screen magnifies the poor quality of the special effects, Cinerama simply makes *2001* all the more awesome. It will be quite some time before we see its likes again.

Within a week of the premiere of *2001: A Space Odyssey,* there was another science fiction film in release, although this one wasn't nearly as good. Four astronauts leave earth and arrive on the *Planet of the Apes* (1968), a world where monkeys are the articulate masters and man the mute savage.

A glass shot from the end of *Planet of the Apes*. This is a frame blow-up from the trailer advertising *Beneath the Planet of the Apes* and reads, "Now . . . its incredible characters come to life again!"

However, as one of the astronauts learns at picture's end, this planet is really earth of the future. The film called for little in the way of optical or mechanical effects. Discounting the glass painting that shows the Statue of Liberty lying decayed on a beach, the only extraordinary aspect of the film is the ape makeup. Indeed, it was accorded a special Oscar, although the award was more for the novelty of the disguises than for their artistry. Developed and executed at a cost of nearly two million dollars, the ape faces were composed of sections or *appliances*, preformed muzzles, foreheads, chins, and so forth, which were made of rubber and applied to the face with a puttylike substance known as *spirit gum*. Wigs and greasepaint completed the makeup, which took over three hours to apply. For scenes that involved crowds of apes, nearly eighty makeup persons were on the studio payroll.

Because the muzzles and chins were separate pieces, they moved when the actors spoke, but only up and down, in the fashion of a ventriloquist's dummy. They were certainly not as versatile as the ape masks in *2001*, nor were they as gritty and realistic. Indeed, there is an overall plasticity about the *Planet of the Apes* faces that is difficult to accept. The apes never sweat, their hair is always perfectly kept, and there is little facial movement other than of the eyes and jaws. In fact, only the dollars and man-hours lavished on *Planet of the Apes* are impressive; the rest isn't even up to the work that Jack Pierce did with primitive tools and materials on *The Wolfman* a quarter-century earlier.

After doing a guest spot in the first of four sequels to the extremely popular ape film, star Charlton Heston made a pair of science fiction films, *The Omega Man* (1969) and *Soylent Green* (1973). *The Omega Man*, the story of a biological war that transforms everyone but the Man who was Moses

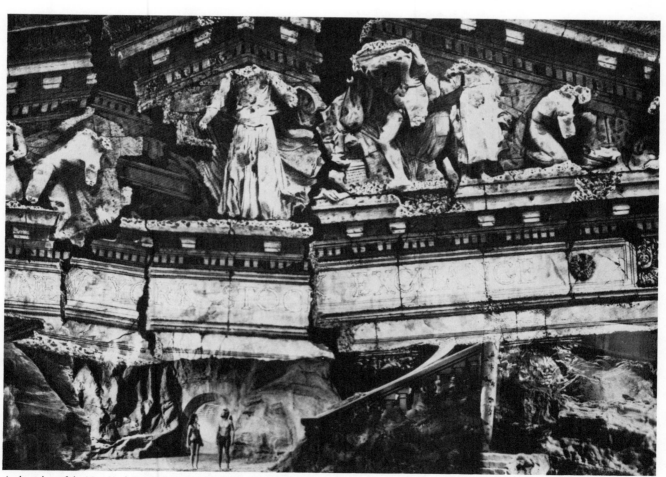

A glass shot of the New York Stock Exchange from *Beneath the Planet of the Apes*. Because of imperfect registry, the background can be seen through the very bottom of the painting.

into a vampire, was a film without special effects or, for that matter, special merit. Worse, however, is the fact that there *were* special effects in *Soylent Green,* and they were worse than everything else in this tissue-thin thriller. The picture is set in 1999: Heston is a police officer whose probe into the manufacture of Soylent Green wafers reveals that human bodies are being broken down and recycled as stiff crackers, something akin to what the producers did with Harry Harrison's excellent novel. Apart from illustrating the various ways in which food for thought can be rendered indigestible, *Soylent Green* is a perfect example of how the public's interest in exciting special effects can be exploited. Tearing a leaf from the notebook of Bert I. Gordon, MGM designed the film's ads and posters to feature huge, derricklike machines labeled *riot control.* These were pictured scooping up dozens of New York's forty million starving citizens with

people falling from the well of its huge claw, screaming and hanging on to carnivorous-looking teeth as they are spilled into trucks. Thrilled with the promise of fermenting masses battling enormous mechanizations, a patron goes to the movie and what does he find? That the vicious-looking people-scoops are actually anemic-looking dump-trucks fitted with oversized shovels. This clumsy appearance makes their mission immediately preposterous since the scoops move so slowly that the extras have to *wait* for the machines to attack. Adding to the dullness of the drama is that only five people are snatched up at a time, all of them overreacting to make the drab situation seem hazardous. Obviously, this shows a throbbing lack of ingenuity on the part of the film crew, and a general insouciance in Hollywood toward its own capabilities. Certainly Jim Danforth or George Pal could have come up with more menacing *riot control* trucks, and for less money

The laughable people scoops from *Soylent Green.*

than these laugh riots cost the studio. In any case, the deception of *Soylent Green* is worse than anything ever perpetrated by Bert Gordon simply because the film *purported* to be a major production. It *was* a major disappointment.

One science fiction film that did not cheat its audience was *Fantastic Voyage* (1965). Ironically, both *Fantastic Voyage* and *Soylent Green* were directed by Richard Fleischer, the man who also helmed Disney's *Twenty Thousand Leagues Under the Sea* and *Tora! Tora! Tora!* The *Fantastic Voyage* is undertaken by five scientists in a submarine called the *Proteus*, all of whom are shrunken to microscopic size and injected into the bloodstream of a physicist. The man has a cranial clot that can only be cleared from the inside. Carrying a laser beam into the subject's brain, the adventurers succeed in their mission and exeunt in a teardrop. The picture ran up a price tag of over six million dollars, owing to the incredible nature of the human body sets. Many of the scientist's inner organs and glands were re-created in colorful detail, as was a full-size model of the *Proteus*, which was forty-two feet long by twenty-three feet wide and weighed four tons. This model was used primarily for close-ups, since there was a miniature of the ship for scenes involving scaled-down models of the various viscera. The cost of this full-scale transport was $100,000, although the organs were subject to equally staggering numbers. Among the most impressive of these constructions was the brain, which was one hundred feet deep, two hundred feet wide, and thirty-five feet high, and decorated with spun fiberglass threads representing neurons, dendrites, and other cellular fabrics. But before they reach the brain and, later, the eye—which was a model some five feet high—the plasmanauts and their blood vessel travel such scenic passageways as the lungs, arteries, and heart. The full-scale heart was over thirty-feet tall and one hundred and thirty feet wide, but the model used in long-shots was by and away more impressive. Sculpted of styrofoam and covered with rubber and latex, the seven-by-fifteen-foot-tall replica pumped and contracted like a real heart. There was also a realistic bronchial sac where the scientists stop to replenish their oxygen supply. The walls of this set were made of rubber, fiberglass, and resin, all of which were flexible enough to pulse with every breath. Littering the floor of the air bladder were particles of dirt and pollution, which appear as huge obstacles to the diminutive travelers.

One of the more interesting effects in the film was used to simulate the flow of plasma through the patient's capillaries. This was done with a special light machine, a set of stenciled plates that, when spun before a powerful lamp, cast violet-tinted shapes over the *Proteus* and the one-hundred-by-fifty-foot set. Another convincing trick was the simulation of a liquid environment when the plasmanauts leave their ship to disintegrate the clot. To achieve the slow-motion movement concomitant with the floating, the actors were supported by wires and photographed at three times normal speed. Indeed, the only dissatisfying effects in the entire film were mattes of the submarine shrinking and the explorers expanding. The camera simply pulled away from or moved in on the subject, after which this image was superimposed over the background set with hand-painted mattes. The subjects jiggle due to imperfect registry in optical printing, and the mattes themselves are not as precise as they should have been, resulting in the ever-frustrating presence of matte lines. Fortunately, the Oscar-winning sets are more in evidence than the Oscar-winning special effects.

Director Fleischer was responsible for another special effects film, the marvelous fantasy *Dr.*

Setting up a special effects shot for *Fantastic Voyage*. The *Proteus* is a full-scale mock-up, placed before a blue screen for matting purposes. The wheel on the left is the trick lighting effects device discussed in the

Dolittle (1967). This film required the creation of four rather bizarre animals, and one that was not so bizarre: an exceptionally intelligent fox, a two-headed guanaco known as the pushmi-pullyu, a great pink sea snail, a friendly whale, and a giant lunar moth. The llamalike pushmi-pullyu was actually two dancers at either end of a well-made costume. It was a trying job. These players not only had to rehearse their steps, since the animal's twin torsos faced in opposite directions, but they had to walk on their toes, since the pushmi-pullyu had hooves rather than feet. Complicating the affair were controls inside the suit that allowed each actor to move the eyes, ears, and mouth of the head on his side. The great pink sea snail was an entirely different sort of beast: like the dragon of *Der Nibelungen*, the twenty-foot-tall mollusk was constructed to size, although it was made of rubber and plastic rather than wood and canvas. Operators inside the gastropod were able to sail it out to sea or move the head in any direction. The whale and lunar moth were both wire-operated miniatures, while the fox was a mechanical model that worked on a table top, in a person's arms, or for that matter, almost anywhere. All the special effects man asked was that the tail be out of view, since it was through this end that the creature was powered.

Back in the realm of science fiction, filmmakers were busy hopping on Stanley Kubrick's bandwagon with outer space films of their own. The first of these was *Marooned* (1969), directed by John Sturges, the man who brought us *Ice Station Zebra*. *Marooned* was a bland adventure that, as the name implies, is the story of astronauts stranded in space. Two of the three spacemen are eventually rescued by a hastily

"Dressing" a studio street for a scene in *Five Million Years to Earth* (1966), in which a Martian spaceship is found buried beneath London.

launched shuttlecraft, while the third is a victim of Russian nastiness perpetrated from a nearby craft. The picture won an Oscar for its special effects, defeating *Krakatoa East of Java*—no sterling accomplishment, this—in one of the most inequitable awards of the ceremony's half-century history. *Never* has outer space looked so disturbingly fake. Elements as basic as light sources were not properly matched in the composite scenes; sunlight bathing the earth originated in one place, while it struck the spacecraft from a different direction altogether. Weightlessness in space was effected with the worst quality piano wire that Hollywood has to offer, while there are enough matte lines on-screen to stretch from the earth to the moon with enough left over for another bad space picture. This was due not only to missteps in the blue-backing process, but because of the method used to impart motion to the spacecrafts. Rather than animate the models or still photographs thereof, special effects director Robie Robertson moved his camera along tracks and photographed a stationary model! This, of course, is bound to cause even the smallest amount of jiggling, which does not make for smooth movement of the spacecraft or a clean matte. The only sequence in *Marooned* that exhibits any visual flair or expertise is the *Saturn V* lift-off at the beginning of the film. The photography and special effects are superb. Needless to say, it was footage taken at an actual launching.

One of the few people with any conceivable claim to Kubrick's space is Douglas Trumbull, the slit-scan man from *2001*. Spurred by his participation on the

One of the many unsatisfactory process shots from *Marooned*.

Kubrick epic, Universal Pictures let the twenty-nine-year-old special effects expert direct a science fiction film. The result was *Silent Running* (1972), a naive but entertaining tale of a time when the only forests on our plastic and concrete world are, in fact, on two huge spaceships. Unfortunately, this proposition proves too costly for the earth, and these last havens of flora are ordered destroyed. One of the four caretakers onboard the stellar greenhouse *Valley Forge* is opposed to this, kills his companions, and takes the ship on a journey through interplanetary space. Eventually, he commits suicide, leaving a

small *drone* to care for the plants and trees. There are three drones in *Silent Running*, yard-high robots that perform menial functions inside and outside the spacecrafts. Rather ingeniously, the twenty-five-pound plastic drone shells were manned by young paraplegics. Fit within the snug machines, they gave the robots remarkable mobility, allowing them to walk or hold things in their pincerlike hands.

The forests are kept alive in six geodesic domes attached to each of the space freighters. These two six-hundred-foot-long vessels were twenty-six-foot-long models, with the domes clustered around one end of a long, skeletal superstructure. This main body of the model was supported by a steel rod, while the inhabitable enclosed sections were made of plywood covered with a styrene compound. As in

A sampling of some incredible makeups, beginning with *Wizard of Oz*

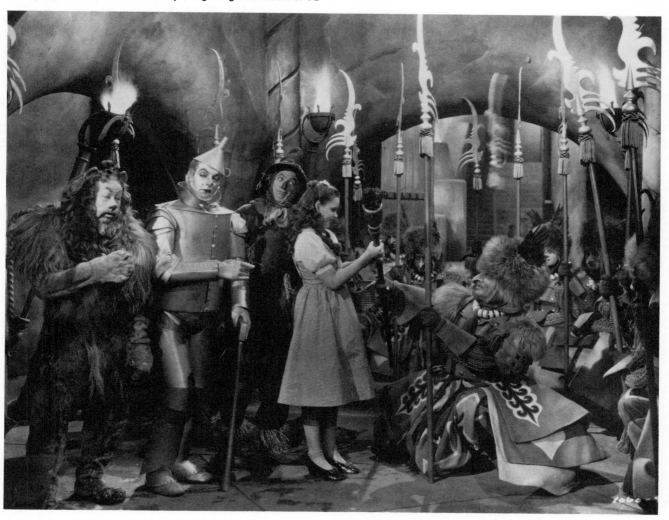

Bruce Dern (in cart) chatting with Doug Trumbull on the set of *Silent Running*.

Rod Steiger as *The Illustrated Man* (1969).

John Chambers with the twins of actor Jonathan Harris.

2001, pieces from over six hundred plastic model kits were called upon to provide detail for the ship's exteriors. Too, the front screen projection system popularized in the Kubrick film was a ready part of *Silent Running's* bag of tricks, particularly on the forest sets. Filmed in a hangar at the Van Nuys, California airport, the glass and metal dome backgrounds were produced from eight-foot-long models photographed against paintings of the stars and planets and added to the set by front projection. Another 2001 standby, the slit-scan device, was brought to bear in scenes of the *Valley Forge's* passing through the prismatic rings of Saturn.

Silent Running cost $1,300,000, a mere nine percent of the budget on 2001, and was completed in eight months—seven of which were devoted to special effects photography—as opposed to the three years lavished on the Kubrick film. Considering these limitations, Trumbull's effects hold up remarkably well. Certainly they were better than those of any other film that year and, thus, were not nominated for the Oscar. As an overall effort, however, *Silent Running* suffers from the same limitations that burdened such contemporary productions as *Journey to the Far Side of the Sun* (1969) and *Countdown* (1968). Long on special effects, they are short on maturity and scientific sense. Speaking of which qualities, it's time we paid a visit with the Peck's Bad Boy of the industry, the medium that nearly destroyed the motion picture.

Roddy McDowall as Caesar in *Conquest of the Planet of the Apes*.

10
Television

If the fiscal gap between *2001: A Space Odyssey* and *Silent Running* seems extreme, then our next step down will be positively unconscionable. It was the unenviable task of producer Gene Roddenberry to bring in every episode of his television series "Star Trek" for under $200,000. Per half-hour this is roughly forty percent of the *Silent Running* budget, for which sum Roddenberry worked some very appealing magic.

"Star Trek" is the logical place to begin our overview of special effects on television. There are a great variety of technical effects on television. There are a great variety of technical tricks in the over seventy episodes of the program, but beyond this diversity we must respect the problem that special effects pose for a television production crew. A show must go on the air every week whether there are two or twelve major special effects elements per episode. In terms of the optical effects alone, this was indeed the ratio between "Star Trek" and a police or western program. Yet, despite this additional cost, the budget had to be in line with other television budgets or there would have been no reason not to replace it with an inexpensive situation comedy. In a word, this means headaches for a producer. Especially when $30–40,000 per program—over one-fifth of the budget—goes to special effects. The show premiered in the fall of 1966, two years before the arrival of *2001*, so there was no space film boom on which to ride. And by the time the Kubrick picture made its presence felt, "Star Trek" was gone from network television. Only after its third season, when the program went into syndication, did interest begin to skyrocket.

The special effects in "Star Trek" can be divided into three categories: makeup, mechanical, and optical. The makeup was the show's weakest area, the occasional monsters and clutch of alien beings usually shut behind expressionless vinyl masks of poorly contrived appliances. Only the pointed latex ears of the alien Mr. Spock, science officer of the show's starship *Enterprise*, were always well-done.

Creating a shipwreck with hoses for an episode of "Disneyland." © Walt Disney Prod.

A matte shot of the U.S.S. *Enterprise* from "Star Trek."

The mechanical gimmicks were generally much better. Most of these were built by Jim Rugg, whose work on "Star Trek" won him an Emmy nomination during the series' second season. Rugg worked miracles for the show, compensating for his lack of funds with ingenuity. One of his more impressive achievements was the four-foot-tall airborne computer Nomad. The device came replete with flashing lights that blinked in synchronization with its electronic voice as Nomad floated through the *Enterprise* on overhead wires. Rugg was also responsible for the realistic instruments of medical officer Dr. McCoy. He made certain that whenever the physician put a tool into practice, something on it worked. Finally, one of his low-budget masterpieces were the prolific Tribbles, small buds of fuzz that reproduced with amazing speed. Designed by Wah Chang and manufactured by Jacqueline Cumere, the five-inch-long Tribbles were made from artificial fur that was wrapped around slices of foam rubber and sewn to patches of cloth. There were five hundred of these creatures in all, and they came in several different varieties. Those that there made to be held and stroked were padded with bean bags to give them the proper subsidence of contentment; Tribbles that were required to breathe in close-ups were fitted with balloons to which rubber tubes and plungers were attached; and walking Tribbles were simply your standard slash of fur wrapped around the headless bodies of mechanized toy dogs.

While a clever use of electronics and existing components was sufficient to build mechanical antagonists, there was no way of getting around the high cost of optical effects. In fact, beyond the normally staggering price of mattes and animation, it was often necessary for the "Star Trek" people to work with three or four free-lance outfits just to finish these visuals by air time. Often, they would complete the special effects just four or five days before broadcast! Work on each optical trick took from three to six weeks. This included such elements as the recurring matte shots that placed an image on the viewscreen of the ship's bridge. While the simple superimposition of a film clip is ordinarily no great task, it must be remembered that what the crew was studying was probably itself other matted footage. Thus, one shot could not be undertaken until its companion strip was completed. Another common matte was one in which the *Enterprise* was pictured flying to, around, or away from a planet. The model of the ship was fourteen feet long, made of sheet plastic with lights inside the bridge, the engines—to create a churning, multicolored "nuclear" look—and so forth, and its movement was effected in much the same fashion as the *Marooned* vehicles. The camera was mounted on tracks and dollied into the ship, turning and tilting as the *Enterprise* changed course. The model, of course, remained stationary, positioned before a blue screen and resting on a stand that held it three feet off the ground. On a small television screen, any shaking that resulted from the camera's tracking movement was barely noticeable.

Phaser Beams, light rays capable of stunning or killing an opponent, were done with animation, while the *transporter* effect involved an entirely different and somewhat unusual process. In the show, a character could step into a transporter and

be sent from the *Enterprise* to a designated spot on a planet below. The crew member would dematerialize into thousands of glittering specks, vanish, and reassemble at his destination. To make this journey possible, the actor would be photographed standing on the transporter platform. After several feet had been exposed, the camera was stopped and the player stepped out of frame. The empty set was then photographed for several feet more. This film was processed and a matte was made showing the actor's form for several frames before and after he had left the picture. This was slowly faded away so that the background would ultimately appear through it. Meanwhile, the sparkles were shot on a separate strip of film, created by photographing aluminum dust as it fell before a high-intensity light source. This footage was joined with the matted image in an optical printer, and the glistening haze held the performer's shape for a short time after his actual self had dissolved. After this, the sparkles slowly evaporated.

In addition to these complex opticals, less intricate tricks were also worked. Glass paintings were used to show an alien city or a natural satellite in the sky of some far-off planet; tilting the camera was used to throw the bridge into a frenzy whenever the *Enterprise* encountered enemy fire or interstellar turbulence. The actors literally threw themselves about the set, their movements choreographed so that everyone would fall at the same time. Exploding control panels and failing lights were also carefully coordinated to embellish such scenes.

Despite the enormous overhead of a large cast and elaborate special effects, producer Roddenberry

A huge canvas and rubber hand frees Barry Lockridge (Stefan Arngrim) from captivity in Irwin Allen's television series "Land of the Giants."

managed to bring in his show at near-budget with little reliance on stock shots from previous episodes. The only technical area that suffered from economy was the planet surfaces. Seldom were there any horizons: the backgrounds were all washed in a monochromatic light, with rocks and foliage obscuring every juncture between the lit backdrop and the floor. In this respect, a contemporary of "Star Trek's," Irwin Allen's "Lost in Space," was vastly superior. Although the series was geared to a more juvenile audience, "Lost in Space" featured excellent production values, including meticulously painted canvas backgrounds that blended with the floor and props on the set. However, what Allen spent on scenery he saved by resorting to as few opticals as possible, perferring to suspend the craft of his wandering space family Robinson with wires before painted stars, or teleporting people simply by stopping the camera, having them step away, and resuming filming. On the other hand, his monster suits were of a higher quality than those on "Star Trek," and one consistently entertaining effect was the Robinson's computer-robot. A plastic costume operated from the inside and featuring a constant array of blinking lights and moving parts it was, in all, an inventive construction.

"Lost in Space" was Allen's second television series, the first being the generally excellent *Voyage to the Bottom of the Sea*—based on his feature film of the same name—followed in succession by "The Time Tunnel," "Land of the Giants," and "Swiss Family Robinson." "The Time Tunnel" and "Swiss Family Robinson" featured nothing extraordinary in the way of special effects, while "Land of the Giants" relied chiefly on low-quality, oversized props and occasional mattes or split screen to create its illusions. "Voyage to the Bottom of the Sea," on the other hand, was a handsomely mounted and photographed series with often spectacular camera magic. Each week, the crew of the atomic submarine *Seaview* faced a monster, outer-space menace, or foreign saboteur. There was even an episode that crossed *Pinocchio* with *Fantastic Voyage* when star Richard Basehart was swallowed by a whale and had to work his way to freedom through the mammal's internal organs. He had had experience, of course, battling *Moby Dick* as Ishmael ten years before. Regardless of the episode, however, the series' real showpiece was the submarine. There were spectacular underwater shots, scenes of the *Seaview* surfacing, and exotic views

Jim Danforth's stop-motion Zanti Misfits from "The Outer Limits."

from the huge bay windows that fronted the bridge. The submarine, of course, was a miniature; two of them, in fact, which were photographed in a studio tank. A twenty-foot-long model was used when the craft had to break water with convincing authority and the incumbent waves; an eight-foot-long replica was used for greater control in the underwater shots. However, it was most distressing for this "Voyage to the Bottom of the Sea" fan when he visited the set as a child and learned that the doors opening and closing so majestically on the *Seaview's* nose were actually hauled apart by workmen standing where the ocean *should* have been. A thin tank of glass, of which the window formed one side, was water-filled and pumped with air to create bubbles, while the seascapes and underwater vistas were either rear projected or matted into the viewport.

With the exception of "Star Trek" and the two Allen programs, few television shows have been deeply dependent upon special effects. "The Twilight Zone" required only sporadic monsters or opticals, while "Bewitched" and "I Dream of Jeannie" used invisible wires to fly objects through the air, stopped the camera to make things appear or disappear, and utilized slow speed photography when people were required to clean a kitchen in five seconds or outrun a car. "Superman" and "The Flying Nun" were hauled aloft by mattes and wire harnesses respectively, and through rear screen projection on occasion; the science fiction series "Outer Limits" owed its remarkable monster costumes and stop-motion models to the staff of Projects Unlimited. "The Starlost" brought Douglas Trumbull's effects to the home screen for one

hapless season, while "UFO" gave the production team of Gerry and Sylvia Anderson an adult vehicle for the miniature work they had perfected with such children's shows as "Captain Scarlet" and "Thunderbirds." Ultimately, this effort led to television's most expensive science fiction show, and also one of its worst, "Space: 1999." This continuing saga of our rootless, inhabited moon's journey through the universe costs nearly $700,000 per episode and *looks* it: the sets, costumes, and model work are magnificent. The rest of the program is considerably less than magnificent. For, despite its technical polish, "Space 1999" is scientifically inept and dramatically shallow. It is not nearly as entertaining as "The Six Million Dollar Man" and his sister heroine "The Bionic Woman." These two characters are cyborgs, half-human, half-robot, with preter-natural powers. Quite ingeniously, to portray absolute control over their bodies, all extraordinary deeds performed by the stars are done so with the camera running at high speeds. This gives bulk to the wood, canvas, and hydrocal boulders they are forever tossing around, and slows down the players to infuse their every move with import.

Thus, with these video comic books and "Space 1999," television has brought us full-circle. We began our study of special effects with George Melies and his naive but technically impressive films; we conclude with naive but technically impressive television programs. The question that thus becomes obvious is where does the art of movie special effects go from here?

The answers may surprise you.

Conclusion

The Parting of the Red Sea on Universal Studios' public tour. Notice that there are steps along the left wall of the parted sea. Perhaps the ultimate in crass commercialism!

Universal Pictures has an odd adjunct to their popular studio tour. It's called "The Parting of the Red Sea," and tourists flock to see it by the millions, which is unfortunate. When Universal began these tours in the mid-sixties, they took visitors on tram rides through soundstages that were actually being used to make movies. Today, they have transformed one of these stages to a standing set that, while it is largely authentic, is never in use. Granted, the deception is a small one, but it *is* a deception. Which is the case with the Red Sea exhibit. The tram stops beside a small lake while the tour guide announces that if you've seen *The Ten Commandments*, *this* is how DeMille wrought his miraculous opening of the waters.[1] While the tourists stare anxiously ahead, oohing and aahing and waiting for God to smite the sea, a path several yards wide forms in the lake, and the tram passes along this dry stretch. As the carriage rumbles between the five foot high walls of water, we see that it is simply pouring over two dams and spilling into a grille-covered tank beneath our wheels. Clever. But dammit, that's *not* how De-Mille did it! This is a magician's trick, not a movie special effect!

A miracle ala Universal.

There is a world of difference between the two, which is not to denegrate one in favor of the other. Both involve great concentration, precision work, and showmanship, but here the similarity ends. The movie magician doesn't hide anything up his sleeve. Indeed, most of the time his sleeves are rolled to the elbow as he nurses along a stubborn mechanical effect, or molds the skin of a stop-motion model. Basically, however, the magician's art exists for its own sake, to entertain with illusion. Movie special effects exist to serve the film as a whole. While there are exceptions to this rule, such as the cartoon or stop-motion animator whose work *is* the film, the camera effects man perfects his craft not for glory or the spotlight, but for the challenge.

As film stocks, emulsions, and equipment continue to improve, so will the quality of movie special effects. And every now and then, in the tradition of 3-D or Sensurround, a new gimmick will surface to advance the technology of movie magic one step further. Indeed, over a decade ago the Disney studios carried the engineering of their mechanical squid to the autoanimatronic figures of Lincoln and the dinosaurs at the New York World's Fair and current Disneyland and Disney World attractions. Perhaps this ever-improving science will soon be applied to the human body, and we'll actually *have* ourselves a six million dollar man. This will clearly be a case of special effects men improving themselves right out of a job!

But that's for tomorrow. In the meantime, good special effects, like a strong script or a moving performance, are a crucial facet in the production of a motion picture. It is our hope that this work has, in some way, increased the reader's appreciation for the special effects man's skills without destroying their hypnotic appeal. For our part, it was the least we could do to herald these craftsmen who work so hard to remain obscure!

Notes

CHAPTER 1

1. There were a number of variations on the basic *Stroboskop* and *Phenakitiscope* design. The most popular of these was the *Zoetrope*. Invented in 1834 by mathematician William George Horner, it was a topless drum with slits around the upper half. On the bottom level were progressive drawings. When spun and watched through the slits, the *Zoetrobe* presented a moving image.
2. The Vitascope presentations were always promoted as Edison's Vitascope. As with many of the inventor's latter involvements, his name was used as a commercial draw even if he had nothing to do with the actual creation of the device.
3. Because the camera rushes more frames per second past the lens, it records smaller incremental movements of the subject than if the film were running at standard speed. Thus, when projected at the normal rate of twenty-four frames per second, this more detailed record gives the impression of slow motion. Conversely, when fewer frames are passed through the camera, the jump of the subject from picture to picture is quite severe, thus resulting in fast motion.

CHAPTER 2

1. Griffith's passion for realism eventually took its toll: working on his 1923 historical epic *America,* a technician had his hand blown off while preparing an authentic explosion.
2. Of course, it can be argued persuasively that Griffith's complaint was basically an empty one. *All* motion pictures are a sham, a creation of the imagination. Scenes are equally as false whether they re-create a common, everyday occurrence, or the destruction of the world. They are filtered through the director's mind and heart, the cameraman's eye, and the writer's sensibilities: there is nothing real, per se, about any of it!

CHAPTER 3

1. So long was the Lang film in production that winter came, and the dragon had to be disassembled until spring allowed for the resumption of shooting.

CHAPTER 4

1. The sad thing about a remake is that a studio will often demand that the original be pulled out of circulation so as to offer their new version no competition. For this reason, such classic film's as John Ford's *Stagecoach* (1939) cannot be rented or shown, for fear of interfering with the low-quality 1966 rehash.
2. Shooting under strict security is popular whenever unique films are in production. The same precautions were taken with such recent efforts as *2001: A Space Odyssey* and *Planet of the Apes.*
3. These scenes were cut from *King Kong* on the occasion of its 1938 reissue. They were deemed, by the censor, as too brutal. An odd point of view coming from someone who uses the scissors with random insensitivity!
4. For interested parties, there is a brief shot during the Empire State Building sequence in which Kong moves his arm and his metallic skeleton is visible for several frames. Noticing this slip-up midway through the action, O'Brien quickly patched the bare spot.

CHAPTER 5

1. In a recent letter, special effects and stop-motion genius Ray Harryhausen, a student of O'Brien, told me that, "few people realize exactly what goes on behind the closed doors of a story conference. Although I was not present during the making of *King Kong*, I could tell what must have gone on by my association with O'Bie during the preparation of *Mighty Joe Young* [1949]. With the latter, he was constantly contributing ideas and rough drawings in the story conferences, all of which were finally absorbed by the writers." Harryhausen went on to say that the animator's imprint is clearly seen on the models and other production aspects of *King Kong.*
2. To see how the squeezed CinemaScope picture projects, one need only watch a CinemaScope film on television. Although the bulk of the picture may be cropped for the small, square picture tube, the only way to fit the opening credits on television is to broadcast the film in its natural, unexpanded state.
3. According to Harryhausen, he animated 50,000 separate frames of the Ymir in the eighty-two-minute film.

CHAPTER 6

1. During its 1975 rerelease, *Seventh Voyage of Sinbad* drew a laugh from audiences while the credits were unreeling: Columbia had not changed the Dynamation title to coincide with the picture's new Dynarama label. It's a small complaint, to be sure. But to a viewer not intimately involved with special effects or moviemaking, it seems like an awfully *stupid* mistake. And in Hollywood, appearance is nine-tenths of the battle!

CHAPTER 7

1. A special on the filming of *Twenty Thousand Leagues Under the Sea* not only promoted an upcoming film on the "Disneyland" program, but it won Walt an Emmy to boot!
2. In the early days of film, as now, European theaters lease screen time to advertisers.
3. Contrary to popular belief, a producer does not pay for a movie out of his own pocket. He sells a property to a studio or to independent backers and, once the money is raised, sees that it is properly and wisely spent.

CHAPTER 8

1. The special effects in *Cleopatra* were moderately effective. However, one must imagine that Twentieth Century Fox put a great deal of pressure on voters—through advertising and promotion—to give the film every Oscar it could possibly get. The award is a well-known box-office draw, and the studio was looking to recoup the picture's $40,000,000 cost. Still, it is odd that the film won the special effects Oscar even considering this hype, since special effects men vote for special effects, composers for music, actors for acting, and so forth. How the technicians could have been duped is curious.
2. As of 1973, there are no longer any nominations in the category of special effects Oscars. There is simply a winner, and it is announced with the other nominations.
3. Despite the fact that both *Circus World* and *Fall of the Roman Empire* were shot in Ultra-Panavision, only the former was billed as a Cinerama presentation. The thinking behind this was that the trade name would help the film's box office, what with its reputation for putting a viewer *in the picture*. *Fall of the Roman Empire* was considered strong enough to stand without the additional cost of "renting" the name. Of course, there *were* motion pictures co-produced by Cinerama, but *How the West Was Won* was the last of these. Other Cinerama involvements include the running of a film distributorship and theater and hotel chains.

CHAPTER 9

1. Strictly as an aside, it is interesting to note that twenty-four minutes of *2001: A Space Odyssey* has passed before a single word is spoken. This is literally mute testimony to the power of Kubrick's visuals.

CONCLUSION

1. The stinging irony of this Red Sea presentation is that *The Ten Commandments* was produced by Paramount, a strong rival of Universal!

INDEX